MW00563818

CATS OF THE WORLD

CATS
OF THE WORLD

HANNAH SHAW
& ANDREW MARTTILA

PLUME

PLUME

An imprint of Penguin Random House LLC
penguinrandomhouse.com

Photographs by Andrew Marttila

Text by Hannah Shaw

LIBRARY OF CONGRESS CATALOGING-IN-PUBLICATION DATA
has been applied for.

ISBN 9780593183113 (hardcover)
ISBN 9780593183120 (ebook)

Printed in China
1 3 5 7 9 10 8 6 4 2

BOOK DESIGN BY SHANNON NICOLE PLUNKETT

Dedicated to the beautiful cats,
both named and unnamed,
with whom we share our world

CONTENTS

Introduction – viii

INTRODUCTION

Where there are humans, there are cats. In nearly every corner of the earth, cats have integrated into our societies, their lives inextricably intertwined with ours. The connection we share knows no bounds and no borders.

The human-feline origin story is one of interdependence. It begins with the advent of agriculture, when the cultivation of grain catapulted our potential as a species but also attracted rodents who threatened our crops. Enter: cats. Valuing their prowess as hunters, we formed an unlikely alliance that would ensure our mutual survival, and the stage was set for a symbiotic partnership that would eventually extend its influence across the globe.

Since the dawn of international travel, cats have been along for the journey. As early seafarers explored and traded, cats disembarked from the ships, spreading far and wide until the world map was covered in paw prints. Today, the question is not whether cats will inhabit areas of human settlement, but how we will engage with them when they do.

Humans have cast cats in diverse roles throughout history and across cultures—villain and hero, nuisance and muse, invader and beloved companion. A wide variety of factors have converged to influence these impressions, such as folklore and belief systems, culture and politics, even climate and topography. We may all share *Felis catus* as a neighbor, but our perspectives vary as much as the languages we use to describe them.

Regardless of where we live, every community has one thing in common: there is always someone showing kindness to cats. The Kenyan fisherman shares his catch. The French foster parent bottle-feeds kittens in her flat. The Chilean shopkeeper adopts a resident feline. Humans navigate through a wide spectrum of circumstances—the abundance or scarcity of resources, the absence or presence of laws—but as we face a kaleidoscope of regional differences, a common virtue connects us all. Compassion is a universal language.

Living in the United States, I've sought every opportunity to voyage beyond my bubble. At home, I'm a professional writer and humane educator focused on the protection and well-being of cats. My talented husband, Andrew Marttila, is a full-time cat photographer, and together we run a kitten welfare nonprofit while fostering a revolving door of neonatal kittens. To decompress from the constant demands of animal rescue and creative work, we've always loved to travel together . . . initially on the (hilariously faulty) premise that it would give us a break from cats.

But of course, with Andrew's camera and my curiosity, we inevitably found ourselves visiting a Japanese cat island, rescuing a kitten in Peru, and encountering cats in a meat market in Malaysia, where we first conceptualized this book. The richness of the discourse we had with international animal advocates opened my eyes, and Andrew's photographs unlocked a breathtaking glimpse into the world of felines. The more we learned and experienced, the more we longed to know about the lives of cats all around the world and the people who love and care for them.

During this labor of love, we didn't travel with a big production team or have fancy accommodations—it was just the two of us, our backpacks, and an itinerary we built around connections we made organically. The photographs in this book resulted from Andrew carrying forty pounds of gear on his back, sometimes through sweltering heat and on treacherously steep hikes. The stories you will read describe real people—former strangers who welcomed us into their lives and became dear friends.

This book does not represent the entire world, nor any chapter an entire country. Rather, we offer a magical peek at the raw beauty of the cats and humans with whom we share our earth, spotlighting the compassion that unites us. We hope it will be a beacon that inspires you to make the world a better place in your own way as the human-feline story continues to unfold.

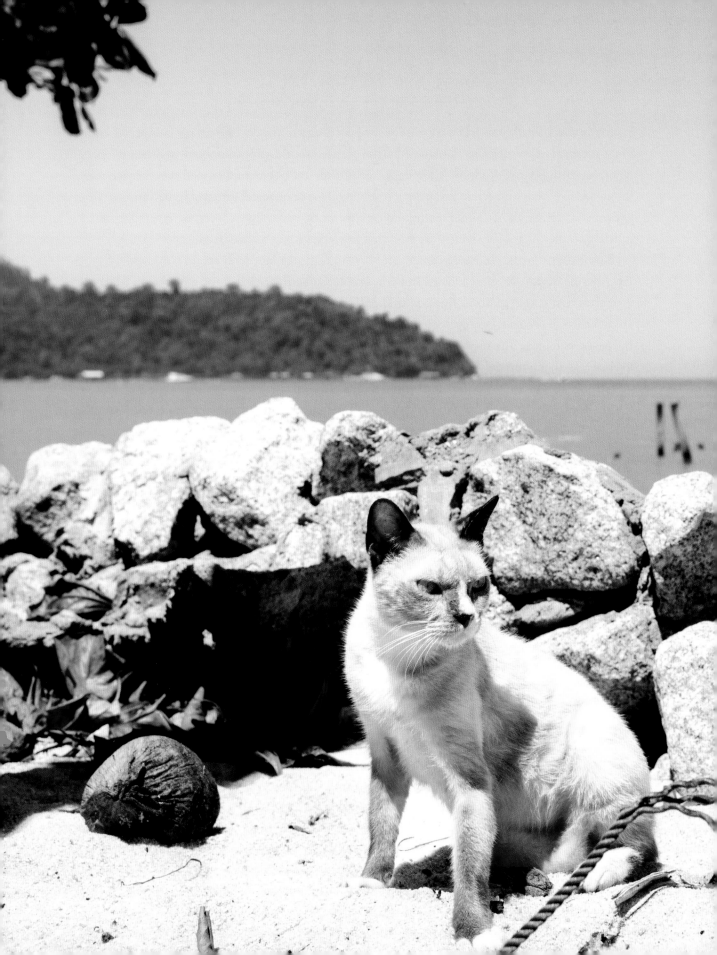

MALAYSIA

OFFICIAL LANGUAGE: Malay

CAT: Kucing

PENANG

George Town, Penang, is famous for its street food, with crowds of eager eaters flocking from around the world to indulge in local delicacies. Food is a great unifier: it brings individuals together across cultures, and even across species. It therefore came as no surprise to find cats living all over this beautiful city celebrated for its cuisine.

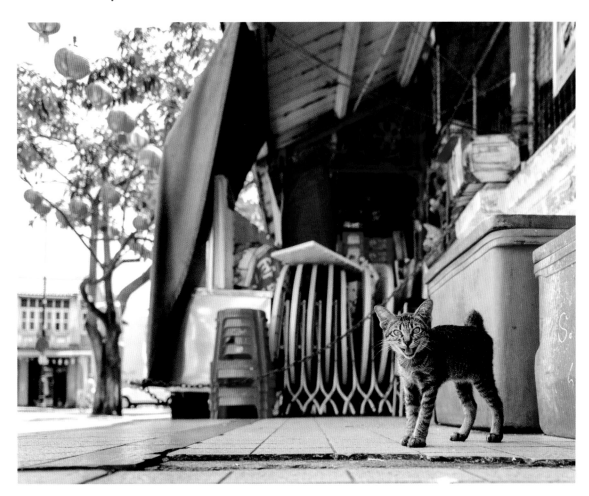

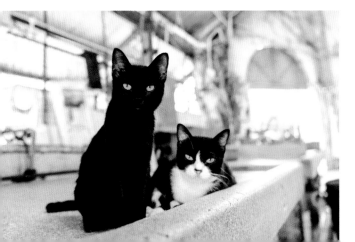

Our visit intersected with Chinese New Year—during which many locals return home to be with family, leaving the markets barren and the neighborhoods uncharacteristically quiet. But while the human residents are away, the local cats stretch out into the scenery more than ever.

Strings of scarlet Chinese lanterns decorated the streets as we walked, not a soul in sight aside from a young brown tabby with a nubby tail standing along the path. He meowed as if to extend an invitation, then pranced into a cavernous, empty meat market where a family of felines was sprawled comfortably across the concrete slabs.

A young kitten sat at the center, her wide eyes illuminated by the skylights overhead. Curious and uncertain, she cautiously approached my outstretched hand, sniffing deeply. Time stood still as we paused in contemplation of one another. Gazing at me, did she see me as a potential companion or a mere passerby? Looking back at her, did I see a displaced baby or a treasured member of an autonomous family? Having had enough of my stare, she galloped away toward a tabby cat who licked her gently on the head, and I had my answer.

Throughout Penang, it's common to see community cats—cats who live freely in the neighborhood. They embody a wide range of experiences: some have one caregiver, some have ten, and others care for themselves by hunting and scavenging. Many even have adoptive homes but are customarily permitted to venture outside. "Only the rich and the famous keep cats like caged animals," said Satya, a local naturalist. "Most of the time, cats are free."

Across the island in the small fishing village of Teluk Bahang, paw prints in the sand led to an open-air refuge along the crystal-blue waters of the Malacca Strait. At Cat Beach Sanctuary, felines lounge in the shade of palm trees while taking in the sea breeze. Free to roam, each cat has their own chosen territory and social group, as well as access to the sandy shore that serves as a giant litter box (which is scooped daily with a large rake!).

A stone's throw from the water, an old wooden house has been reimagined as a base of operations and a maternity ward for feline families. Inside, cats yowled in anticipation as a volunteer prepared a mixture of cooked rice and ground chicken with a bit of commercial cat food blended in.

According to Teviot Fairservis, who founded the organization with local fisherman Nana Bin Wanchik, many of the cats they rescue arrive heavily pregnant or already nursing young kittens. "Unfortunately, superstition causes many not to spay or neuter. Some say that they wouldn't sterilize a cat because it could cause their own family to become infertile," she shared.

Teviot hopes to inspire change throughout the region by inviting visitors to spend time with cats at their sanctuary on the shore. "Here in the fishing village, people live close together in a small community where the cats go in and out. But as you get into higher-income areas, you find that many managements will not allow cats in the building. We want to see that change, because a house is not a home without a cat."

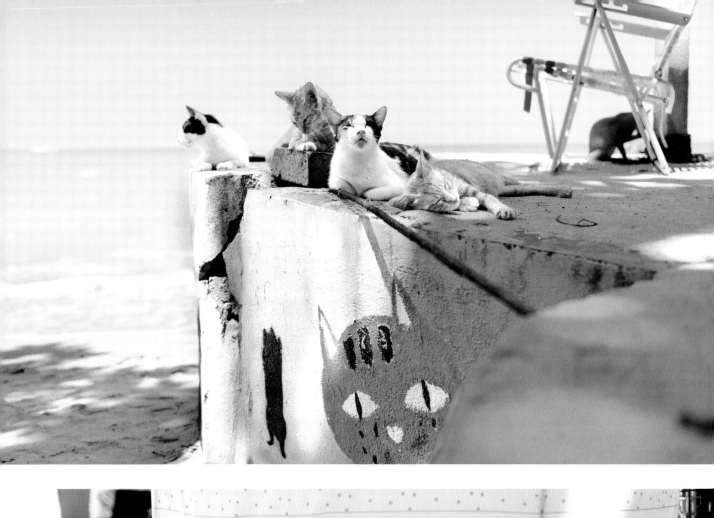

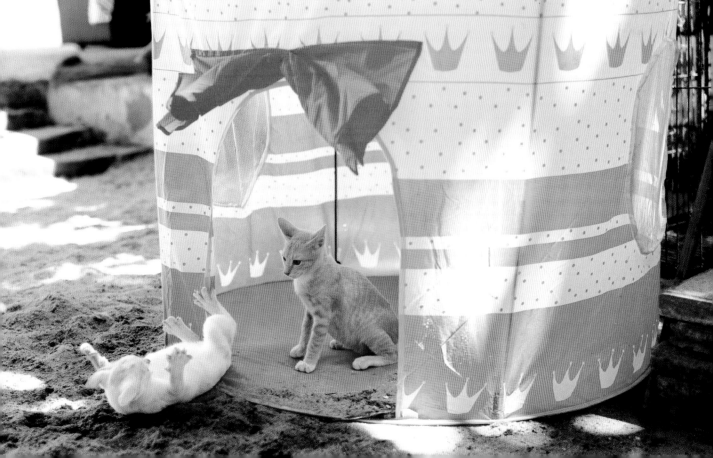

PAHANG

Nestled in the Titiwangsa Mountains, the rolling hills of Cameron Highlands are adorned with tea plantations and strawberry farms as far as the eye can see. The fertile landscape and scenic vistas are attractive not only to visitors and locals, many of whom work in the agricultural sector, but also to a number of cats who live in the residential areas.

Enjoying the cool mountain breeze as we explored by foot, we came upon Khalil, who was rubbing a cat's belly in the driveway of his Brinchang home. "If someone throws them away, I take them in," he said lovingly. On the side of his house, a yellow collar hung in remembrance of a treasured cat who had recently passed. He held his hand to his heart. "When I see the collar, my heart is so sad."

One town over, in Tanah Rata, a street vendor battered whole fish and dropped them into a deep cast-iron pan. The sizzling scent attracted local families—human and feline alike. The closest seat to the kitchen was occupied by a mama cat and one of her young kittens, who were patiently perched on a plastic chair like loyal patrons awaiting their favorite meal. The wilier kittens darted between table legs and customers' feet, tumbling over one another in friendly competition for fallen table scraps.

The presence of the cats was commonplace, and none of the dinner guests seemed to pay them any mind, except one: a small child seated toward the back. With his little legs dangling off the chair, the boy strained to look over the tabletop and shyly smile at us. I smiled back and pointed to the kittens.

"Meong," said the child, mimicking the sound of a cat.

"Meow," I responded.

We both giggled—we'd found a common language.

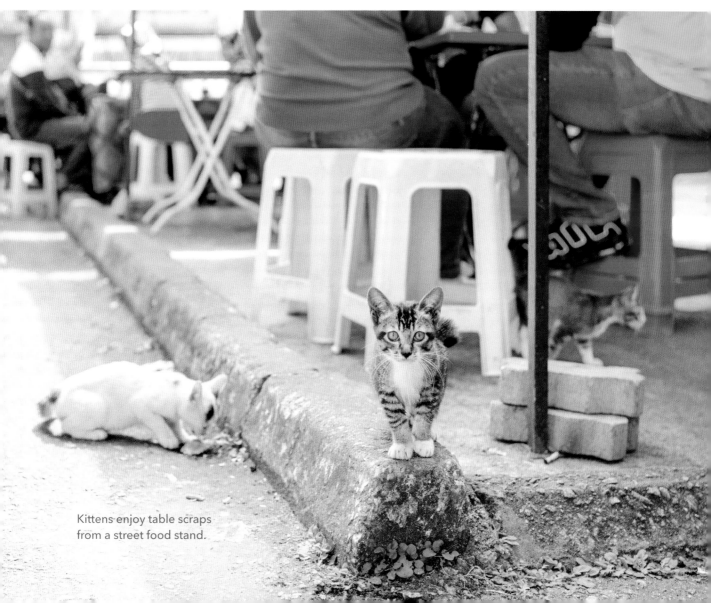

Kittens enjoy table scraps from a street food stand.

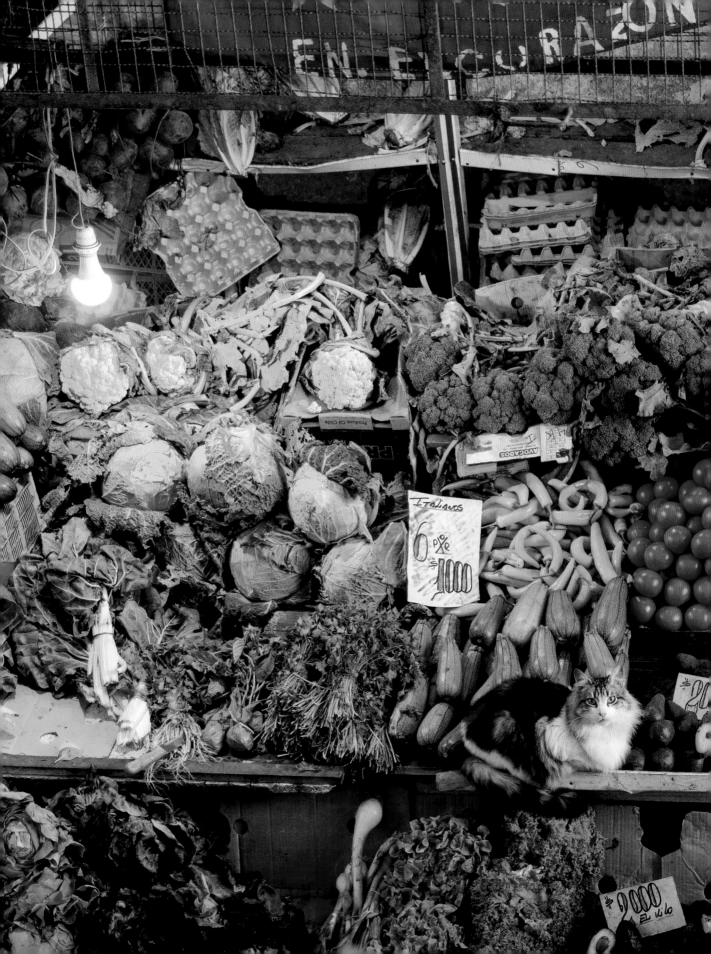

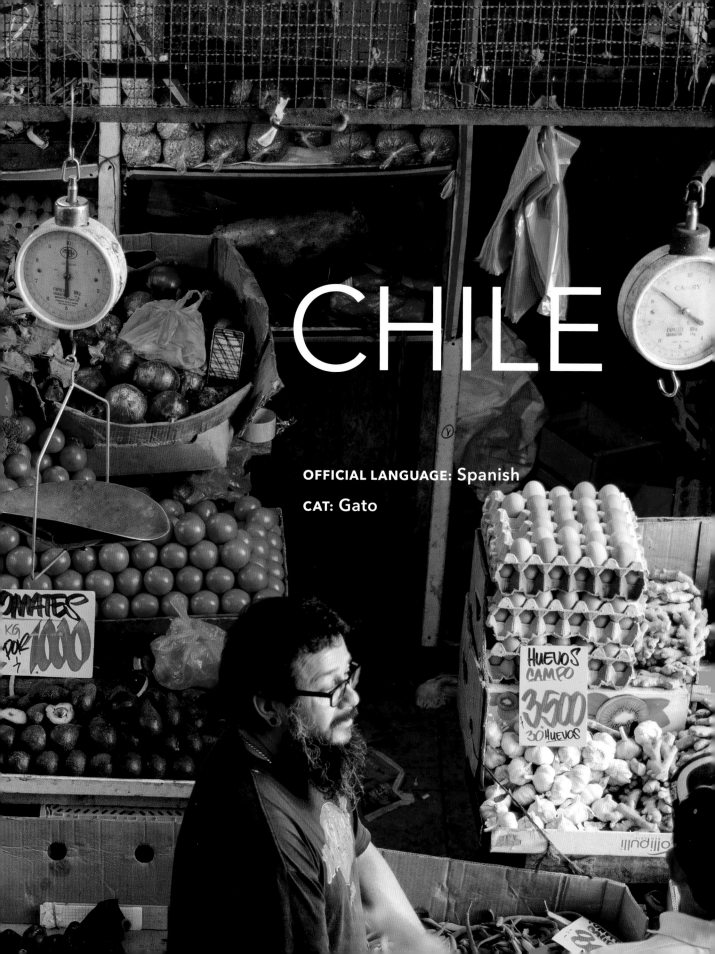

CHILE

OFFICIAL LANGUAGE: Spanish

CAT: Gato

SANTIAGO

There's no place on earth quite like the sprawling produce markets of Santiago, Chile. To step inside La Vega Central—one of the largest markets in South America—is to enter a vibrant labyrinth of flavorful foods. Step slowly through the hundreds of stalls, and you'll see cats slinking between bags of aromatic spices, resting on piles of potatoes, and popping out from under tables to say hello.

"The cats who live here are really the kings of this place," said Francisco Cabezas, cofounder of the advocacy project Gatos de la Vega. "They have a very huge presence, and they are very respected."

It's said that the shop owners in La Vega do not choose the cat, and the cats do not choose the shop owner; the cat simply chooses the shop. Once the cat has selected the stall of her choice, the vendor begins to feed her, and a working relationship is born. If the vendor moves or closes their business, the next owner of that stall will inherit the feline along with the location.

"The cats really belong to the store," explained Mireya Osorio, the project's other cofounder. "Once

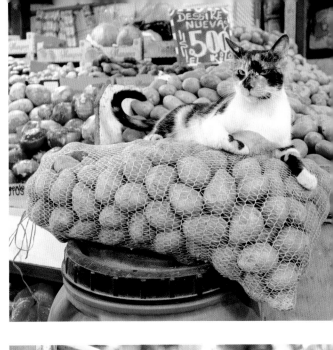

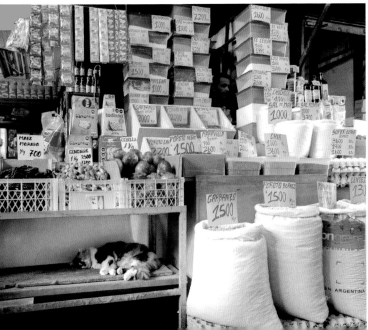

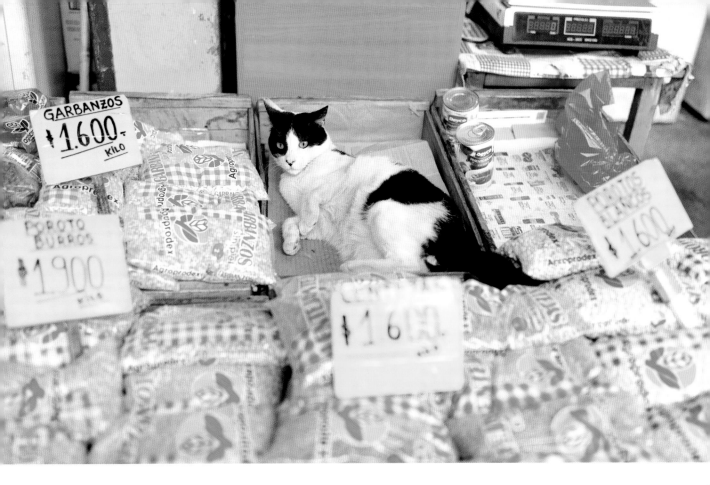

the vendors get to know them and build a relationship with the cat, they love them. They name them; they're like a part of their family. Those are cats that could have been stray, but they're being taken care of, and they're safe there."

At a dried-bean stand, a friendly feline rolled around in an empty box, dissuading the shop owner from restocking. The gray-haired gentleman leaned over from behind the stand and emphatically pronounced: "His name is Diego. Diego de la Vega!"

Farther into the market, we stopped at a stall that sold plant-based specialty goods and deli items. Next to the cash register, a chunky torbie named Violeta was curled up in a soft bed with a sign that translated to "Do not disturb the kitten. She is not here to amuse the customers. She is the boss."

At a large tomato stand, one vendor has developed a very quirky ritual with a calico cat named Lady. Every few hours, he slices the top off a fresh tomato and sets it on the table so she can lick the juices. While she has plenty of access to water and food, tomato juice is her favorite snack. A row of sliced tomatoes sat side by side, displaying the evidence that she is adored.

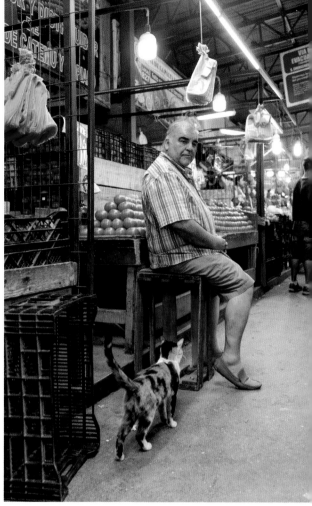

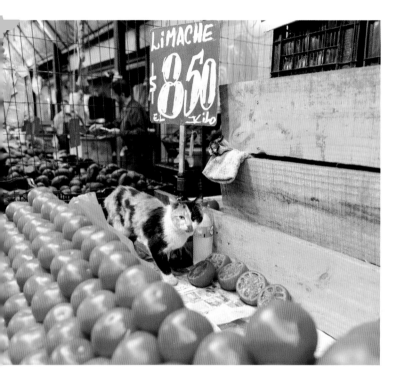

Francisco explained that food providers are considered cleaner if they have a cat, because customers can feel certain that there are no rodents there. "This is a very big market in the center of the city, so every measure to have this place clean—like having a cat—is very well seen."

Central to the success of the cats in the market is volunteer group Callejeritos de la Vega, who work to provide sterilization, veterinary care, and food to the cats. Caring customers can donate through tip jars at many of the shops to support the cause.

According to Francisco and Mireya, caring for those in need is a universal principle in the market. "In Chile we have this word, *aguachar*—it means 'to take care of.' We embrace that," Francisco shared. "La Vega has this motto—it's like: 'After God is La Vega.'"

Mireya nodded. "If you need food, you can find it here in La Vega. If you don't have money and you need food, you can still find it here."

Francisco agreed. "This applies also to the cats. It's part of our culture. No one is left behind."

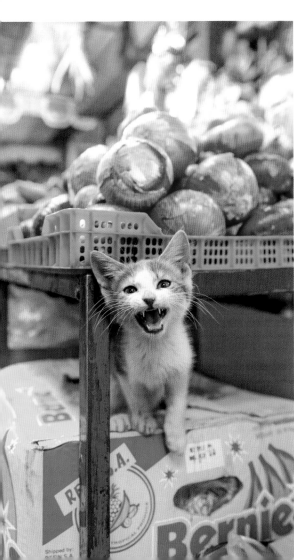

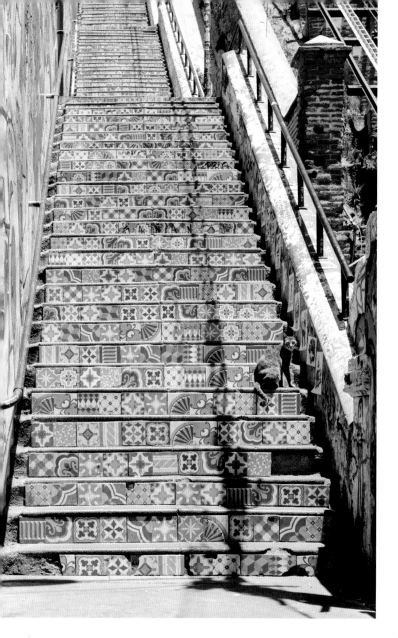

VALPARAÍSO

A colorful maze of buildings hugs the coast in Valparaíso, the beautiful Chilean city aptly nicknamed "the Jewel of the Pacific." We followed a silky tabby to the base of the steep, sloping hillside, where we had a choice to make: ride the funicular lift to the top or brave the steps that seemed to go upward without end. Hopping onto the ornate, tiled stairs, a tabby looked back and winked—a clear invitation to take the road by foot! One step at time, we made our way up, wandering past vivid murals and greeting all the cats along the way.

Atop Cerro Panteón—one of more than forty hills in the city—a vocal cat named Larussia welcomed us to her home at Cementerio N° 1, a gorgeous nineteenth-century cemetery and national monument. "Don't believe her, she is fed every day," a guard laughed as Larussia pursued us, meowing in search of snacks. Leaping over neoclassical mausoleums, she sat perfectly poised on a tomb, taking in the panoramic view of the multicolored hillside homes.

Valparaíso is known for being the street art capital of Chile, and you'll find that most walls are adorned with brightly colored murals—many of which involve cats! This artwork has an important history: under the military rule of Augusto Pinochet, all political art was banned, and Valparaíso became a secret haven for

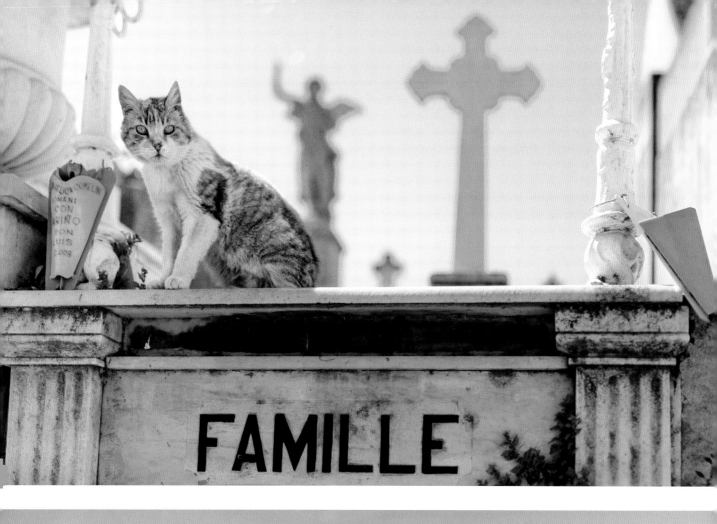

FAMILLE

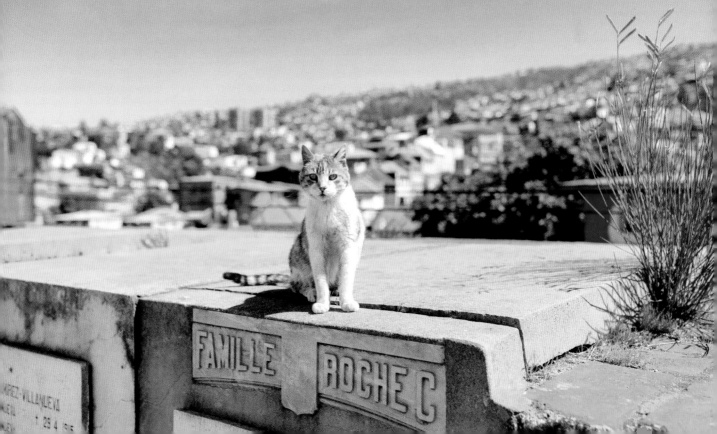

FAMILLE ROCHE C

visual expression due to its steep and slender streets, which could conceal artists and protect them from arrest. Murals became a symbol of hope, and in the 1990s Valparaíso made street art legal to celebrate artistic freedom.

For decades, the narrow winding roads have been home to cats, who have no doubt inspired many of the artists who have lived there—including Nobel Prize laureate and Chilean poet-diplomat Pablo Neruda, who wrote multiple poems about the local feline muses. "The cat, only the cat, appeared complete and proud: born completely finished, walks alone and knows what it wants," he wrote in "Ode to the Cat."

If only Neruda could have known Zuttu, a literary cat who has become the official mascot of the local bookstore he calls home. The chunky tabby sat in the doorway of Librería Mar de Libros—a perfect lure for lovers of lap cats and literature. As we greeted him, the clerk called over to us excitedly, pointing to the store's line of Zuttu-themed merchandise.

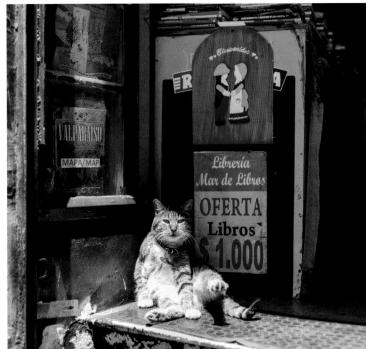

Near the bookstore, open-air bodegas are welcome way stations for wandering cats.

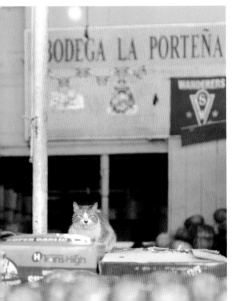

Through a large decorative window at Mercado El Cardonal, the silhouette of a cat slinked by. We stepped inside to find an enchanting realm of food and felines set in a lively nineteenth-century produce market, where resident cats were overseeing the sale of peppers, corn, and eggplants and sleeping on literal beds of lettuce. A vendor named Horacio picked vegetables for a customer, careful not to disturb his feline friend. "That's Alfonzina; we have cared for her since she was two months old," he said. When asked how he came to befriend her, his answer was simple: "We chose each other."

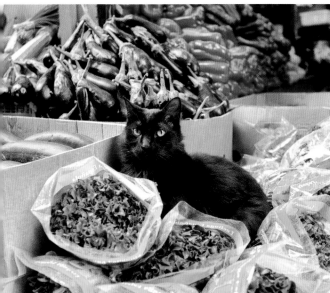

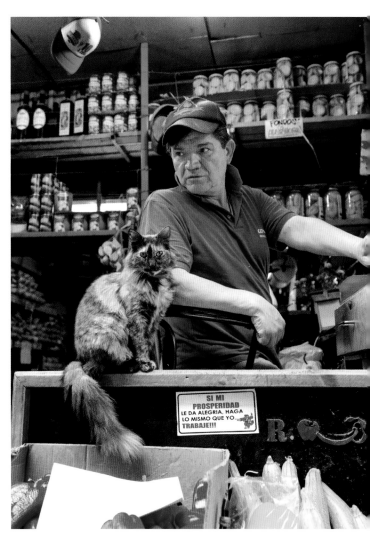

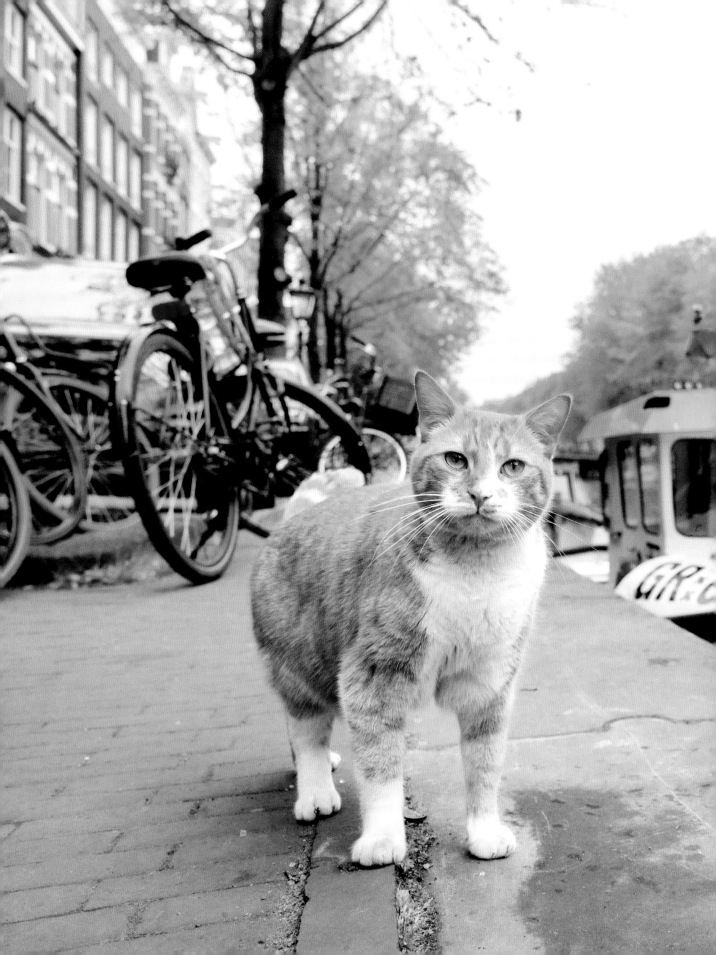

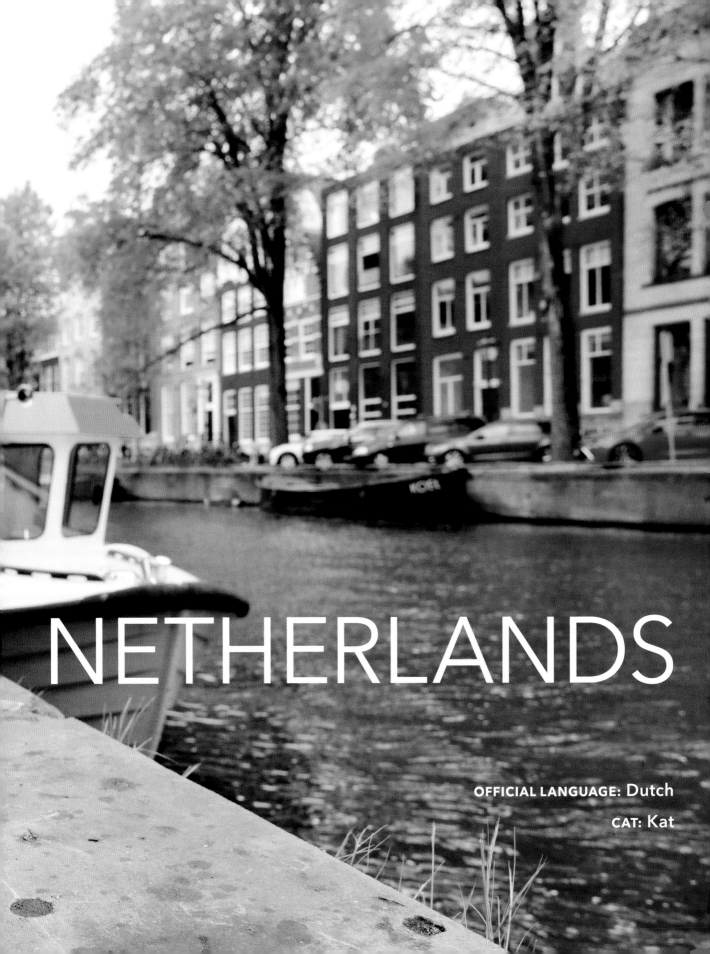

NETHERLANDS

OFFICIAL LANGUAGE: Dutch

CAT: Kat

AMSTERDAM

Wander the streets of Amsterdam's city center, and you'll pass by narrow canal houses, busy cafés with seating spilling onto the sidewalk, and quaint houseboats docked in the canals—any of which just might be home to a cat or two. In fact, the populous city has friendly felines living in and around all sorts of businesses, from offices and hotels to its world-famous cannabis shops. Most of them don't travel far, except to patrol the vicinity in search of mice.

It turns out that the iconic buildings that line the canals are attractive not only to tourists but to lots—and *lots*—of rodents. "What would you rather have around food: a cat or a lot of mice?" one animal rescuer asked, explaining that it's common for restaurants to reach out wanting to adopt a resident cat. Despite recent crackdowns by food safety inspectors, it is still largely socially accept-

able for restaurants to keep cats for purposes of rodent abatement.

"We're technically not allowed to have a cat, but people really like to see him here," a server said of Pedro, a tuxedo cat who splits his time between a brunch café during the day and a tapas bar at night. "He can go wherever he wants except the kitchen."

"We used to have a cat, but then it was forbidden. So now we have the mice," said an employee of another café, woefully shaking his head.

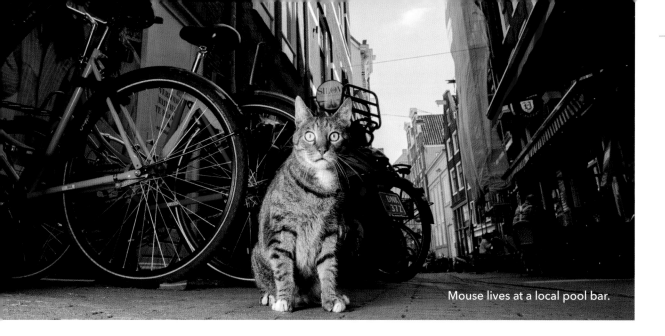

Mouse lives at a local pool bar.

On the patio of a popular Dutch eatery, we were introduced to Mango, an orange cat with white boots. "You can put a lot of money into destroying the mouses, and it won't work. Only the cat works," the server explained, sharing why the restaurant refuses to give up the feline tenant. "And of course . . . everyone likes a cat."

While restaurant owners face a challenging decision to give up their cats or face fines, for other business establishments it's perfectly legal to have a cat—and you'll often see them lounging in

windows and walking the aisles of retail shops. At Kilosale Vintage, a cat named Gerda is the queen of the store. "She gets fur on the clothes, but everybody loves her and nobody minds," said Els, the owner. "People love her too much sometimes, and we have to ask them to stop following her!" A sign at the counter read in Dutch: "Leave me alone, or I'll bite your head off."

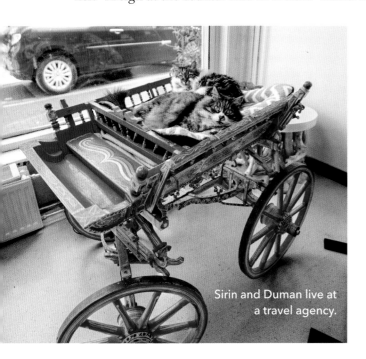
Sirin and Duman live at a travel agency.

Jackie calls a boutique hotel her home.

Memati resides at a tailor shop.

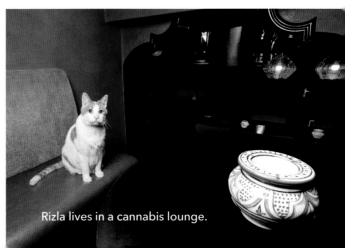
Rizla lives in a cannabis lounge.

Amsterdam's appreciation for cats runs so deep that the city is home to one of the largest cat museums in the world, KattenKabinet. A resident tuxedo cat named Oscar guided us through the grandiose mansion, which houses an impressive collection of cat paintings, sculptures, photographs, and memorabilia. Wandering into the music room, he took a noble perch on a grand piano, surrounded on all sides by works of art celebrating his species, then guided us into a courtyard lined with cat posters from around the world.

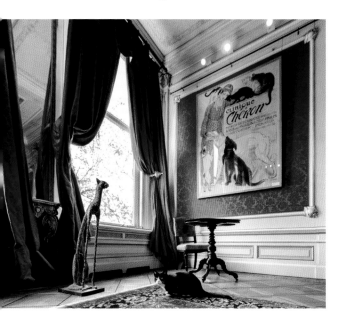
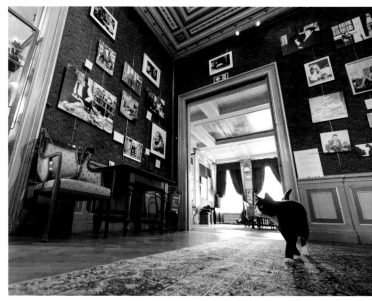

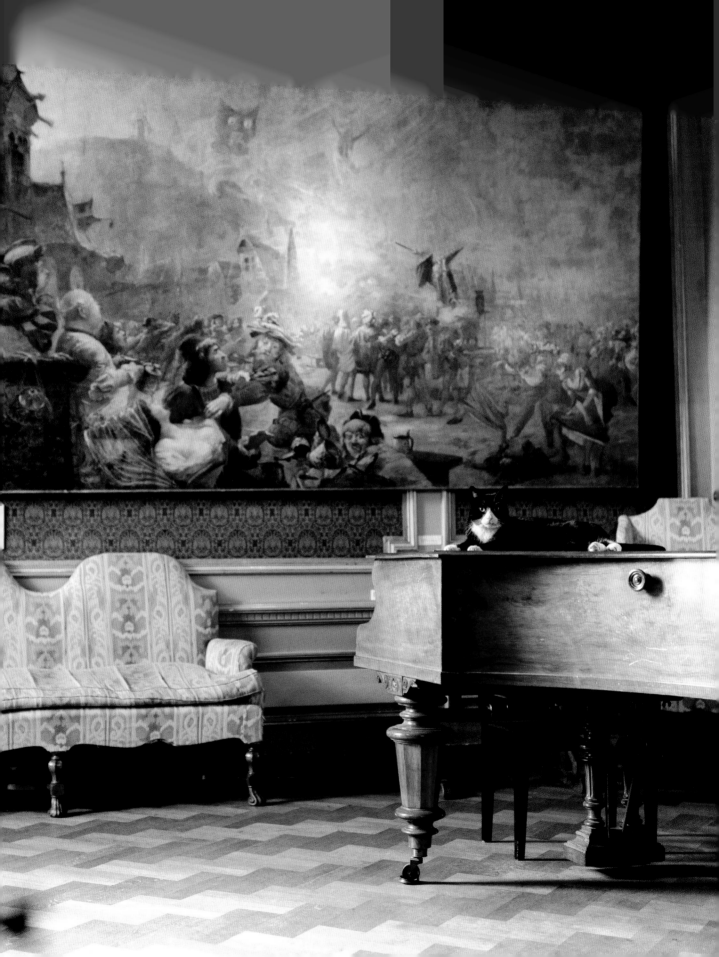

While all cats like fresh air, not every cat in Amsterdam is given free range. Teddy and Monty live in an apartment, where they enjoy the outdoors from a protected balcony. "We use garden netting to keep cats safe and contained," explained their adopter, who volunteers with a local rescue. "Cats can fall trying to chase a bird, so I always recommend that you need to put a net."

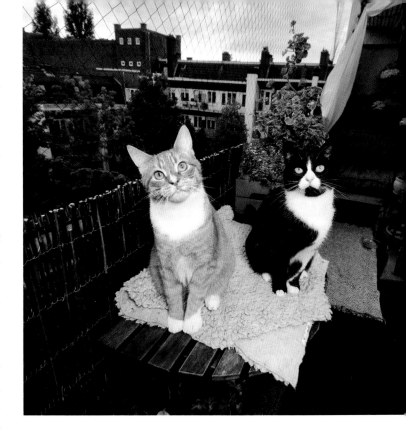

There are a number of organizations in Amsterdam dedicated to saving cats, none of which are run by the government. Rather, these groups operate as charities that receive both public and private funding, and they work collaboratively to fulfill the needs of their community. There are animal ambulances for sick and injured cats, there are shelters, and then there's Stichting Amsterdamse Zwerfkatten, an organization that serves as an "in-between" resource for cats.

"I say SAZ is an 'in-between' organization because cats come here between the street and the shelter. All the cats here have something special about them, like medical issues or trauma," explained volunteer Judith Dekker as she walked us

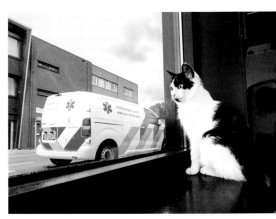

through the modern, pristine facility. "We can give them extra time, space, and attention to help them recover." Once the cats are ready, SAZ seeks placement in one of the local animal shelters, where the cats can meet prospective adopters and find a home.

If you're looking for a shelter in the city, keep your eyes on the water! De Poezenboot (The Catboat) is the world's first floating animal shelter and is home to dozens of friendly felines awaiting adoption. The Dutch houseboat is uniquely outfitted for cats, complete with cat trees, window perches, and a long open-air walkway where the residents can feel the breeze against their fur as barges pass by.

De Poezenboot was founded in the 1960s when Henriette van Weelde, who lived in a house along the canal, began taking in cats from the street. "She had too many cats . . . and arguments with her husband," laughed Judith Gobets, who now runs the organization. "At that time you could just buy a boat and put it in the canal. So she put it here, and that was it." The houseboat has since become a charity rescuing hundreds of cats a year and is beloved by tourists and locals, who can leave donations to help keep the rescue afloat.

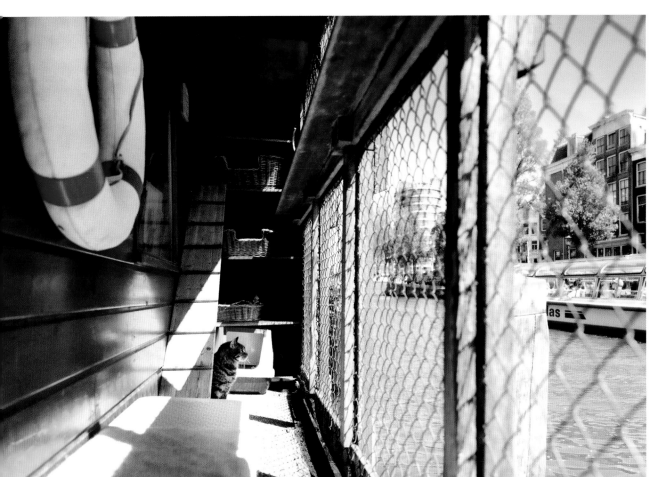

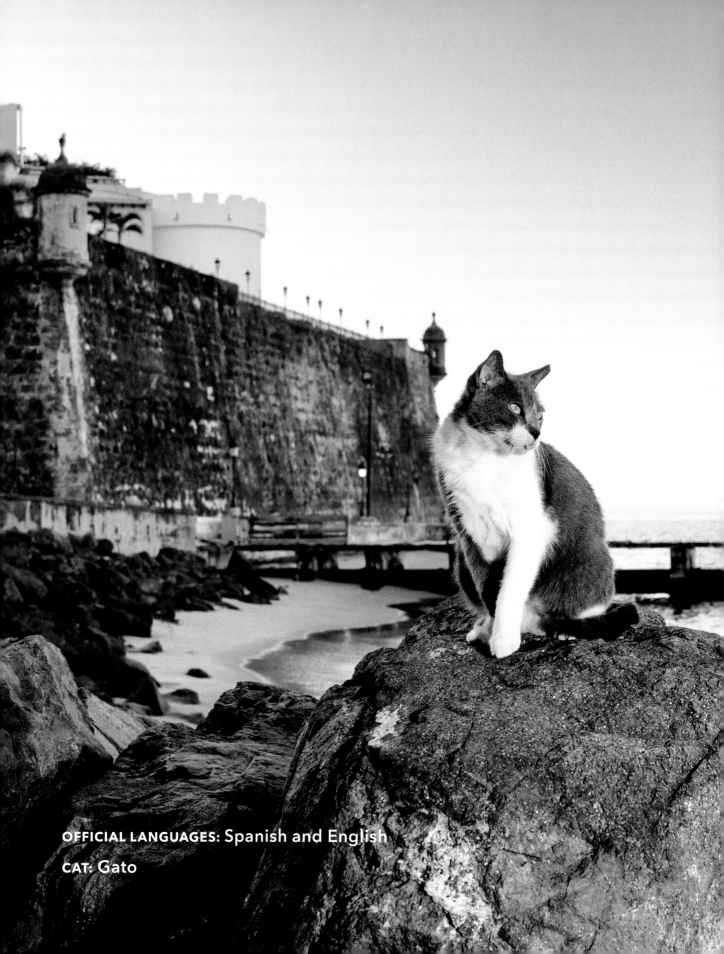

OFFICIAL LANGUAGES: Spanish and English

CAT: Gato

PUERTO RICO

VIEQUES

Boarding a twin-prop airplane, we made our way to the small island of Vieques off the eastern coast of Puerto Rico. Originally inhabited by the Taíno people, the island was colonized in 1508 by the Spanish, who brought the first cats to its sandy shores. After Vieques became a US territory, military weapons testing led to decades of environmental devastation, and in the aftermath, concerted community efforts to restore the ecosystem began.

To assist the large populations of community cats, dogs, and horses, local and visiting animal advocates came together to create the Spayathon for Puerto Rico: a fast-paced, island-wide sterilization event aiming to reduce the proliferation of domestic animals. Volunteering on the trap team, we packed into a rugged truck towing dozens of crates and humane traps and set out in search of cats to bring in for surgery.

Papolte, a lifelong resident, handed us a gray kitten to bring to the clinic. "I feed more than sixty cats each day," he said as he divvied out kibble on the street with a ladle. The only caregiver in his neighborhood, he was once overwhelmed by the number of kittens being born. "Most are sterilized now, so it's better."

With no animal shelter on the island and fewer than ten thousand residents, adoption isn't an option for the majority of cats. "That's why trap-neuter-return is a no-brainer here . . . There is no other option,"

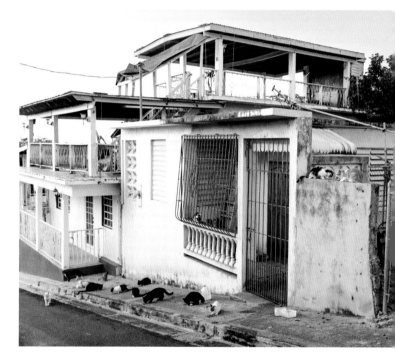

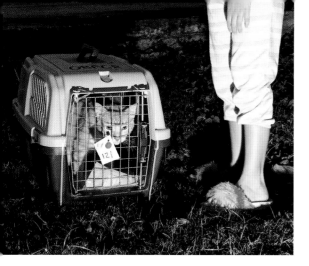
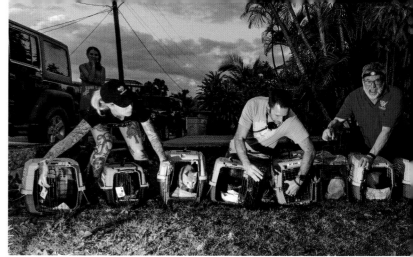

After sterilization, cats are returned to their communities.

said field trapper John Peaveler. To ethically reduce the population, cats are trapped, neutered, vaccinated, and returned to their outdoor homes with an ear-tip—a small notch in the ear that serves as a visual cue that they have been sterilized. Determined to catch as many as we could, we searched for cats without ear-tips by starlight and headlamp late into the night, serenaded by the enchanting chirps of coquí frogs.

"When Hurricane Maria hit, people fled—rightly so—and there were animals left on the island. You couldn't walk twenty steps without encountering a stray," explained Laurie Mosher, cofounder of Our Big Fat Caribbean Rescue. "Maria was actually the force that we needed to realize we had to solely put our resources into spaying and neutering."

After long days of trapping, it was lovely to return to a hotel with a resident cat. "Chita spends most of the day outside, but every night she chooses which room she wants to stay in. If you're lucky, she'll choose you," said the hotel owner. Maybe it was luck, or maybe it was that we smelled strongly of tuna from long days of trapping . . . but she chose us every night.

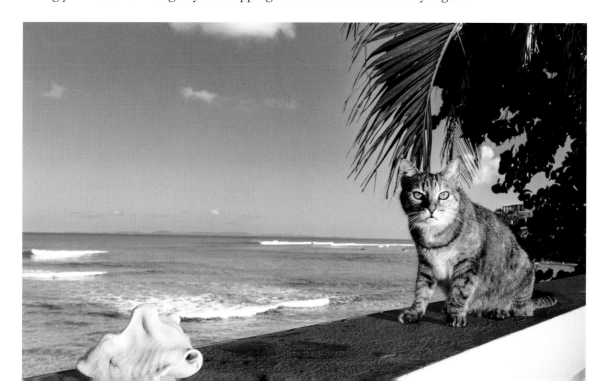

CABO ROJO

Just days before our visit, the west coast of Puerto Rico was hit with a devastating earthquake that left people and their animals displaced. Along with a friend from San Juan, we loaded a car with as much cat food as we could fit and drove across the island to lend a hand.

In a local arena, a Red Cross shelter was erected to provide temporary housing to families—including their furry loved ones. As we unloaded bags of kibble, a man invited us into his family's unit to meet their ten-year-old cat, Chari. "When the earthquake hit, she hid under the roof and we couldn't find her. So we went back every day to look," he told us. "We raised her since she was three weeks old . . . She means everything to us."

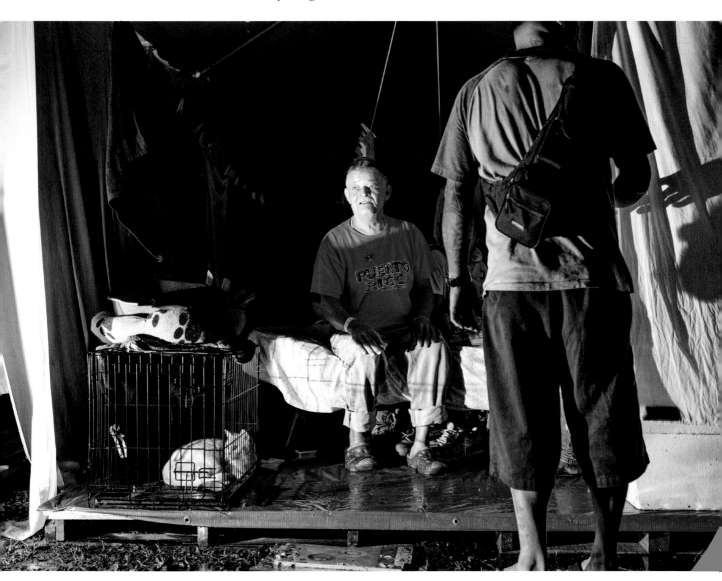

In the seaside area of Boquerón, cats congregated on the boardwalk to seek food. We walked with Dellymar Bernal, president of local shelter Santuario de Animales San Francisco de Asís, as she shared information with locals about how to get help. "So many people are leaving, and they leave behind animals," she sighed.

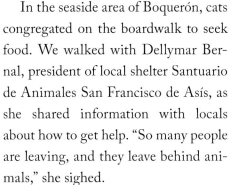

While a large section of the shelter was damaged by the earthquake, no natural disaster has ever stopped her from assisting. "During Hurricane Maria, we were flooded. There were no lights, no phones, nothing. I stayed alone with three hundred animals," she recalled. Now, the shelter was tasked with rebuilding again, all while rescuing displaced cats.

"The cats know about the earthquakes before we do," said Angel Vega, who works as a builder for the shelter. "They growl at the floor . . . and then the rumbling starts." He held an orange tomcat tenderly in his arms and sighed in resignation that they would have to rebuild once more. "In this work, there are many losses. The only win is for the animals."

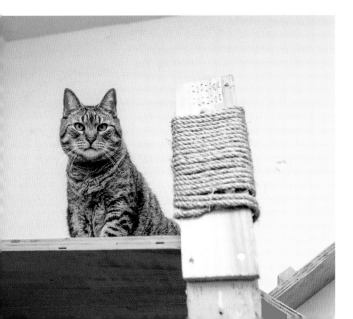

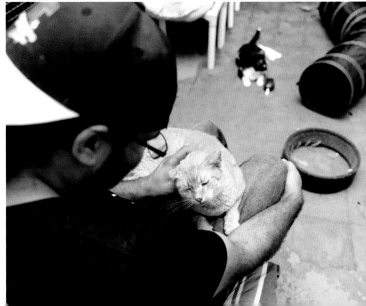

SAN JUAN

The capital city of San Juan is known for its colonial architecture, historic landmarks, coastal views, and, yes—its many meandering felines! Cats can be found keeping company with the locals, walking the stone-paved streets, and even relaxing along the fortress walls that encase the shoreline.

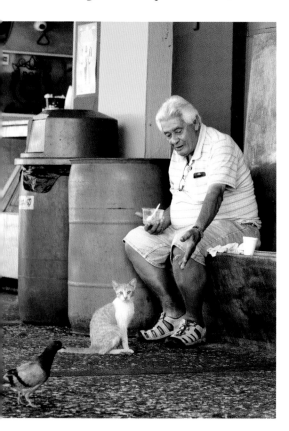
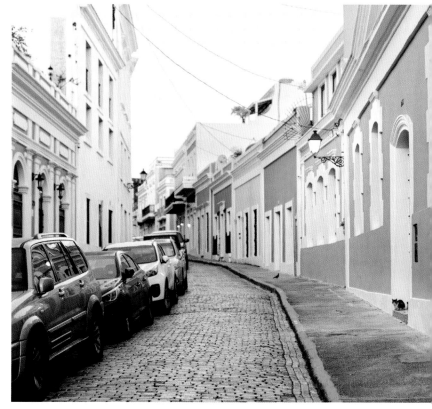
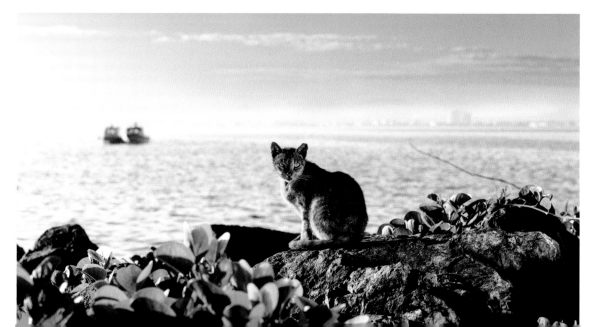

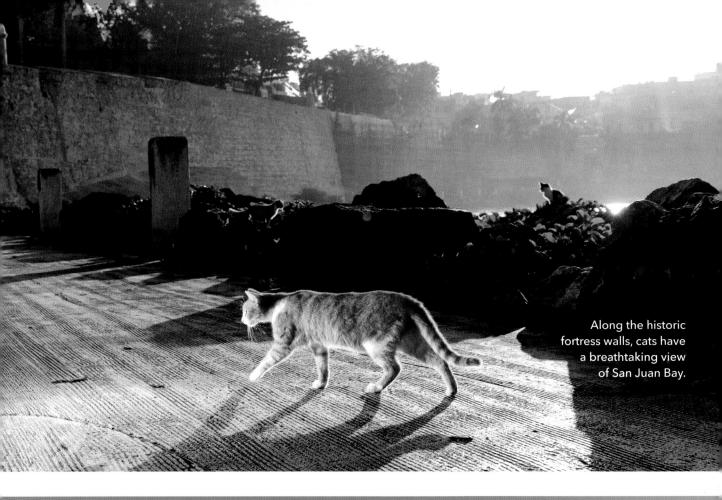

Along the historic fortress walls, cats have a breathtaking view of San Juan Bay.

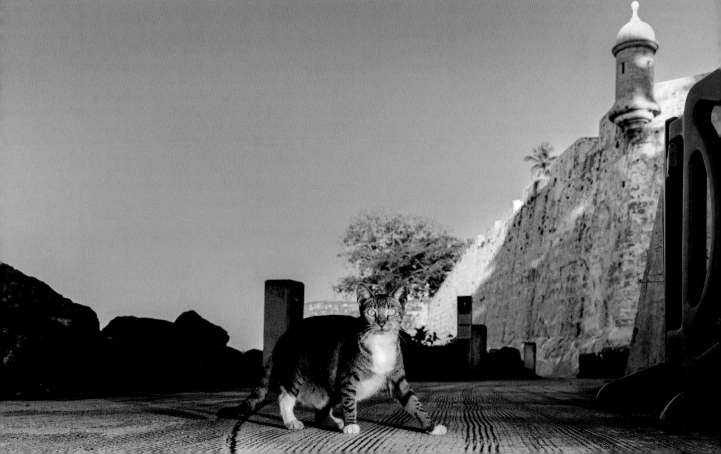

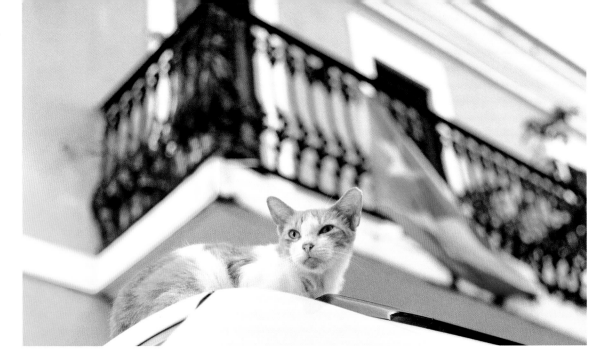

Colorful homes are stacked along the seaside in La Perla, and there's one woman who knows every cat in the barrio. Irma Podestá, president of Save a Gato, showed us around the close-knit community where she has trapped over a thousand cats. "I caught thirty cats here in only forty-five minutes," she told us as she stood in an open-air pavilion that holds a free library. At first glance, it looked like none remained . . . until I perused the titles and spotted a stealthy ear-tipped tabby blending in to a stack of books!

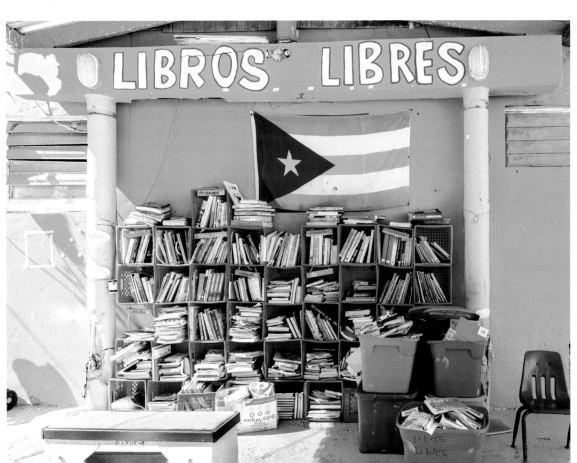

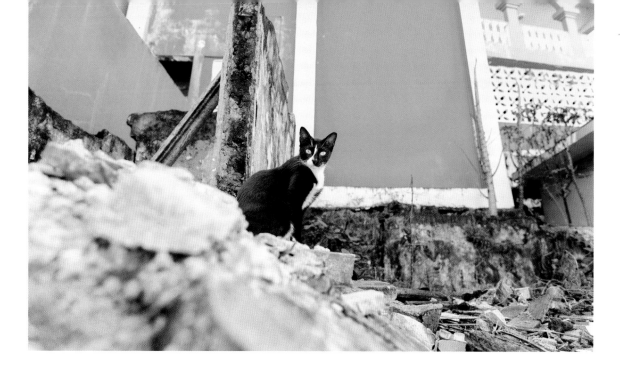

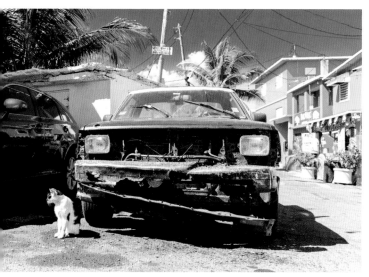

As we walked through the steep, winding streets, Irma seemed to know everyone. "This woman here, she had a factory of cats before I convinced her to spay," she said in a hushed voice as we turned the corner and saw a family of felines gathered at a woman's feet.

"Nena! Nena!" called the woman to the cats. I introduced myself and asked which was Nena, and she smiled. "They're all Nena!"

Group names aren't uncommon in La Perla; at a neighborhood bar, we were introduced to a group of tabbies all named Kitty. The bartender offered a free beverage to Irma, who over the years had helped her to sterilize close to fifty cats. Now, only a manageable number remain, and they have carte blanche to lounge on tabletops and rest on coolers.

"I used to not like cats, you know that?" Irma told us, shaking her head. "Then I moved to Old San Juan. I was obligated to like them because they were everywhere. You don't understand until you're part of it. Then you understand."

Just outside La Perla, the historic Cementerio Santa María Magdalena de Pazzis makes a serene home for a colony of cats. Step slowly past stone crosses and towering statues of Catholic figures and you just might spot a cat sunning herself on a grave, enjoying the silence of the hallowed space.

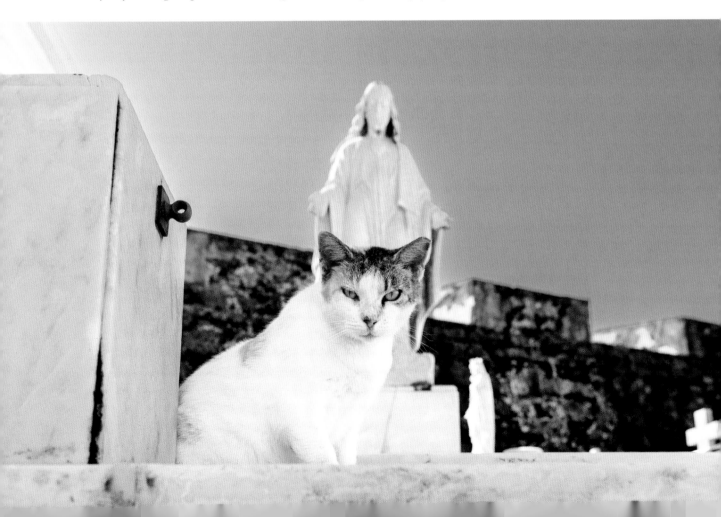

It's often the quietest areas where cats proliferate most. Paseo de Diego, a once-bustling shopping area, has become "more like a ghost town," according to a local, and the chasm has left an opening for cats to take over. As we walked past boarded-up, graffiti-covered storefronts, the streets were so silent you could hear a pin drop—or a cat's paws hit the concrete as she landed on all fours. Weeds burst through the cracks on the facades of abandoned buildings and rodents scuttled by; nature was reclaiming the neighborhood, and cats ruled over the territory.

While most businesses had fled the area due to economic hardship, one couple had moved their business there intentionally. "It's the best location for us. It's quiet, and the only tourists who visit us come because they love the cats," said Des Rodríguez, creator of Necromancy Cosmetica. Des and her partner, Zal Pérez, not only produce a successful line of cruelty-free cosmetics but also operate a feline advocacy project, Cats of Necromancy.

Malévolo and Macabro were adopted from the area

Inside their makeup shop you'll find gothic artwork, heavily pigmented lipsticks, and an entire room of traps and kennels for fostering kittens and housing cats for sterilization. On the empty footpath outside their shop, they feed feral felines who pop out of an abandoned building via a hole in the wall. "They don't really like people," Des said with a smirk, ". . . but neither do we!"

Cats don't simply live in and around the empty buildings—they have taken over the rooftops, too. Skywalker, an aptly named cat who lives atop a stretch of vacant shops, refuses to come down to street level. "We were wondering, how can we get her to eat if she can't come down?" Zal explained as he scooped kibble into a sheet of newspaper and crumpled it into a ball. "We started making 'food bombs,' and now she expects it every day."

Skywalker watched intently as Des hurled the food bomb overhead. When it hit the rooftop, she pounced and tumbled with it until kibble spilled out like a prize.

Heading back into Old San Juan, we visited Save a Gato's facility—the only animal rescue located inside a US national park! The prime location by the port allows cats to be seen by hundreds of tourists who arrive by cruise ship, and with roughly 90 percent of Save a Gato's adoptions occur-

ring off the island, this visibility is essential. "We even buy travel bags in bulk so people can take cats back with them," Irma shared.

Happy to help, we offered to fly home with four little foster kittens of our own, giving them Taíno names: Cacique, Nanichi, Yukiyu, and Anani. Irma prepared their paperwork and drove us to the airport, kittens in tow. "This is definitely a community effort," she said. "We've been able to change the lives of many cats, and more importantly the minds of many people. Everyone can be a rescuer, you just need to act when a cat needs you. And believe me, they do."

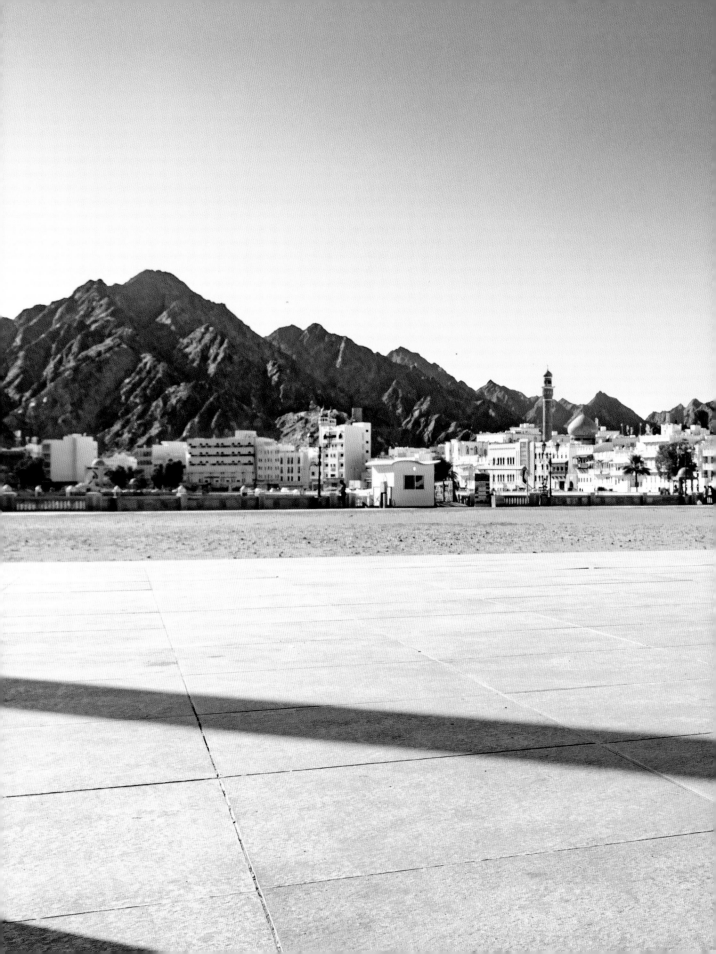

OMAN

OFFICIAL LANGUAGE: Arabic
CAT: ‫ةطق‬ / Qittah

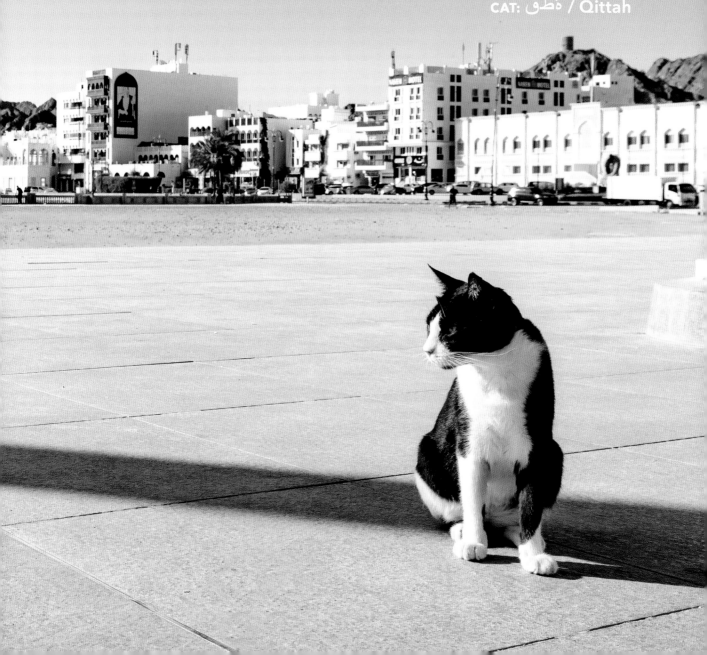

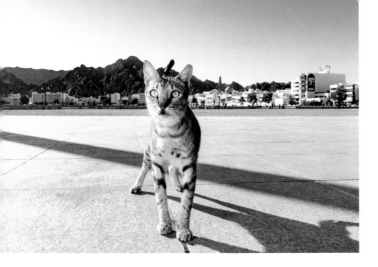

MUSCAT

The capital city of Oman is a peaceful, scenic oasis. A striking skyline of white buildings is starkly contrasted against the dark, jagged peaks of the Hajar Mountains and the calming blue of the Arabian Sea. In the early morning the streets are quiet, save for the adhan—the Islamic call to prayer—which seems to echo on the sea breeze as the city wakes. Between the corridors of homes and markets, wandering cats slink about, casting long shadows in the sunrise.

Neighborhood cats are first in line when the doors of the local butcher shops open for the day. These loyal customers seem to each have their own preference for lamb, mutton, or fish; the shop owners know these preferences and are generally happy to oblige. Outside one shop, a kind man in a kuma—a traditional Omani cap—sat next to two

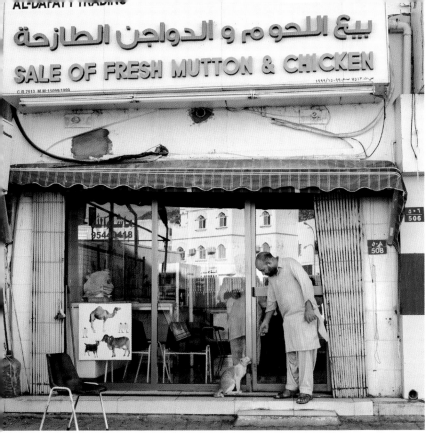

young cats as they sunned themselves on the warm pavement. "Wherever I go, they go," he said, smiling. "I feed them chicken hot dogs, so of course they like me!"

At the Mutrah Fish Market, cats aren't shy about their preferences either. While tiny herrings are regularly offered, many cats will turn up their noses to anything less than their preferred flavors. There's a silent understanding between fish vendors and felines, and most of the time the former will give in to the latter with no more prompting than a soft mew.

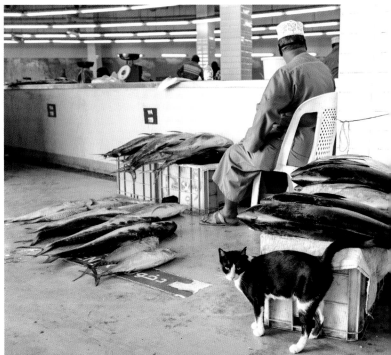

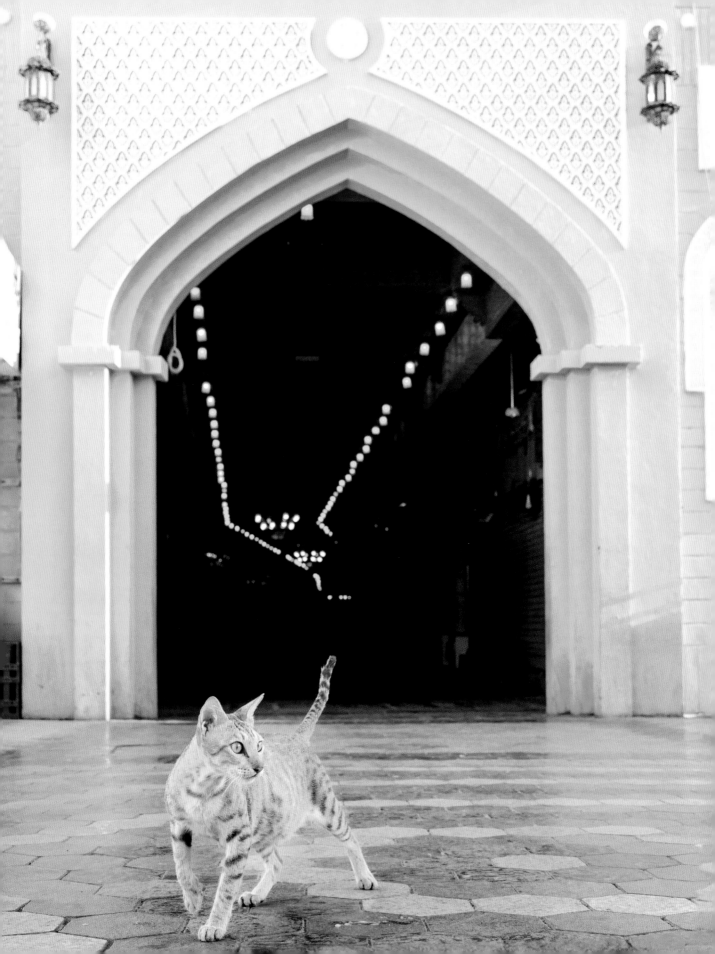

Farther along the corniche, you'll find one of the oldest bazaars in the Arab world, the Mutrah Souq, which is also home to several free-spirited felines. A green-eyed tabby at the entrance led us through the arched doorway and into a dimly lit maze of stalls selling pottery and silver crafts. The scent of Omani frankincense was fragrant in the air as shops burned the aromatic resin, which has been a precious local commodity for millennia. Following prowling paws through the seemingly endless halls of the market, one could happily get lost there forever.

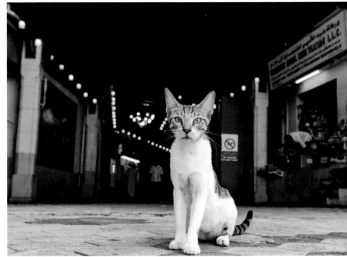

Not all cats in Muscat live outdoors; some are pampered in indoor homes. The country's most famous cat is Moet, a blind Persian rescued from a market. Along with her look-alike sister, Chandon, Moet has attracted hundreds of thousands of followers online, giving a social platform to her adopter that otherwise may not have been possible. "There is no free speech protection for humans

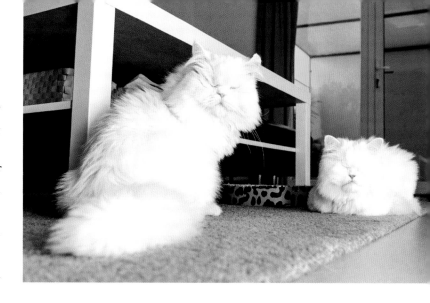

in Oman . . . but Moet expresses herself very freely online," said her guardian with a cheeky grin. "What are they going to do? She's a cat."

Moet and Chandon live a life of love and luxury, with every element of the home designed to suit the needs of blind cats. "Everything stays in its place, and they'll navigate their way around it. They are really amazing," their adopter said as she poured bottled water into their dish—due to the high mineral content of the desalinated seawater that flows from Muscat's taps, many people opt for commercial water instead. While she spoils her own cats, she is just as passionate about helping those who are less fortunate, which is a challenge in a country with no infrastructure to create an animal nonprofit. She belongs to a network of caring individuals, Omani Paws, and uses her platform to raise awareness.

"Unfortunately there are a lot of people who take in more animals than they should because there aren't enough homes here," said a veterinary technician who works with Omani Paws. Due to a lack of local adopters, she focuses instead on preventing more births. "We have nearly no people who want to bring home a cat, because if you want a cat you can find twenty outside. So we focus on sterilizing them and putting them back."

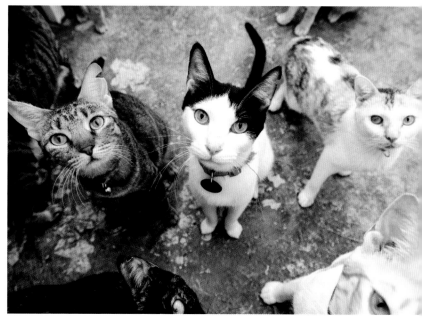

A kitten receives support through Omani Paws.

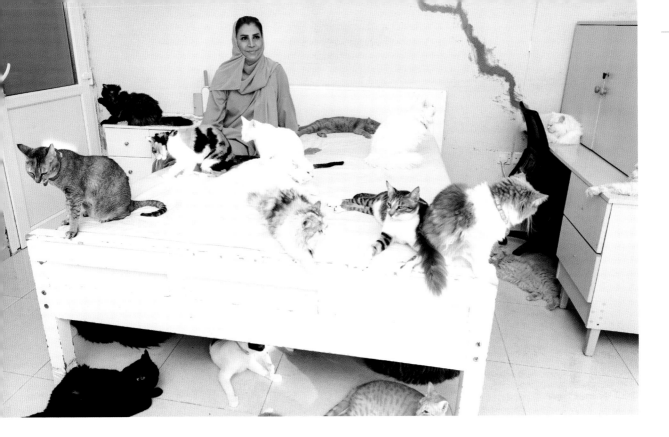

But no one in Oman knows more about what life is like with an abundance of animals than Maryam Al Balushi, who has opened her large Azaibah home to an astonishing 480 cats and 55 dogs. "This is my problem: I don't have a limit," she said as she showed us her bed, which she shares with dozens of friendly cats and a handful of smiling Pomeranians. Along with four full-time staff, she runs her home like a full-fledged animal shelter, with a series of large catios attached to every doorway and daily visits to the vet. "If I find a cat with bad eyes . . . a broken leg . . . how can I leave them? I cannot."

Maryam is fiercely passionate as she speaks, and it's clear that she doesn't see any option but to maintain her open-door policy. "Messenger Muhammad says cats are part of the family. And he tells also that if any blind cat comes to the house, you give him food. So I don't understand why people treat animals like an enemy." She reports feeling misunderstood and ostracized due to her efforts. "People complain about me, but still, they leave cats at my door," she sighed.

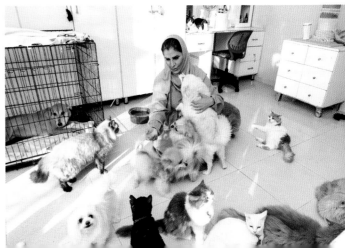

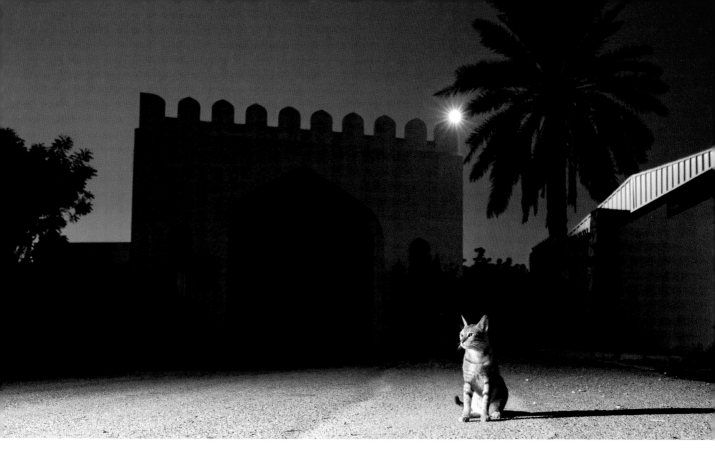

Across town, crepuscular cats scaled walls to come out in search of dinner as the sun set over Muscat. Their palates are refined: offered kibble or fish and rice, they all chose the freshly cooked meal laid out for them. "You cannot ignore cats here. If you have even a little bit of kindness, you cannot," said a local woman named Parul as she fed a neighborhood colony. She leaned down to offer pets to a cat circling her feet and smiled. "Whatever little we can do in this world—you know?"

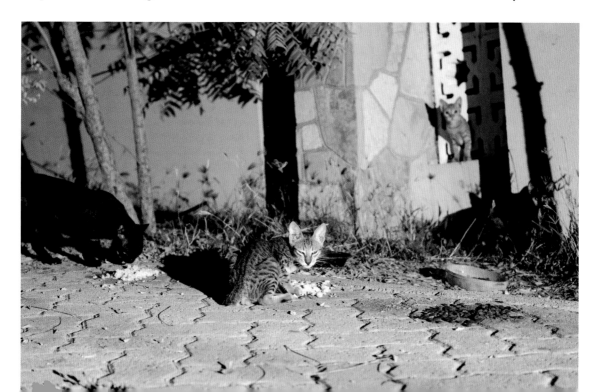

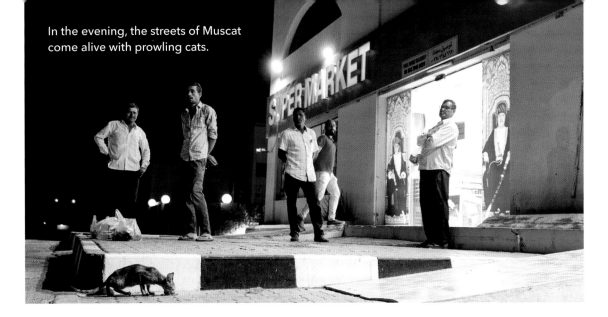

In the evening, the streets of Muscat come alive with prowling cats.

FRANCE

OFFICIAL LANGUAGE: French

CAT: Chat

PARIS

Our first day in Paris began at a neighborhood café, where we met with Princess Alice, a small black cat with a larger-than-life personality. Sitting atop the table like she owned the place, Alice sniffed at our offerings. Tea and coffee didn't interest her, but as I tore a piece of baguette with my hands, she shoved her face into the center of it and began to chomp away as if she had bought the bread for herself. Her adopter, Tyler, laughed—this was typical Alice.

In Paris, a café isn't a place you grab a takeaway coffee to chug while you walk—it's a place where you're meant to sip slowly and stay awhile. "Going to a café is a very social experience here," said Tyler, "and this is Alice's favorite café."

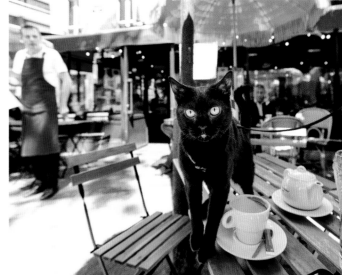

After finishing our drinks, we walked down rue Mouffetard, a quaint cobblestone road where vendors sell fresh vegetables and flowers. At the end of a thin black leash, Alice strutted with cool confidence, taking in the scents and sights. "People ask me how they can take their cats out with them," Tyler said. "I tell them, you just have to be patient and listen to your cat."

If you peer into the shops as you walk the streets of Paris, you'll occasionally spot a feline face in the window! At Fleurs de Prestige, we

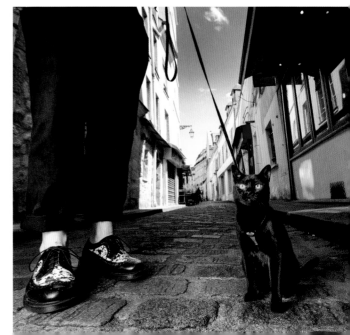

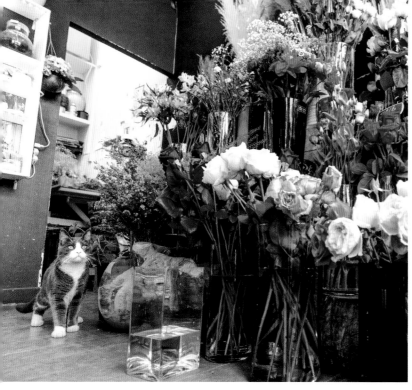

met Moustache, a shy one-year-old cat who was slinking past a collection of stunning long-stem roses. "He came from my supplier, and I said, 'Oh no, I don't need a cat.' But then I saw him and I said . . . 'Okay,'" recalled Charles, the owner of the flower shop. "Now he comes with me every morning to go to the flower market. And after, we arrive here in the shop. At night, he comes home with me. Every day."

At Mergui, a luxury jewelry shop, sisters Rolex and Chelsea make their home in the showroom. "My name means 'lion,' so that's why I have cats," said owner Arie Mergui, taking out a €2,000 gold chain and waving it like a cat toy. The tabby duo has a knack for sitting in the window and attracting customers. "You see the face of people when they see the cats—they make this face like: 'Ah!' They love them!"

One Parisian business that always has a revolving door of feline visitors is Aristide, an ultramodern boarding facility where cats can stay while their families are away. But this isn't your average cat hotel—it's a stunning feline retreat. Cats run up and down the walls via bold, colorful catwalks and sophisticated play areas, with plenty of space to choose between privacy and socialization. "As a kid I always wanted to be a hotelier, and now, you know, I did it," said owner Gauthier Berdeaux.

Observing a high concentration of purebred cats, I asked if it's more common for people to rescue or to purchase a cat in Paris. "The problem is, there is no adoption center in the city," explained Gauthier. "You have to leave, and most Parisians don't have a car. That's why a lot of people buy a cat even if they want to adopt."

While it's true that you won't find a centrally located animal shelter, there is one place you can go to adopt cats that is a bit nontraditional . . . and loads of fun! Le Triangle is an immersive escape room where visitors play a mystery game about power-hungry felines aiming to take over the world. But the best part is that there are real, adoptable cats inside the escape room. "We love cats. We love escape rooms. But I had never seen an escape room with cats," said owner Shona Roulleau, whose goal isn't just for people to make it out—but for them to make it out with a cat.

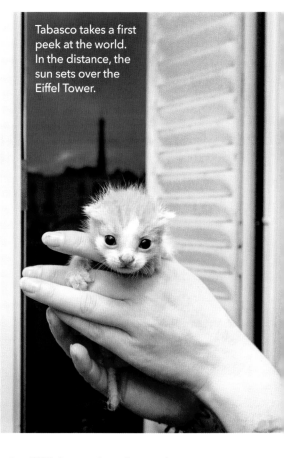

Tabasco takes a first peek at the world. In the distance, the sun sets over the Eiffel Tower.

Totoro and Tiramisu lounge on a playpen in the living room with a traditional balcony behind.

In the 15th arrondissement, one heroic woman has started her own adoption organization, Kitties in Paris. Nastassja Renard, a veterinary technician by day, invited us to meet the thirteen foster kittens residing in her apartment on an upper floor of a classic old Parisian building. Steep steps led to a light-filled space abounding with energetic kittens, most of whom had been rescued from the suburbs. "We have a lot of spayed cats in Paris, so there are fewer kittens here," said Nastassja. "But outside of the city, it's different."

Parisian balconies are undeniably beautiful, with their large glass windows and ornate metalwork. But unfortunately, due to the lack of protective screens, they do pose a risk for curious cats. Some residents have gotten creative, installing safety netting so that they can open their windows for cool air without the risk of an injury. "The very first thing I did when I moved in was install a net, because it gets so hot here, you need to leave the window open all summer," said a cat guardian who lives in a 1750s building with no air-conditioning. "Squirrel loves it; he just sits in the plant box and looks out."

But perhaps the most whimsical cat-friendly balcony in all of Paris belongs to Samuel Vezinat's Curiosités du Monde, a "cabinet of curiosities" collection of ancient art and artifacts dating from 3000 BCE to 1930. From the interior to the exterior, every wall and surface is covered in the relics he collects and sells, and lying among them are Samuel's enormous black cat, Ponpon, and his friend Domino. "Each time I bring something new, they love it. Ponpon is very inspired by antiquities."

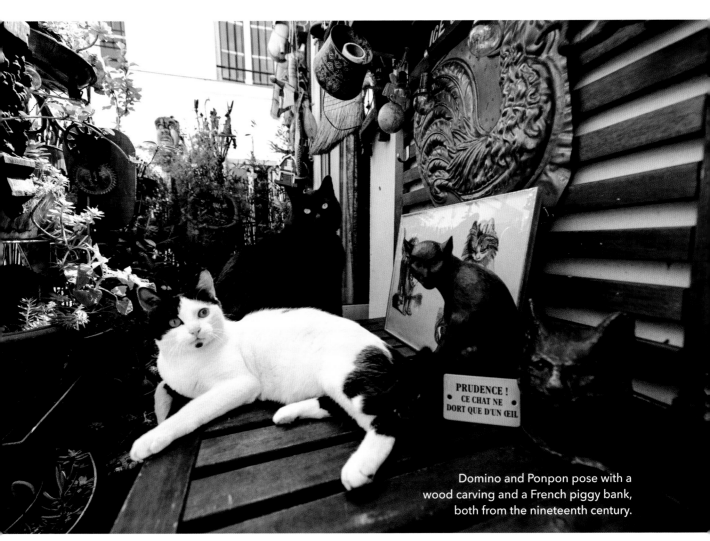

Domino and Ponpon pose with a wood carving and a French piggy bank, both from the nineteenth century.

Samuel, who studied the history of art and archaeology at L'École du Louvre, has a special interest in the cultural and historical significance of black cats in art. "In medieval France, from the thirteenth century to the seventeenth century, they would accuse the black cats of sorcery—of black magic. The black cat became a symbol of anarchy and standing against authority," he explained as he showed us an antique wood carving. "As you can see, this face is a devil black cat. This cat is not very friendly . . . That's why I like him."

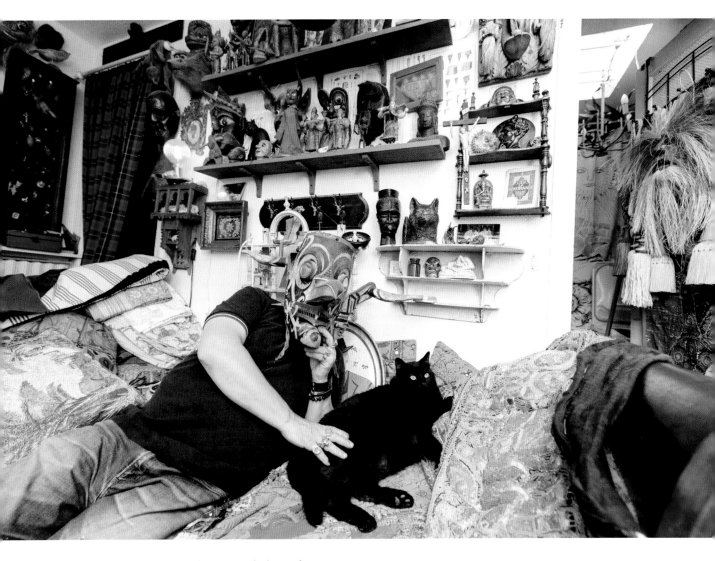

Samuel and Ponpon showcase shelves of curiosities.

Black cats have long been emblematic of rebellion and artistic freedom in French art and folklore; this representation is most globally recognizable in the iconic black cat poster advertising Le Chat Noir, the world's first modern cabaret. "It's one of my greatest inspirations," Samuel said of the art-work, which advertised the nineteenth-century nightclub where artists performed variety shows in Montmartre. More than two hundred years after its inception, Samuel found a black cat of his own in Montmartre Cemetery, bringing his love for them to the next level. "Lots of people would never have black cats in France. Some people are still superstitious and might think it's dangerous," he said. Luckily for Ponpon, he isn't just accepted—he's revered as if he were a piece of fine art himself.

It's no surprise Ponpon was rescued from a cemetery; the peaceful memorial gardens of Paris are welcome havens for cats. Walk the sacred grounds of Père Lachaise Cemetery and you'll find shy cats

tiptoeing between the graves of Jim Morrison, Oscar Wilde, and Édith Piaf. Or head to Montmartre Cemetery, the resting place of Alexandre Dumas and Dalida, and you'll pass by dozens of well-loved cats, all sunning themselves in the dappled light that spills through the green leaves overhead.

As I silently strolled, I spotted a silver-haired woman filling bottles of water at a spigot and placing them in a rolling cart. "Bonjour. Parlez-vous anglais?" I asked, trying to recall the little French I knew. I pointed to my tattoos of cats and put my hands on my heart.

She smiled and nodded. "Just a little English," she said, turning off the faucet so that we could chat. We spoke in a combination of French, English, and hand signals, each eager to connect with a kindred spirit. She shared that long ago, she and her friends set out to sterilize the many Montmartre cats. Now, the population is stable, with just forty cats remaining—each with a name and family group. As I showed her our photos, she pointed at the screen like a proud mother, calling out their names: "Snoopy! Nouga!"

Monique, who is eighty-six years old, has come to the cemetery every day for twenty years—long enough to see generations of cats come and go, some being adopted as babies like Ponpon, others living out their lives in their chosen territories within the vast gardens. Now that the only felines remaining are older longtime residents, she wishes for people to leave them in peace. "It's not good if people take to the apartment. They are happy here. Because they are born free. They are born free."

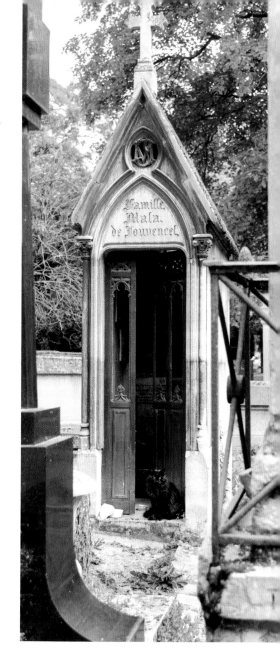

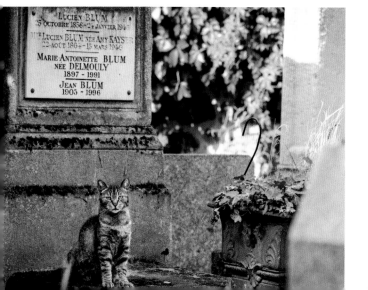

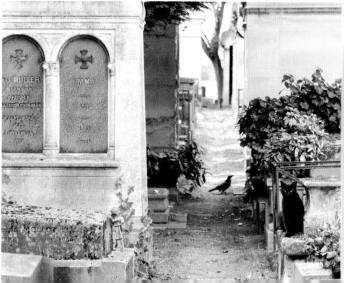

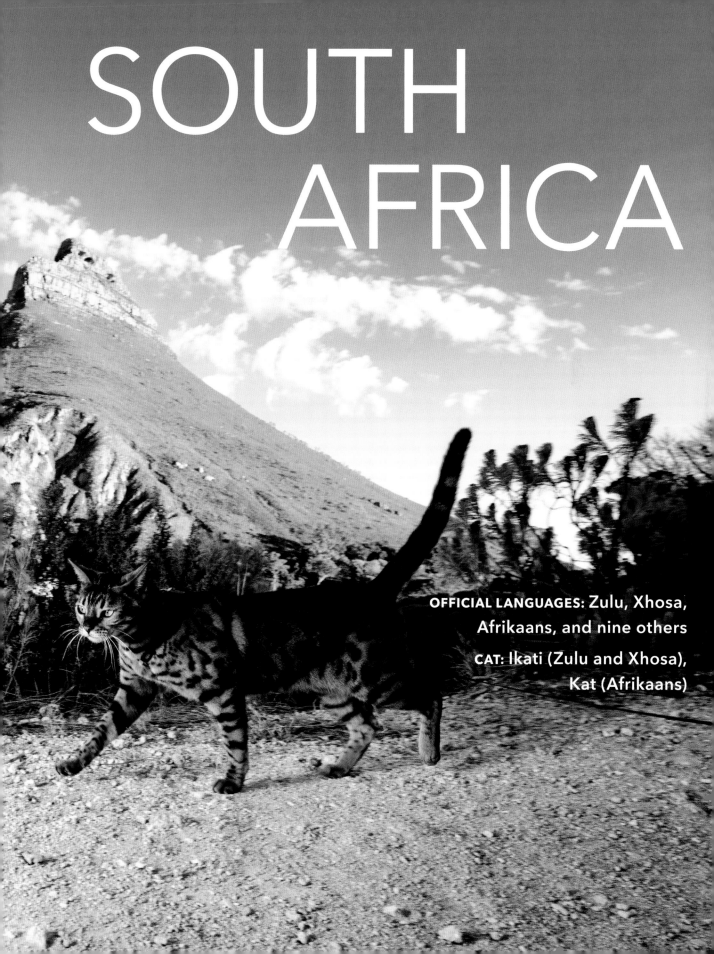

SOUTH
AFRICA

OFFICIAL LANGUAGES: Zulu, Xhosa, Afrikaans, and nine others

CAT: Ikati (Zulu and Xhosa), Kat (Afrikaans)

CAPE TOWN

Cape Town is a nature lover's paradise. Situated at the mountainous southwestern tip of Africa where the Atlantic and Indian Oceans converge, the landscape boasts scenery of epic proportions, and it's easy to see why so many people—and cats—love to hike and take in the views. On a windy morning, we met with a spotted Bengal named Pancake to embark on her favorite trail at the city's most iconic setting, Table Mountain.

"People are very connected to nature here. It's more breathtaking around every corner," said Pancake's caregiver, Nicky Stokes, as she held on to her leash. "Pancake loves the mountains. She's an indoor cat at home, but I don't feel bad because . . . look at her!"

Farther south, Silvermine Nature Reserve is a favorite hiking spot for Maya, an adventurous tabby on a safari mission. "Looking for wildlife is her thing; she likes to follow game trails. She's seen ze-

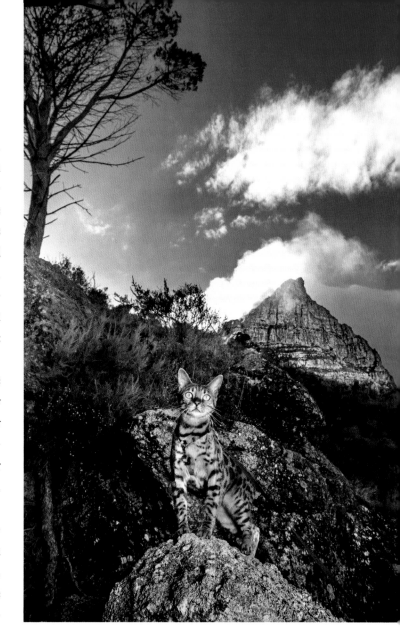

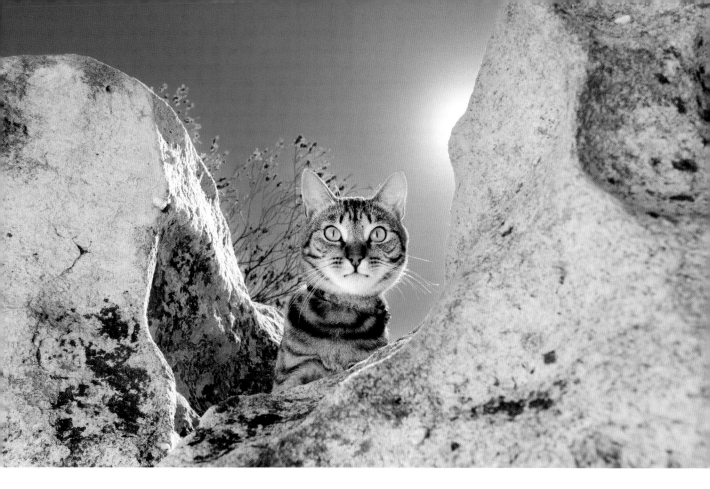

bras, giraffes, wildebeest . . . She's even found leopard tracks," said adopter Leonie Mervis as we took in the scenic beauty during a long hike. Eventually, we came upon a cluster of large rocks, piquing Maya's attention. "This is the caracal cave—her favorite!" she said as Maya quietly tiptoed through the cracks to sniff an antelope jawbone.

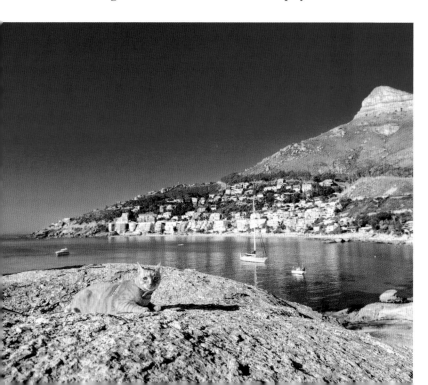

Even in the city, nature is all around. In upscale Clifton, an orange cat named Nacho is known to frequent the sunny cliffside. "A lot of people here harness-train their cats," said Kavish Govender, who adopted Nacho after spotting him digging through a garbage bin. "He loves parks and trails. He is very inquisitive."

A walk in the park is lovely for anyone. But when it's time to return home, the reality is that cats, and the humans who love them,

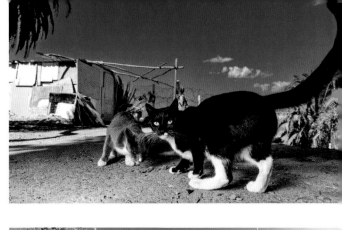

live quite disparate lives in Cape Town. With significant housing inequality—South Africa consistently ranks among the world's most unequal nations—the prosperous live in spacious abodes while those lacking financial resources inhabit informal settlements.

In historic Bo-Kaap, housing varies greatly from street to street. Tucked into the hillside, a small settlement is home to a few dozen families and their felines, who live in makeshift dwellings constructed of corrugated metal and scrap materials. Local resident Michelle invited us into the open-air brick facade where she resides with several cats, including her beloved seventeen-year-old Spike. "I don't have much, but I give my life to the animals," she said.

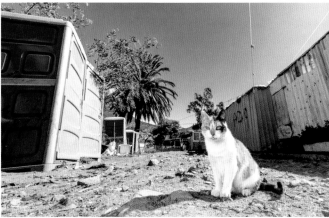

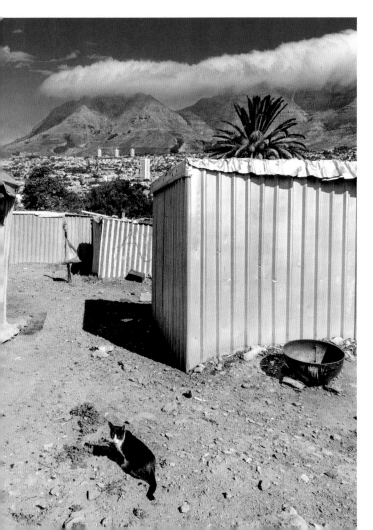

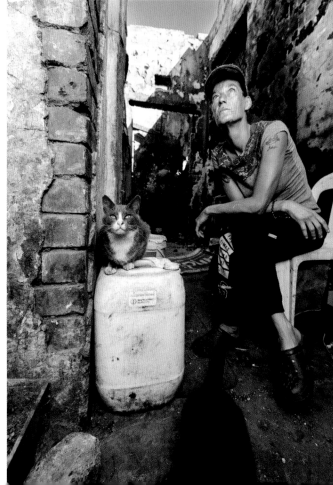

Just steps away, brightly painted row homes line the cobbled streets. "When slavery was abolished, people decided to paint everything colorful," explained Iekraam Najaar, a local who supports the cats in the settlements surrounding the neighborhood. "If someone can't afford vet care, I'll ask what they can afford, and then I'll pay the rest. They accept my help because I help them with food for themselves, too."

Across town, Junaid Hoosen, an ex–special forces officer, is helping cats in areas that many organizations will not enter due to the prevalence of crime. "I don't follow the rules, the laws, or what anyone tells me, and that's why I get things done," said Junaid as we walked through a Bellville South settlement

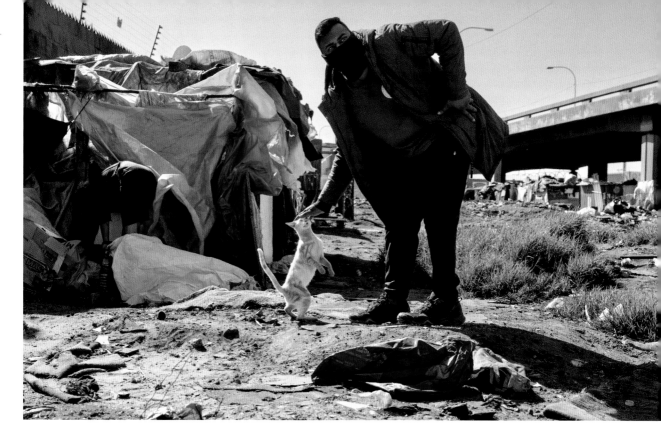

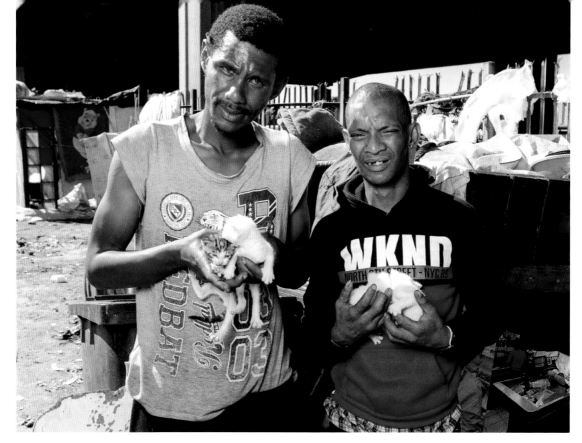

Rowan and Ricardo gently cradle Mia's kittens.

where he is working to sterilize cats who would otherwise have no such resources. "You have to be strong here; you cannot be soft. Crime here is taken up four notches, but the longer we wait, the more animals suffer. So yes, I'm intimidating, but I get the job done."

Junaid offers free cat food in exchange for permission to sterilize. As we walked with him, his community members were welcoming and eager to introduce us to cats in need of kibble: a brown cat named Clumsy and an orange kitten named Ginger. One resident, Wafika, waved us inside her humble patchwork home to meet Stormy, a white-bibbed tabby who had recently begun to share her bed. "He loves it here," she said. "The cat chooses you."

A few doors down, two men invited us into a construction framed with scrap wood to meet Mia, a cat who was raising her babies inside. "I'm going to offer you food for them—but I need you to understand that I will only continue if you let me sterilize them," Junaid said, and the men agreed, grateful to receive help for the cats they'd come to love.

While some locals live with little access to resources, others live in relative abundance. "It's very easy to live in a bubble here," said rescuer Jess Levitt, who fosters vulnerable felines and offers sanctuary to nearly twenty cats in her family's spacious garden. The idyllic setting seemed like utopia for the cats, many of whom came to her as fosters with kittens. "Sometimes I end up keeping the moms . . . They come here and are so comfortable, so they stay."

As an adoption coordinator for Rescue is Life, Jess regularly places cats in indoor-outdoor homes. "It's quite common to have enclosed gardens like this for privacy and safety," she said of the tall perimeter fences that surround many yards, offering the serendipitous benefit of safe containment for the cats. "The walls are primarily for crime prevention, but it works out for the cats, too."

Security walls provide contained outdoor areas for cats.

Even in rescue organizations, outdoor enrichment is key. At Lucky Lucy Foundation, hundreds of adoptable cats roam in the sunshine amidst chickens and tortoises.

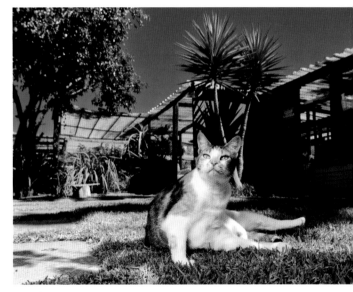

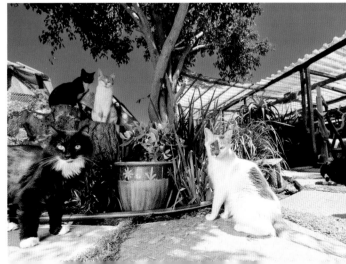

In the Khayelitsha community, Mdzananda started out as a simple door-to-door shopping trolley offering food and mange baths. Now, the impactful organization runs a full veterinary clinic and shelter out of ten bright orange shipping containers. "You do as much as you can with what you have," said executor Marcelle Du Plessis of their setup, as a chunky gray cat named Gimba awoke from a nap. "He came in one day, skin and bones—and he decided to stay."

"It's all about education," said animal welfare assistant Nombulelo Mashinini. "There are stereotypes about cats that come from our parents, from the villages. Through education we can change a lot of minds."

That Cape Town's cats live such varied lives is undeniably tied to the inequitable experiences of its human residents. But regardless of circumstance, the human-cat connection remains an unbreakable bond. In District Six, an area with a painful history of forced removals during the apartheid era, many are returning and bringing their companion cats along. At the foot of Table Mountain, small constructions of rocks and tarps mark a new beginning for those rebuilding what was lost, one stone at a time.

"In the beginning I had no food for them, so I would give them a portion of my food. Now, they only eat cat food," said Lucas as he leaned over to feed his darling torties, the sunlight beaming over the empty field. "They are named Lady . . . all of them."

Emerging from their blanket-draped home, a couple named Nicoline and Shooter introduced us to their dear cat, Junior, who gazed contentedly at one of the city's most picturesque views. "You won't believe me: he sleeps on my feet every night!" Nicoline said, smiling.

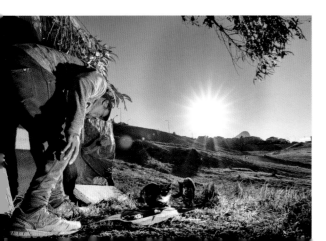

Shooter leaned in to offer Junior a gentle rub on the cheek. "People ask: 'Why'd you name him Junior?' I say it's because I'm taking him as my baby brother," he told us. "I tell my cat, don't think of me as your father—I am your brother."

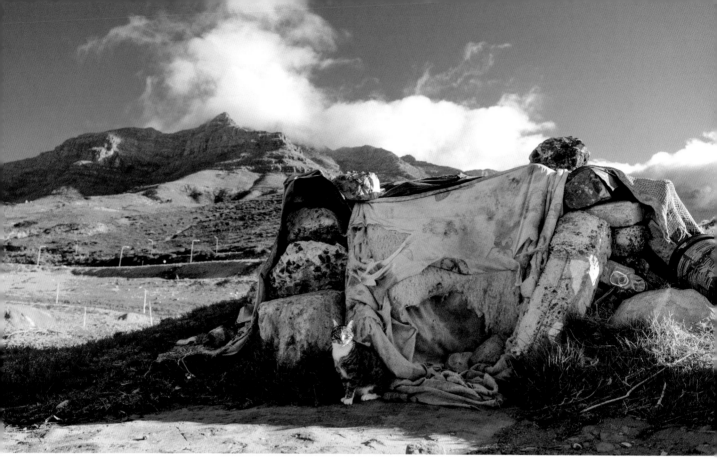
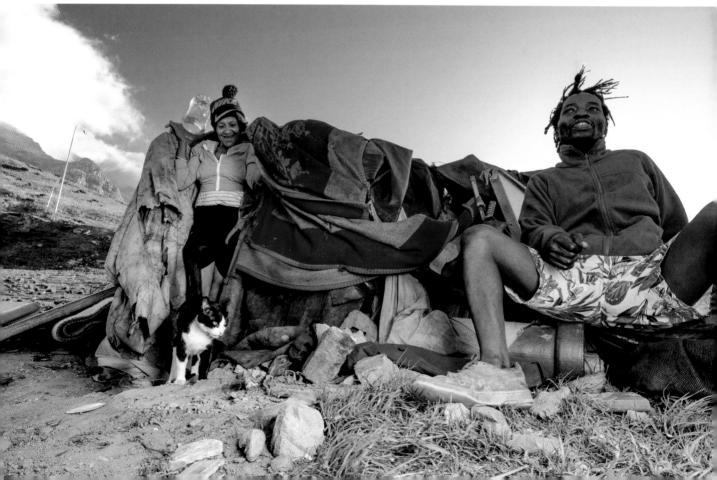

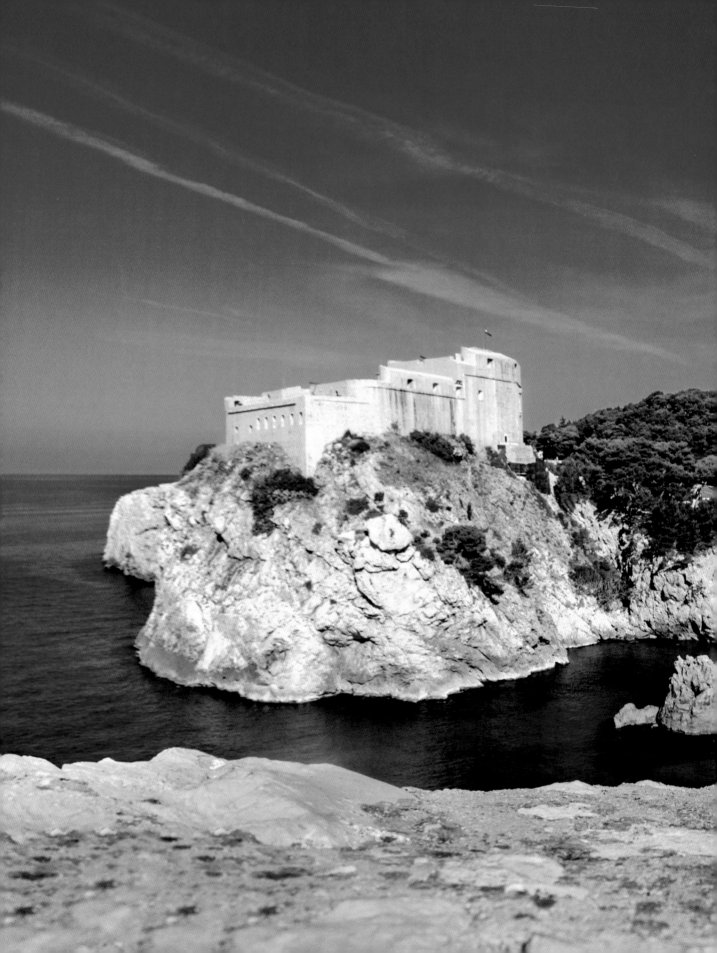

CROATIA

OFFICIAL LANGUAGE: Croatian

CAT: Mačka

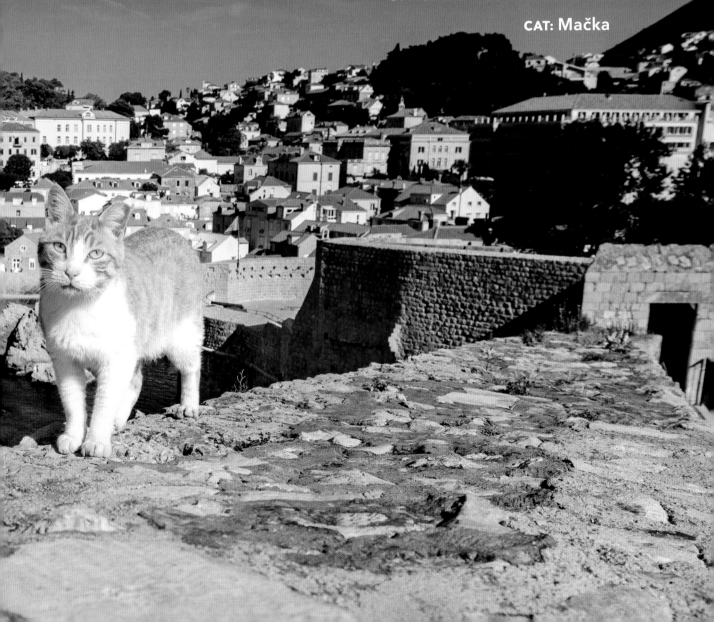

DUBROVNIK

Along the Dalmatian Coast of Croatia lies a picturesque walled city jutting out into the bright teal sea. Old Town Dubrovnik, known as "The Pearl of the Adriatic," is one of the most well-preserved medieval cities in the world. Within its walls, narrow streets and steep stone steps lead to Baroque churches, marble palaces, and gorgeous limestone buildings with terra-cotta rooftops. Explore on foot, and you'll find that around each corner, a cat is waiting to greet you.

The streets of Old Town Dubrovnik fill with human pedestrians for most of the day, but in the early hours when all is silent and still, cats are masters of the domain. As the sun begins to rise, local felines roam the empty walkways, enjoy breakfast at the shop fronts, and leap from boat to boat as fishermen dock at the pier. Some daredevil cats can even be seen tiptoeing along the stone walls that enclose the city—a complex fortification system constructed between the twelfth and seventeenth centuries. The cats' friendliness is a testament to the care they receive from locals as well as their frequent interactions with tourists.

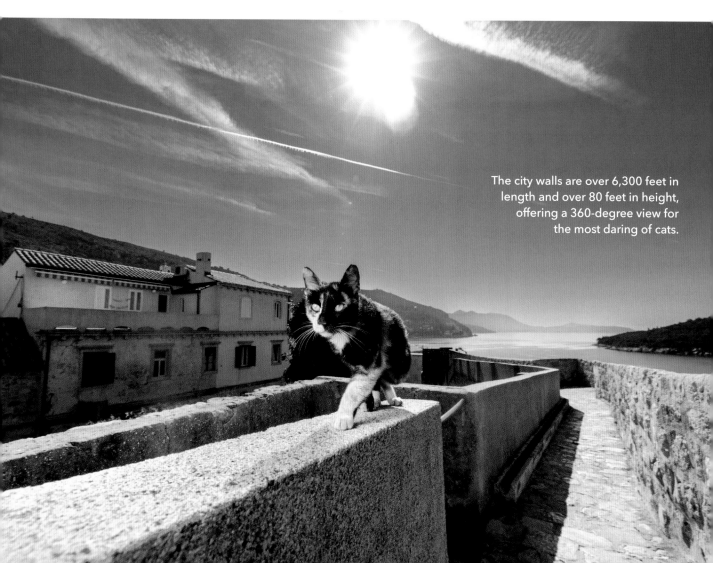

The city walls are over 6,300 feet in length and over 80 feet in height, offering a 360-degree view for the most daring of cats.

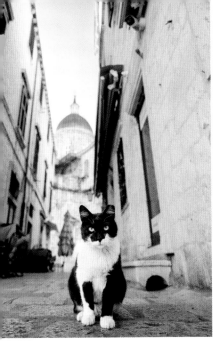
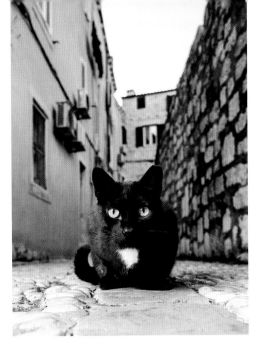
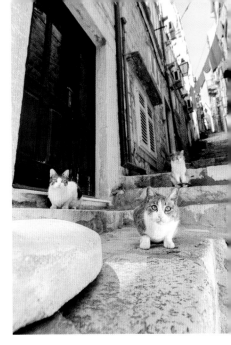
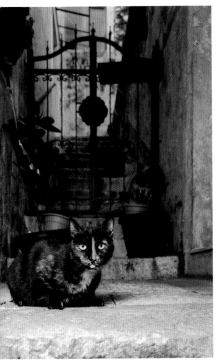

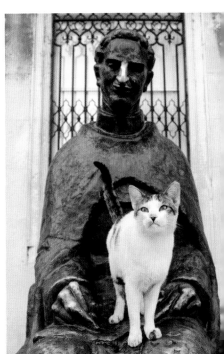

Cats lay claim to the city, even resting in the bronze lap of sixteenth-century Croatian writer Marin Držić.

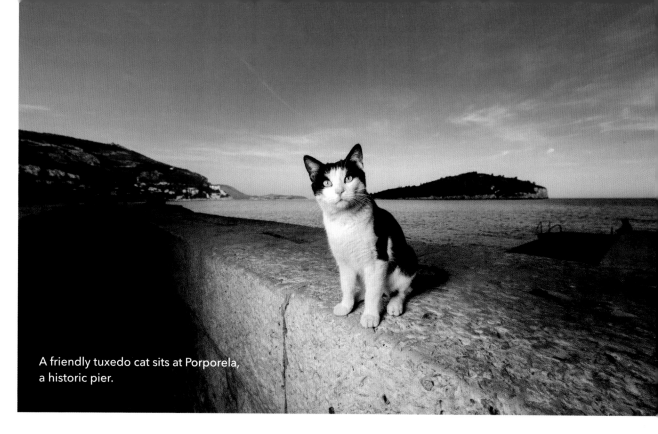

A friendly tuxedo cat sits at Porporela, a historic pier.

Widely adored, many of the cats have become celebrities in their own right—but none more than Anastazija, a seventeen-year-old dilute calico who lives in the entryway of the Rector's Palace. She is a local favorite—so much so that a craftsman created a custom cat shelter bearing her name, built in the architectural style of the fourteenth-century palace she calls home. When government officials removed the cat house, it caused an upheaval resulting in thousands of signatures on a petition against her wrongful eviction. At the time of our visit, Anastazija was resting instead in a cardboard box where her palatial shelter had once been, demonstrating that the battle with the mayor was far from won.

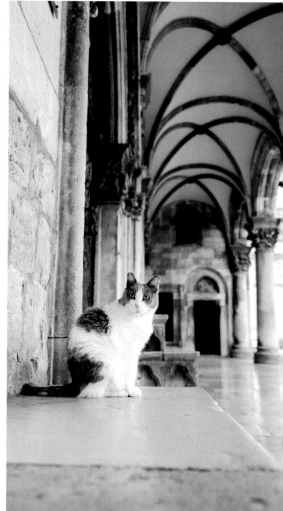

Not far from the Rector's Palace is the "Jesuit staircase," an iconic Baroque staircase known for its prominence in *Game of Thrones*. But in order to visit it, you'll need the okay from Johny Boss: a cheeky tomcat who can be found sitting atop the bottom pillar of the curved steps, overseeing all who wish to pass by. The four-year-old cat is the leader of his pack and has won the affection of the

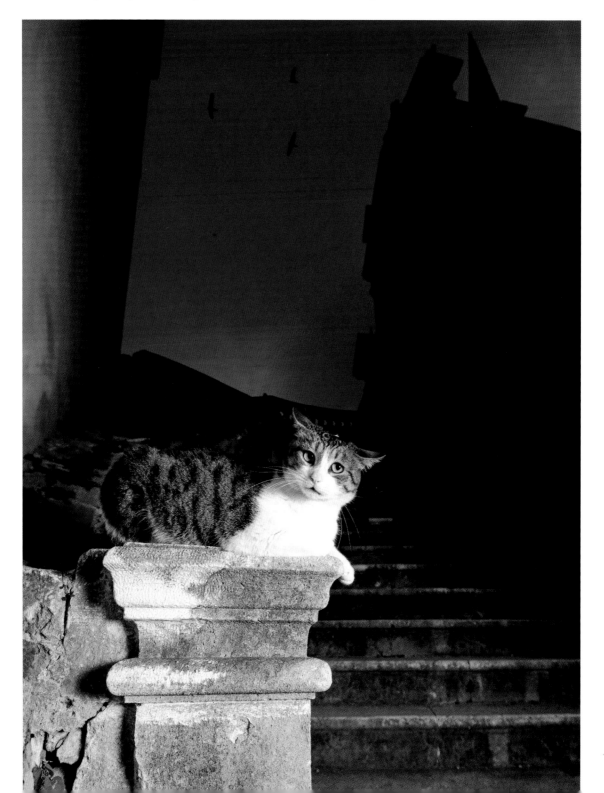

CATS OF THE WORLD

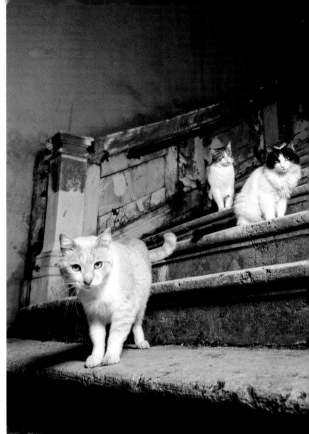

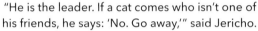

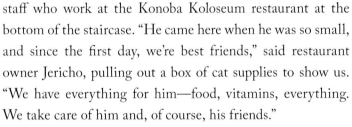

"He is the leader. If a cat comes who isn't one of his friends, he says: 'No. Go away,'" said Jericho.

staff who work at the Konoba Koloseum restaurant at the bottom of the staircase. "He came here when he was so small, and since the first day, we're best friends," said restaurant owner Jericho, pulling out a box of cat supplies to show us. "We have everything for him—food, vitamins, everything. We take care of him and, of course, his friends."

Johny Boss lives up to his name through his big persona and the respect he commands from all who enter his orbit. "Johny is the boss here," Jericho said as the cat hopped up into the window where food orders are placed. "If somebody comes here to eat and doesn't like Johny Boss, we tell them: 'There are three hundred eighty other restaurants here. Go to the next one.'"

Across town on the Lapad Peninsula, a local woman has been caring for cats outside a hotel for two decades. "There is no animal shelter here. They promised this for twenty years, but nothing," said Izabela, who has instead created a hidden village of handmade shelters in the woods to accommodate the area's felines. When she opened her trunk, the trees shook

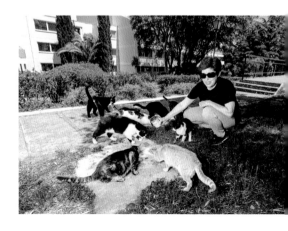

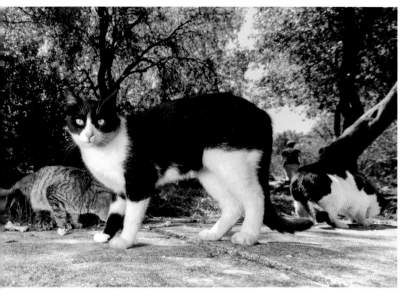

as cats galloped toward the parking lot by the dozens to greet their caregiver. "People drop them off here because they think tourists will feed them, but they don't think how in the winter, the hotels close. It used to be complete chaos. Now, I think the level of consciousness is higher."

The cats in the woods may not live inside a traditional shelter, but Izabela runs the operation as if they did. We watched in awe as she completed a detailed ritual of medications and prepared an elaborate nine-course meal, carefully noting each of the cats' nutritional needs and preferences. "And now, for the desserts," she laughed as she opened a bag of home-cooked chicken to give each of them. "Just something special to make them happy."

While the rest of the cats live in the woods, the most senior cat in the colony, Blazenka, has self-adopted into the hotel lobby. "She just walked inside one day, and now she has been going inside the hotel for thirteen years. They love her and spoil her," Izabela said.

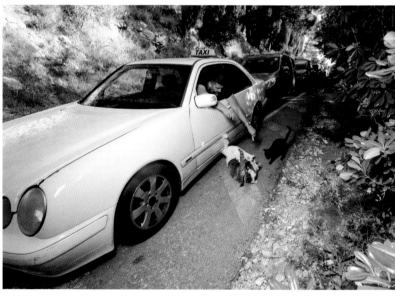

Some taxi drivers bring their own food to distribute as they await customers.

Along the southern coast of Dubrovnik, the dilapidated ruins of a once-luxurious hotel serve as a makeshift shelter for dozens of cats. Built along a cliffside with a panoramic view of the Adriatic Sea, Hotel Belvedere is a shell of what was once a high-end retreat before falling victim to bombing during the Croatian War of Independence in 1991. Since then it has stayed completely unoccupied, save for the seventy-plus cats who are cared for daily by local rescuer Ljubica.

Ljubica has sterilized hundreds of cats along the coastline surrounding the hotel since she started helping the massive colony ten years ago. "It started because people abandoned cats here. Someone started feeding them, and they saw the opportunity, and then . . ." She gestured to dozens of cats circling her feet as she opened a large bag of cat food. "I know them all, so if I see a new cat, immediately I spay them.

"We had more than sixty adoptions last year," she said proudly. She even worked tire-

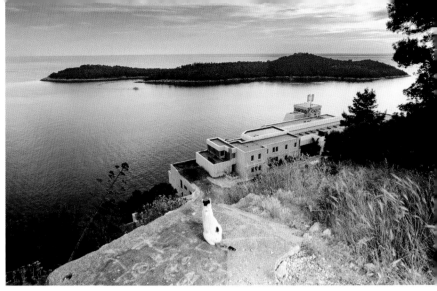

lessly to help treat a cat with cancer, Flake, who still lives in the hotel ruins and is now in remission. "I wish we could find her a home," she said, and petted her lovingly on her earless head.

With no organized animal shelter in Dubrovnik, the heavy lifting falls on individual rescuers like Ljubica, Izabela, and others—and it's plain to see the lifesaving impact that just a small number of compassionate people can have within their community. When asked how she manages it all, Ljubica simply smiled and said, "What can I do? I love them."

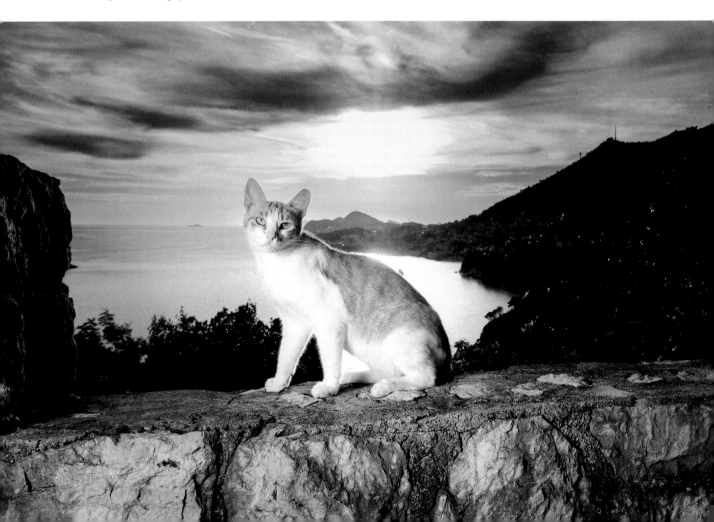

OFFICIAL LANGUAGE: Japanese

CAT: ネコ / Neko

JAPAN

TOKYO

Tucked into a sea of pedestrians, it's easy to feel overcome by the immense scale of Tokyo. But amidst the high-end retailers and iconic karaoke bars, numerous cat cafés offer a tranquil respite from the city's fast pace.

In the bustling neighborhood of Shinjuku, we placed an order for two green teas with a server at a small cat café. With perfect comedic timing, a fluffy resident cat leapt onto the server's back and stared us down as if to ensure that we'd ordered a cup of cat treats for him, too. One look, and we were sold.

While Japan didn't invent cat cafés, the country is often lauded for popularizing the concept in the early 2000s, when it scaled from one to more than 150 cat cafés within a ten-year span. Café owners and customers alike report that while it isn't easy to have cats in Tokyo, a cat café can offer a way for the public to interact with furry felines and to seek respite from the demands of the workplace.

A short train ride away, the Yanaka district is celebrated for its traditional atmosphere and charming prewar architecture, offering a glimpse of life in old Tokyo. Sometimes called "Cat Town," Yanaka has many shops selling cat-shaped sweets and lucky "maneki-neko" figurines of cats beckoning with a raised paw. But if it's flesh-and-fur feline company you seek, you'll need to head to Yanaka Cemetery, where a family of cats lives peacefully among the graves.

Founded in 1872, Yanaka Cemetery is one of the largest cemeteries in Tokyo. To walk the pathways is to step into a painting of colorful foliage and feline quietude. Smooth stone slabs provide cozy spots for cats to curl into crescents, while twisting trees offer sturdy scratching posts and falling leaves that crunch beneath paws. Cats drink from birdbaths and softly brush against visitors, consoling grieving guests in exchange for gentle pets.

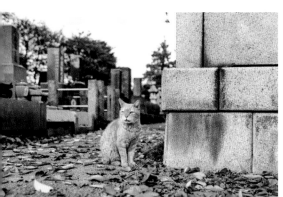

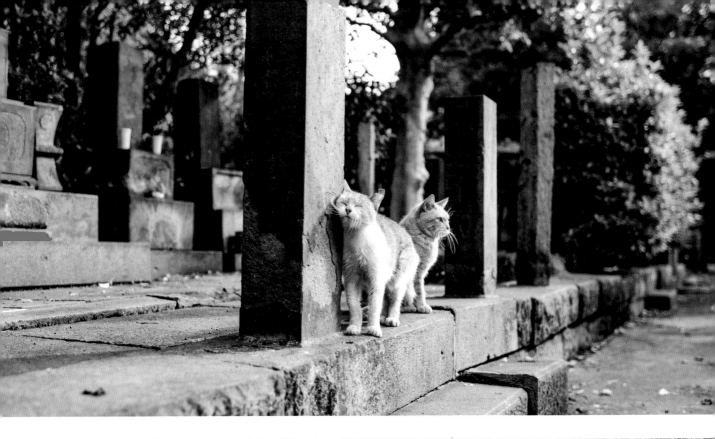

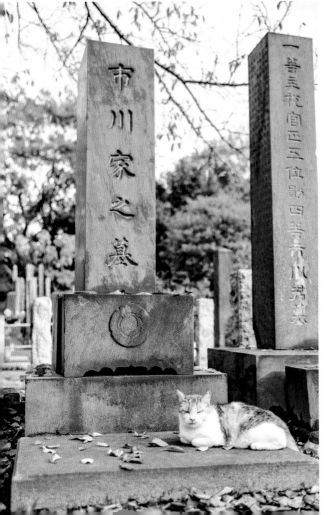

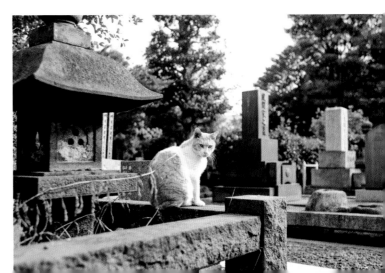

FUKUOKA

With the rise of cats in popular media, stories of Japanese "cat islands"—remote fishing villages inhabited by large populations of free-roaming felines—caught like wildfire. At the time of our visit to Ainoshima, one of roughly a dozen such places in Japan, the community was undergoing significant changes due to the sudden surge of tourism. "International news suddenly introduced Ainoshima cats, and people on the island were confused at many tourists," a local told us. The rural and largely undeveloped island, which had only one road and no public businesses, was now grappling with such overwhelming interest that its port had to upgrade from a small boat to a large ferry to accommodate the influx of feline fans.

We boarded the ferry in Fukuoka along with our local friend Sumire Harayama and about three dozen other visitors, an even mix of fishermen and tourists. When we arrived at our destination, an orange tabby was the first to approach, walking bravely along the concrete pathway that lined the dock. He had a short, stubby tail—a common genetic variation found throughout East Asia—and beneath his posterior nub, a spherical mound of fur made it clear that he was an intact male. I wondered what we might find at this intersection of tourism, food abundance, and the absence of veterinary resources.

Along the water, cats lounged on fishing nets and looked longingly at the fishers' catch. They hunted in tall grass, hid in the shade of wheelbarrows, and rested against rusted cleats where boats were docked. Many were kittens; some were ill. Signs were posted in every language, begging: "Don't feed the cats."

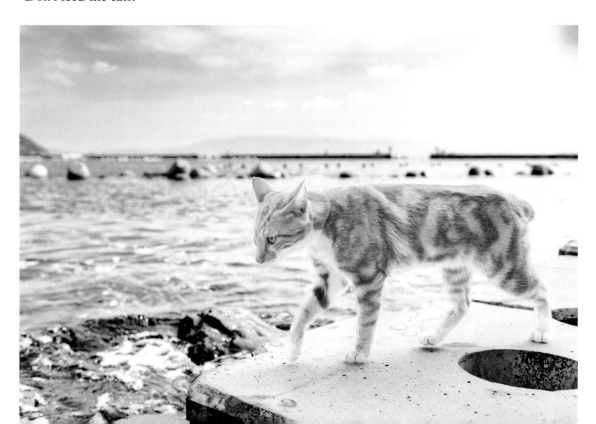

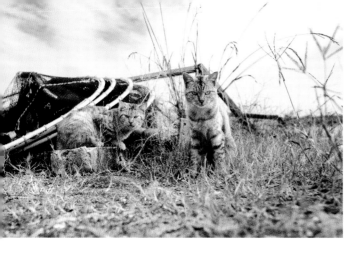

The locals of Ainoshima never set out to develop a tourist attraction. For them, sharing the island with cats was nothing new, and the population had always stayed manageable enough between the availability of fish and the harshness of life without veterinary care. Through Sumire, a resident of the island conveyed that most neighbors believed in allowing the population to be managed naturally, as it always had been.

But the sudden influx of visitors feeding cats was anything but natural, and there was a striking juxtaposition between the expectations of these outsiders—who had assigned the name "Cat Heaven" to the island—and the reality. Stepping past kittens with respiratory infections huddled together on the pavement, many tourists seemed happy enough to snap selfies and toss excess cat treats to the ground. It didn't matter that we were there to capture the true story; I couldn't help but feel complicit myself.

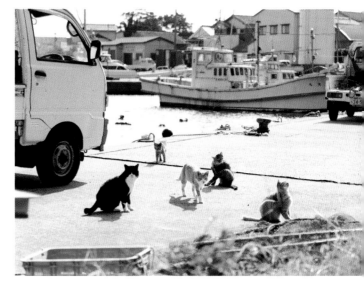

In the years since our visit, a local updated us that "the situation of the cats has been changed," sharing that all the cats are now sterilized and receive monthly vet visits thanks to a small group of cat lovers on and off the island. But the sentiment from locals remains clear: "We don't want more tourists to come. We just hope [for] calm and peaceful lives for the cats."

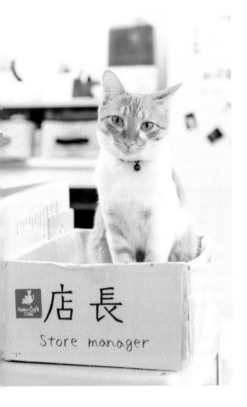

KYOTO

Steps away from Fushimi Inari-taisha, the iconic Shinto shrine famous for its thousands of crimson torii gates, lies a serene space where humans and cats alike can find tranquillity. On a rainy November afternoon, we walked up the steps to Neko Café Time, where we traded in our wet sneakers for soft slippers and entered a peaceful realm filled with content cats. At the front desk, a curious creamsicle cat named Ponzu sat confidently in a box labeled "Store Manager," an honorary title bestowed upon him by the café owner, a woman named Satoko.

Satoko became inspired to open her café while searching for comfort after experiencing a tragedy. "I was so sad I couldn't eat or sleep, and it became difficult to lead a normal life. My daughter took me to a cat café to cheer me up, and my heart began to heal," she said. "With this method, would I be able to save stray cats? Would I be able to save people who were hurting like me? I set out to create a place where both cats and people can be healed."

Satoko now shares her café with over a dozen felines she's rescued from the street and hopes that she will help others find solace in the companionship of cats. As rain drizzled against the windows and soothing music played, she offered us canned tea and coffee from a hot beverage case—atop which a tabby named Kinako soaked in the heat. Surrounded by sleepy rescued cats with hot drinks in our hands, we, too, found ourselves in a place that radiated warmth.

OFFICIAL LANGUAGE: Spanish

CAT: Gato

DOMINICAN
REPUBLIC

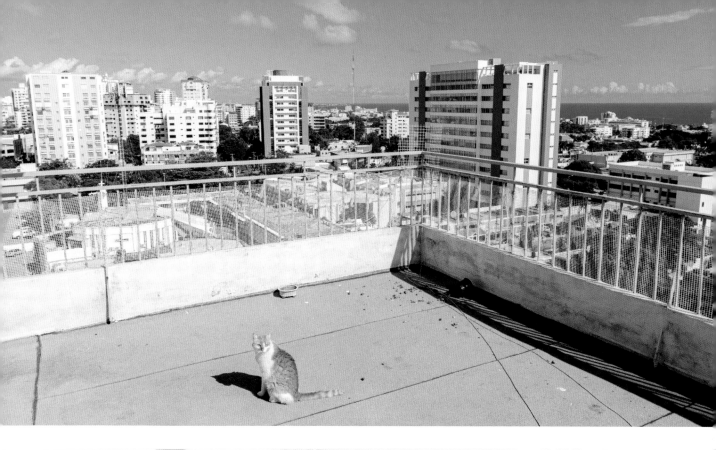

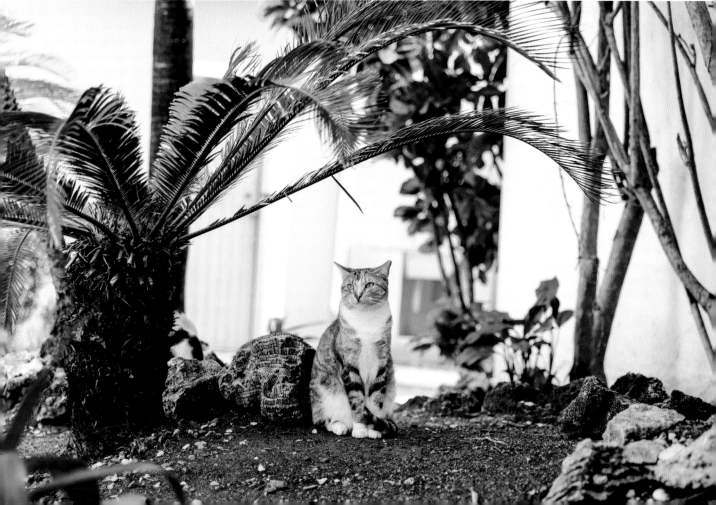

SANTO DOMINGO

The grand colonial buildings and cobbled streets of Santo Domingo tell a tale as old as the ancestors of the felines who traverse them. In the late fifteenth century, the Spanish brought furry voyagers to the shores of what is now Hispaniola. Hundreds of years later, generations of cats have borne witness to the capital city's booming growth—some as pets looking out from high-rise buildings, others as modern-day wanderers of the busy streets.

Some local cats have retained their age-old roles as mousers. At a manufacturing plant, two cats brought in as hunters had rapidly bred a family of twelve, evoking concern from a caring neighbor. Standing in her tropical garden, Yvette climbed a ladder to peer over the twelve-foot retaining wall that separates her yard from the industrial complex. "I was worried about them but couldn't reach them. Then I figured out that I could help by using this pipe," she said.

She scooped kibble into a long PVC pipe, delivering it to the base of the wall on the other side. "Once they got comfortable eating, I started to lower a trap to the other side and lift it back up using a rope!" With this ingenuity and determination, she was able to sterilize the whole population without ever setting foot on the property.

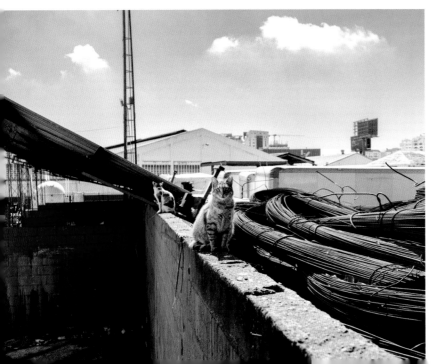

At another factory, cats are regarded not as protectors against mice but as companions. Monica, who manages the two-story business specializing in denim, has opened the space to dozens of foster cats . . . and has even "hired" four of them as permanent employees! "People who work here have to accept the cats," she said as she introduced us to Frigga, a dilute calico who she refers to as the office manager.

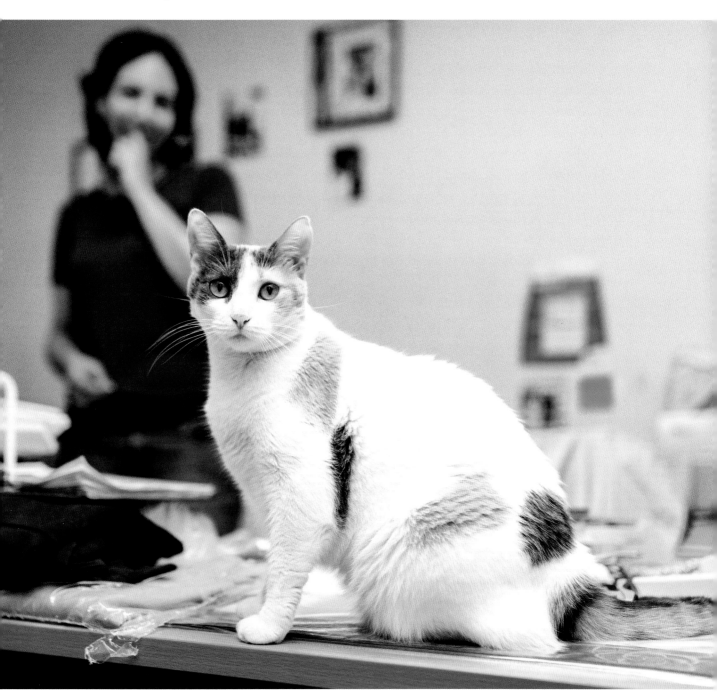

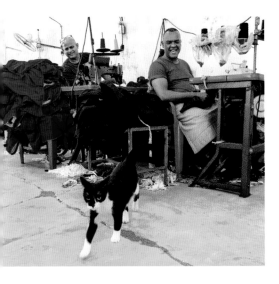

Frigga may oversee the administrative end of the business, but a tuxedo named Loki is the boss of the factory floor. She sauntered through stacks of blue jeans and climbed on industrial sewing machines while taking us on a winding tour of the large warehouse. The employees couldn't help but pause and laugh as she rubbed against their legs, demanding to be petted.

According to Monica, exposing employees and visitors to the cats has inspired many of them to take feline friends under their own wings. "It's our work of love," she said, Loki lying peacefully at her feet.

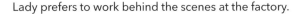

Lady prefers to work behind the scenes at the factory.

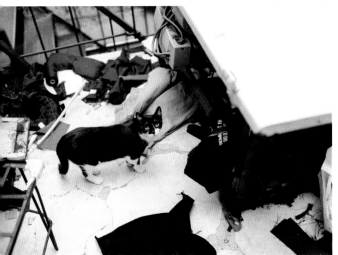

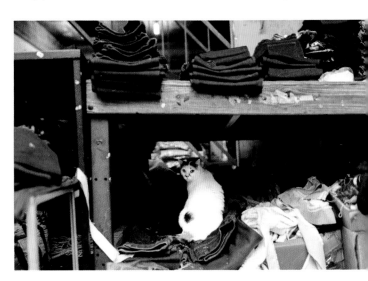

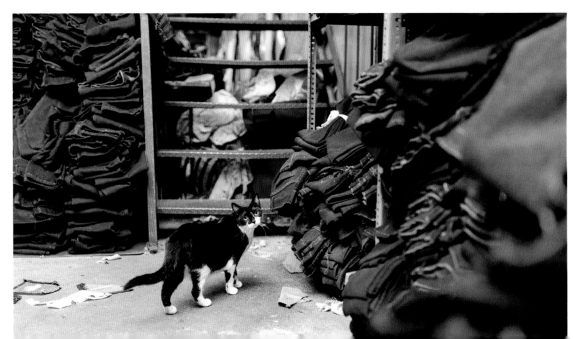

SAN PEDRO DE MACORÍS

On a warm January morning, we took a road trip with Emily, Penelope, and Tammy, the co-founders of Cat Lovers República Dominicana. Their group is transforming the landscape for cats by providing education and support throughout the country. With the wind in our hair, we drove past lush tropical forests and palm tree–lined beaches, the car packed with food and supplies to distribute to animal caregivers in the southeastern province of San Pedro de Macorís.

The organization's mission centers around shifting cultural perspectives to elevate the status of cats on the island. "There is so much education needed. For example, if you get pregnant, your ob-gyn will tell you to get rid of your cat. So we are working with medical doctors and community members to provide education," said Emily. "There are a lot of good-hearted people trying to do their best. We can provide food and litter, but, of course, education is the most important part."

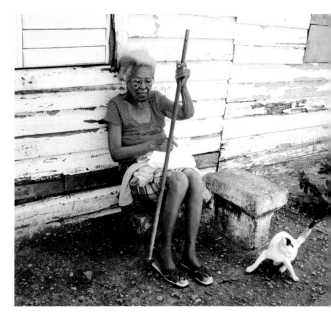

The women hope to inspire people to think differently about cats, whether they are in a home or on the street. "We try not to use the term *gato salvaje* ['wild cat'] to describe street cats, because we want to change perspectives. If we say they are wild, people will be like: 'Ahh!'" laughed Penelope.

"Instead we use *gato realengo*, which means a cat who roams," explained Tammy. With an impish smile, she added that this term can also be used to describe a promiscuous man, as in: "That guy gets around . . . He is a real gato realengo!"

We arrived at a long stretch of homes constructed of corrugated metal and wood and accented with splashes of brightly colored paint. An elderly woman sat on a concrete stoop eating bacalaitos with one hand and holding a long stick in the other, which she used to gently shoo cats away from the crunchy codfish fritters. She laughed wryly; their begging was incessant.

"Mishu, mishu!" called a loving voice, and the cats came running. It was Marisol, who acts as a voluntary godmother for animals in the area. As we unloaded several large bags of supplies for her to distribute, she explained that most neighbors are happy to open their doors to cats and dogs if someone else provides the food.

While most of the residents don't take cats inside intentionally, one young woman has willingly brought dozens of cats in need of shelter into her colonial home and backyard garden. "They are my family. I love them, and they love me," she said as she eagerly introduced us to them one by one.

In her bedroom, a litter of four plump kittens rolled around inside a handmade cage fashioned out of chicken wire. When the women of Cat Lovers RD asked about the possibility of eventually placing them for adoption, the caregiver recoiled. "I have clarity . . . I understand this is too many," she sighed. "But I'm so scared about giving them up for adoption. I don't trust people."

The women listened empathetically. According to the group, the perceived risk of mistreatment is so strong that many rescuers resist the idea of adoption. But with community education improving, they aim to help people become more optimistic. With gentle understanding, Emily leaned in. "You've found your life's purpose helping cats. Now we can help you do more through adoption. We have the resources to screen people and find good homes. You can trust us."

Change doesn't happen overnight, but Emily is certain that their approach is working. "We cannot be too harsh and tell people we won't help unless they come to our terms. Sometimes we have to gain trust slowly. So we will help with everything: not just cat food but even clean water or school supplies for the kids. Then we touch on the topic of sterilization and adoption again in a kind way. People do listen—once they can trust."

Later, we visited a colony of cats in a vacant building. "It was meant to become a large estate, but the builder lost the funding and abandoned it. Now the cats own it," Emily explained as we stepped inside the partially constructed structure, where the group is helping a local woman care for cats. The less social felines scurried away as we entered, growling emphatically from underneath wood pallets and inside ceramic pots.

A cross-eyed orange kitten and his brown-and-white friend curiously followed us, too uncertain to seek direct contact but inquisitive

enough to sniff our shoes. Without a sound, a third kitten leapt up onto a concrete wall to say hello: she had a sparse, patchy coat, a scrawny body, mite-crusted ears, and piercing copper eyes that gazed directly at us as she meowed. Before I knew it, she was flopping in my arms, purring.

The three were in luck: all of them were scooped up and placed into homes—and the crusty girl I fell in love with found a lifetime of love with Emily herself. "So many people are open to having a cat, and with our help they learn to do it in a responsible way. Dominicans are caring people," Emily said. "I believe with the right information, every home in this country has the potential to be a good home for a cat."

KUWAIT

OFFICIAL LANGUAGE: Arabic

CAT: قطة / Qittah

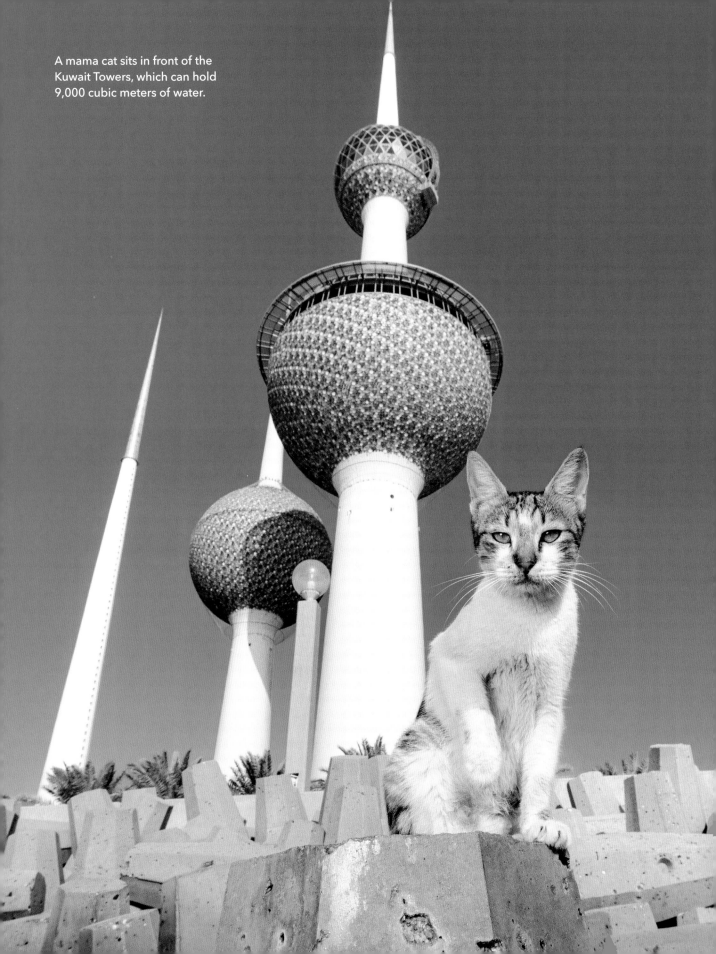

A mama cat sits in front of the Kuwait Towers, which can hold 9,000 cubic meters of water.

KUWAIT CITY

Along the Persian Gulf, the coast of Kuwait is dotted with modern skyscrapers, eye-catching monuments, and manicured parks. But look closely and you'll notice that the shoreline also features countless families of cats hiding in the shade of palm trees and escaping the desert sun in the seawall stones. Even the grounds of the iconic Kuwait Towers are home to a handful of felines.

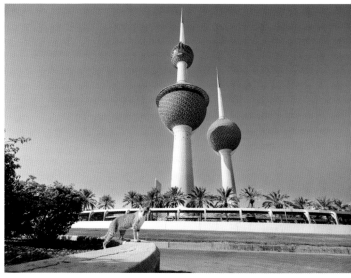

But one waterfront park tells the story of cats in crisis. "Here we are: Kuwait's famous dumping site by the sea," sighed animal rescuer Laila D'Souza as dozens of cats approached in the violet sunrise. "We don't have an official shelter here, so a lot of people resort to putting cats outside . . . and they bring them here. You want to help them all, but it's physically impossible," she said in a somber tone. "It can feel hopeless at times."

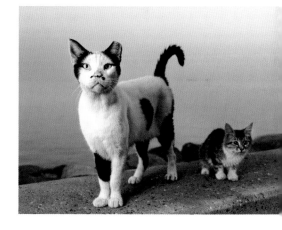

Most of Kuwait's street cats are a breed native to the area, the Arabian Mau. Known for their long legs, large ears, and typically bright green eyes, Arabian Maus have naturally evolved to have very short fur and no undercoat, which makes them better suited for life in one of the hottest climates on Earth. But Laila noted that many of the cats are mixed with other breeds due to a widespread trend of pedigree cats being left outside.

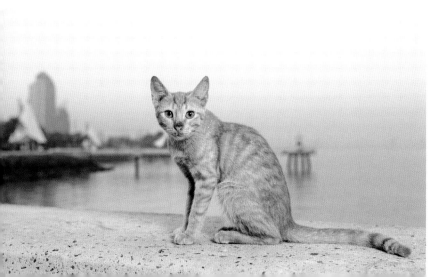

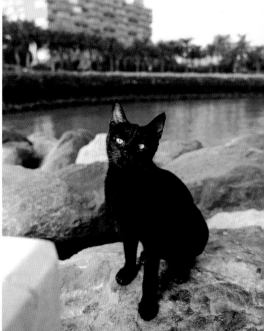

"So many people here buy fancy cats, and when they have babies or they can't keep the cat, they just put them here," Laila explained, approaching a cat crate that had been left in the grass. "This happens multiple times a day. We all know the story behind the crates. It means that a cat that has been so used to being indoors all their life—their world suddenly changed."

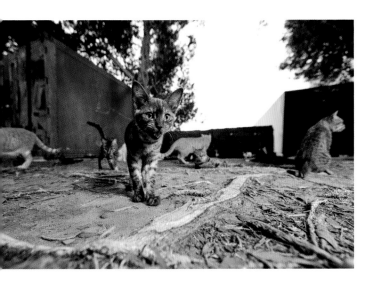
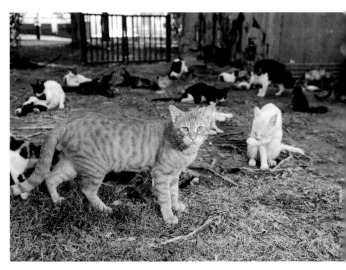

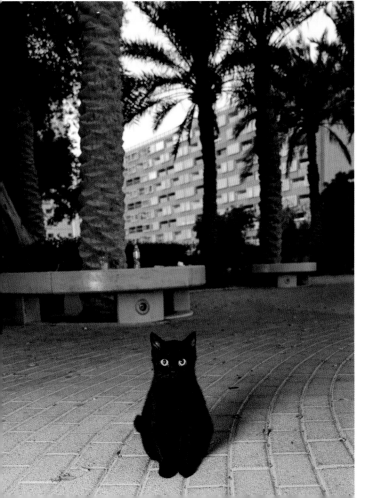

A local man jogging through the park stopped to look up at a cat in a treetop. "People just dump," he told us, unprompted. "Look, a ragdoll . . . one with a collar. Probably new. People get tired of paying money and they just dump. It's a shame."

Overwhelmed rescuers find that there are limited local adoption prospects, but overseas adoption has provided a lifeline for some cats. "A lot of people in other countries like the fluffy, fancy-looking cats but can't find them in shelters, so they actually like getting cats from here," said Laila, who regularly sends cats on flights to animal rescues in the United States. "Sometimes I feel guilty because I know there are so many cats in America who need homes, but it's just hard to find a long-term life for them here. You have to do what's best for them."

Laila has difficulty finding adopters for native Maus, but says that the international desire for "fancy" cats does benefit the non-native breeds, who urgently need to be rescued due to the challenges they face on the streets. "Arabian Maus are almost always born outdoors. But dumped cats come from indoor homes with A/C, and suddenly they are outside in the scorching heat in an unfamiliar place. Of course having long fur or a flat face doesn't help them breathe in this weather. Some people think they'll be okay, but they don't see what we see." In these cases, she is grateful that they are easy to place, although she wishes that more people were interested in adopting the Maus she rescues, too.

At a mosque where ear-tipped Maus roam, a fluffy Persian caught Laila's attention. "I'm going to get him," she said, his care taking precedence due to his struggle to survive outdoors. She picked up the long-haired gray cat with no trouble, and he purred loudly as she set him up in a guest room. Later, at the fish market, we spotted a black Scottish fold who was panting in the heat, and she took him in without hesitation, too. "I know for a fact when I send a picture of a cat like him, someone will say yes." Within mere days, she had arranged transportation for both of them to go to Washington, DC, for adoption.

"So much work goes into sending cats overseas. I wouldn't do it if there was any other way," Laila said as she prepared a large crate with name tags for three Mau mixes who would be leaving on the next flight.

Another local rescuer, Mona Bash, sends so many cats overseas that she began renting an apartment just to house the cats who are awaiting their flights. She cares for a motley crew of discarded purebred cats: Persians in need of enucleation, Scottish folds with limb malformations, a recently rescued emaciated Bengal. "For me, my cats are my babies. For many people they are like toys or something," Mona said. Each month, Mona sends dozens of cats to Europe, the UK, the US, and Canada.

"I don't call this a shelter," Mona explained, "because then people will bring me so many animals, it will be too much. This is just my unit where I do as much as I can."

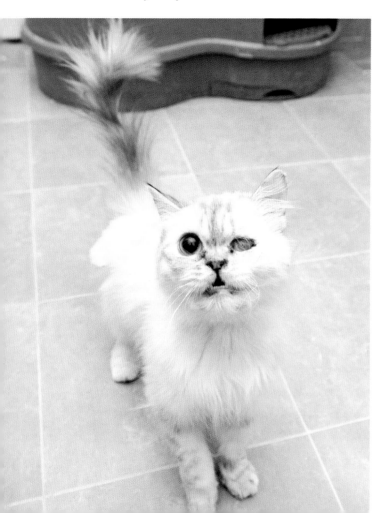

Mona proudly pointed out which cats would be living in London or Toronto, beaming with excitement for them. But of all the cats she has rescued, there's one she will never send away: a one-eyed black cat named Shadow who has won her heart for good. "She was a little kitten from the fish market. Now, I take her to participate in the cat show! People bring long-haired cats . . . not a cat like Shadow. But she has won 'Best House Cat' many times," she said triumphantly, leaning in as Shadow

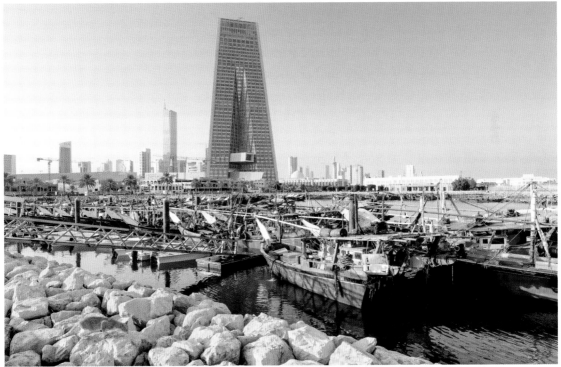

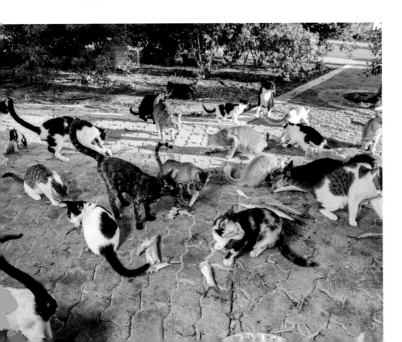

rubbed faces with her. "She isn't up for adoption. She is my best friend."

The Souq Sharq Fish Market is one of Kuwait City's most populous sites for cats. In the early hours, as the fishermen dock their boats, cats sniff the air, yowling ravenously to request a morsel of mackerel or a scrumptious sardine. "Every day I feed the cats," said a worker as he gleefully tossed fish onto the walkway outside the market, and the cats each ran off with

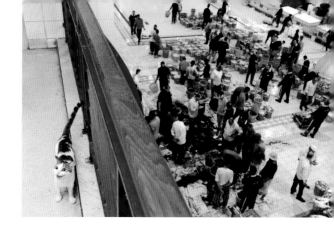

their prized piece. While most of these cats will not find a home like Mona's Shadow did, they are content to live in the seafront bushes, where they have community, a bit of shade, and as much fish as they can eat.

The fish market cats mostly live outdoors, but one opportunistic mama cat has taken it upon herself to upgrade her living arrangements by moving inside the gigantic indoor marketplace. We giggled as the fearless tabby snuck a fish from an unsuspecting seller and scurried up the steps, where she was secretly raising three adorable babies in a boot closet. Satisfied and sweet, she meowed as if to show off her private suite overlooking the all-you-can-eat buffet.

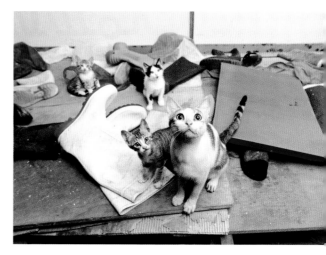

Souqs offer Kuwait's street cats plenty of shelter and opportunities to hunt, forage, and find moments of affection with passersby. At Souq Al-Mubarakiya, one of Kuwait's oldest souqs, cats saunter between shops selling wholesale spices, gold jewelry, and traditional clothing. We strolled with local cat advocate Hamad Almehaiteeb, and he shared his reflections on growing up with cats in Kuwait. "Unfortunately, cats are abandoned here for small problems. When I was a kid, I had two cats, but they got ringworm— such a simple fix—and my family dumped them. I was so angry and hurt. But I think a lot of people have been hurt and now want to help. Wanting to help stems from the pain."

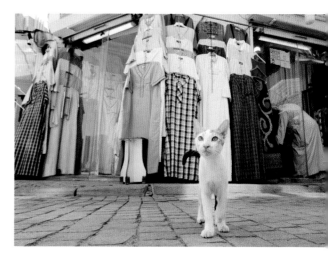

With a growing generation of young people invested in animal welfare, Kuwait's cats have more advocates coming to their aid than ever. Hamad kneeled down to pet a street cat, the dust from her fur rubbing off against his pristine white dishdasha. He smiled and offered her chin scratches anyway. "People put humans on a pedestal and see animals as expendable, but they're not. What I wish people understood—and it sounds so simple—is that cats are living beings like me and you."

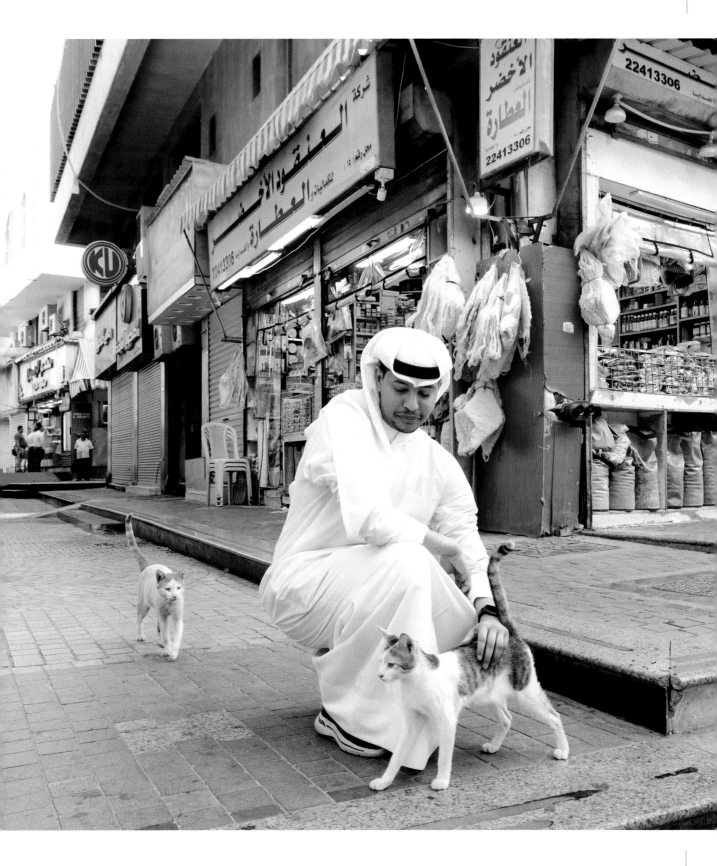

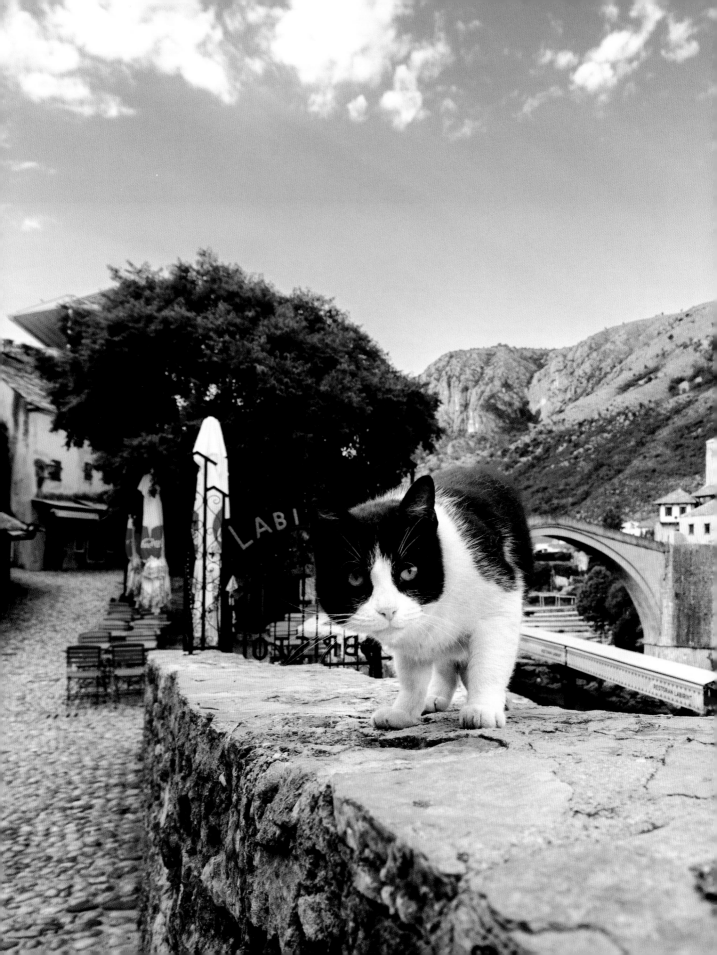

BOSNIA AND HERZEGOVINA

OFFICIAL LANGUAGES: Bosnian, Croatian, and Serbian

CAT: Mačka (Bosnian and Croatian),
мачка / Mačka (Serbian)

MOSTAR

Mostar is a charming city set along the bright-turquoise waters of the Neretva River. In the old town, cobblestone streets lead to vendors selling traditional copper arts and Bosnian coffee, which is meant to be enjoyed without haste. There is an important cultural notion referred to as "ćejf": an intentional activity that brings deep gratification and connection with oneself, like sipping a warm cup of coffee slowly or stroking a cat. It's a simple pleasure that no one can take from you.

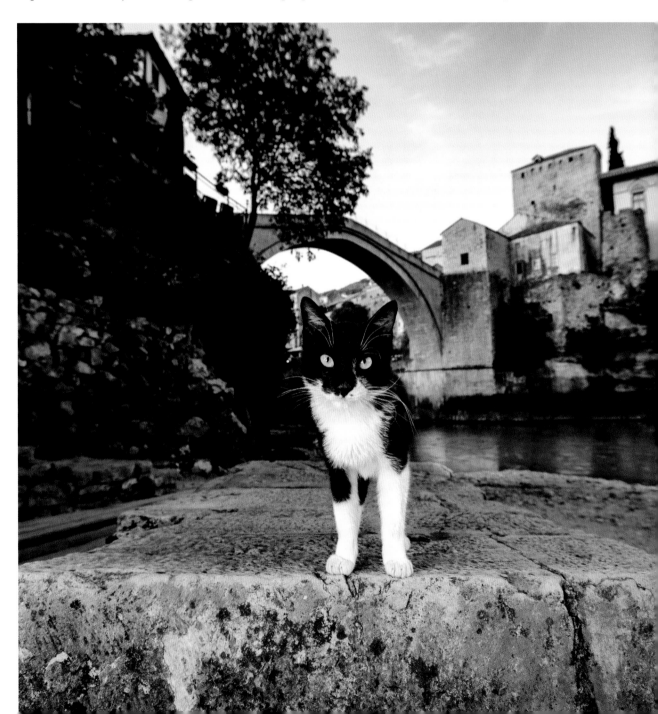

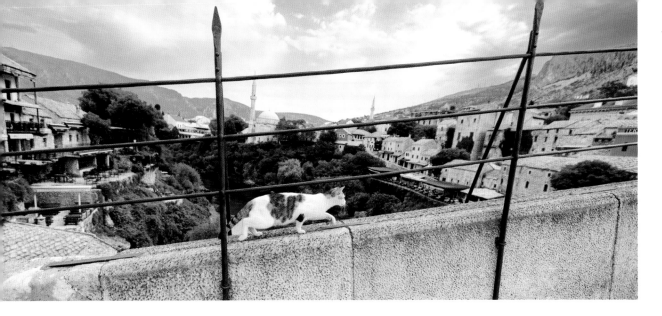

The city is named for the Stari Most, an iconic sixteenth-century Ottoman bridge that arches high above the river and holds great cultural significance. We stood along the edge of the water, admiring the unique single-span arch and petting a golden-eyed tuxedo cat who stood on a giant block of jagged tenelija limestone. "That stone is part of the original bridge," a local told us, "before it was destroyed." In 1993, war devastated the city, and the Stari Most was demolished. The bridge that stands now is a re-creation using the original architectural techniques and is protected as a UNESCO World Heritage site.

As we walked up the steeply slanting bridge, we spotted a little thrill-seeking calico named Ferida hopping onto the ledge. As the resident cat of the Mostar divers' club, her adventurous nature was a perfect fit; at this club, young locals train to dive off the seventy-nine-foot bridge into the fast-moving, icy-cold river below! Diving from the Stari Most is a tradition that requires careful strategy and is a rite of passage that dates back for centuries. "We love animals," said one of the members at the club. "We always give them food."

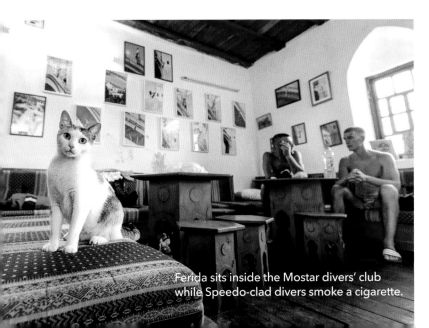

Ferida sits inside the Mostar divers' club while Speedo-clad divers smoke a cigarette.

Walking past the Hajji Memiya Mosque, we encountered a friendly orange-and-white cat at the entrance. "There are a lot of connections to the cat in the Kur'an. A cat is the only animal permitted in a mosque, because they are the cleanest," explained Ševko Jakirović, who was born and raised in Mostar. "With ablution, you have to perform a process to clean yourself of everything that is dirty. What is dirty needs to become clean. If you touch a cat—it's still considered clean. If you touch a dog, you have to start again."

Ševko, who spoke openly about his experiences fighting in the war, explained why cats are so welcome in Mostar. "With the war, buildings were destroyed and roofs came in, so everything was kind of rotten and there came a lot of rats. So the cats were important; cats are very much respected as friends because they keep the neighborhood clean," he said. "We have a saying here: *teška krv*. It means 'heavy blood.' We say that cat blood is heavy on the soul. It means if you do something to cause pain to a cat, something bad will happen to you—like karma."

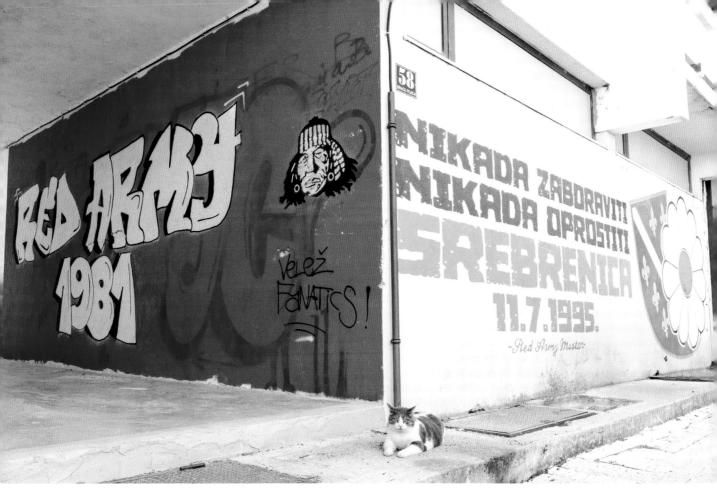

Kiki models near graffiti by fans of the Fudbalski klub Velež, a revered Mostari football team.

Cats can be seen throughout the residential areas of Mostar, and while a few live independently, many have some degree of care. As we admired a chunky cat seated next to a large wall of graffiti, a woman turned the corner and scooped him up to bring him home for dinner, introducing him as Kiki. "Most cats are cared for in an informal way," explained cat advocate Caroline Wisler.

Some of the city's luckiest cats live in a private backyard with Amela Kreso, an actress at the National Theatre who is also a passionate cat advocate. Amela invited us

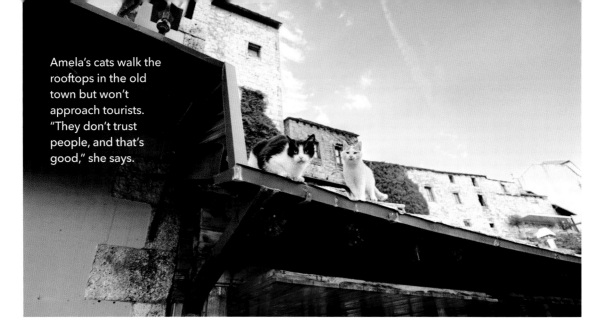

Amela's cats walk the rooftops in the old town but won't approach tourists. "They don't trust people, and that's good," she says.

to the terrace behind her sixteenth-century home, poured us a glass of sok od nane made with mint from her garden, and introduced us to her cats, Gica and Bijelo. "My children found Gica when she was a very small baby by the bridge. Bijelo came here as a small kitten, too—blind in one eye."

Along with her children, Amela is sterilizing and caring for cats all around her neighborhood. "Helping cats is one of the biggest loves for my family," she shared.

Walking through the town, Andrew tapped me on the arm and said: "I hear kittens." We turned the corner and saw a group of young boys, each with a three-week-old in his hands. I held my breath as we approached, eager to learn if the kittens were okay . . . and what happened next was absolutely heartwarming.

The children explained that this wasn't their regular playground—they were only there to check on the kittens! "We found them seven days ago in these tires. Their mom is right there," a little boy named Harun told us, pointing to a calico across the playground. "We come here every day to see them. Because they are cute to us, we just look at them, hold them, and put them back."

He showed us a kitten whose eyes were sealed shut, and asked if we knew how to help. Using water and a cotton pad, I compressed and gently opened the kitten's eyes, and the boys cheered. We sat in the dirt and had a wonderful, touching conversation. "Some people say this is the country of the heart, because it's shaped like a heart. I love every animal," said a boy named Hamza. He gently returned the kittens to the tire, and the boys climbed the playground equipment, singing a song about loving cats.

While there are no formal resources to help animals in Mostar, the warmth and compassion of the people in the community are exemplary. "It's caring individuals who make a difference here," said Caroline. "People have limited material resources, but what they do have, they try to

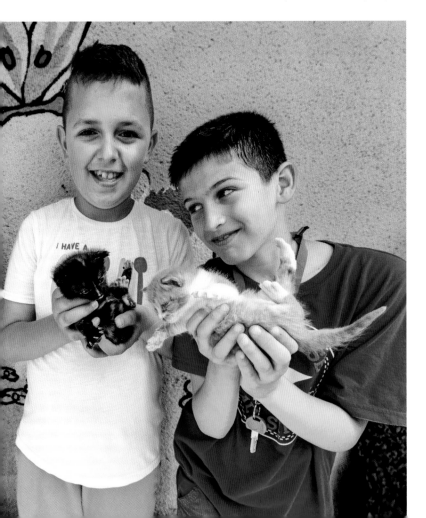

The boys call themselves a "mala raja," which means a close-knit group of neighborhood friends, and directly translates to "small paradise."

share. There is an unparalleled generosity of spirit." The openhearted nature of Mostarians is a testament to their resilience and kindness. And while Mostar looks ahead to the future, reminders are everywhere to hold remembrance for what has passed. Just as we turned to leave town, we read two important words under the paws of a cat: *DON'T FORGET.*

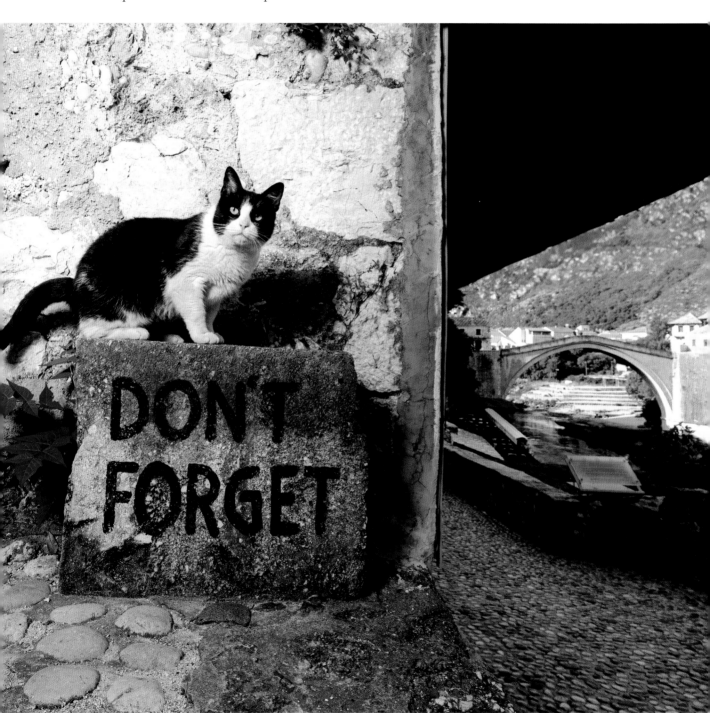

URUGUAY

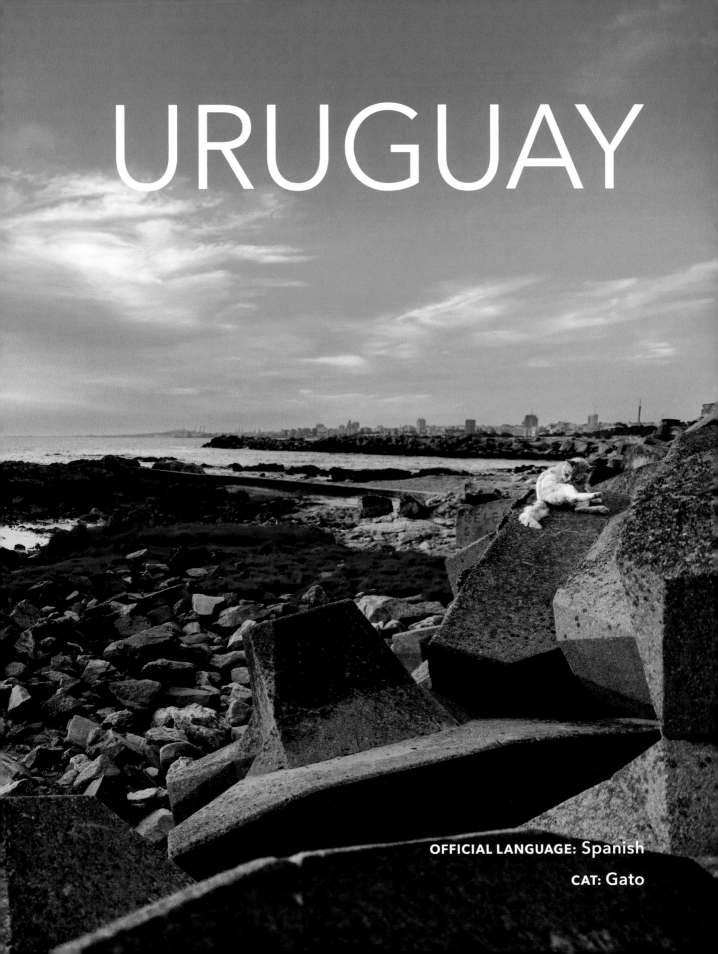

OFFICIAL LANGUAGE: Spanish

CAT: Gato

MONTEVIDEO

The coastal city of Montevideo is home to more than half of Uruguay's residents, and with its welcoming community and picturesque views, it's easy to understand why. Uruguay is consistently ranked as one of the most progressive and prosperous countries in Latin America, lauded for its strong social programs and high quality of life. We made our way to the city's port by ferry, curious to learn about life for local cats.

"Montevideo has programs for people, but it's very different for animals," explained Jessica Schöpf, whose life changed when she learned that the municipality was moving three hundred

community members from a nearby park into a housing development but that the animals living in the encampment would be left behind. "I went to the settlement and they were bulldozing everything. There were eighty cats there, hungry and scared. Ever since, this has been my life."

Now, Jessica's home by the serene Río de la Plata serves as a refuge for a revolving door of dozens of felines. Inside you'll find a half dozen kittens lounging in her bed; outside you'll find even more relaxing in a spacious courtyard. Standing in the grass, kittens gathered at our feet to meow hello.

According to Jessica, the displacement of animals is a serious issue in Montevideo. "People are given free homes, but the biggest problem is there is nowhere for the animals to go," she sighed. "So many of them are left behind." As part of the organization Garritas Charruas (*garritas* translates to "little claws," and the Charrúa are the indigenous people of Uruguay), she and others take these animals to the vet for care and sterilization and place as many of them into homes as possible.

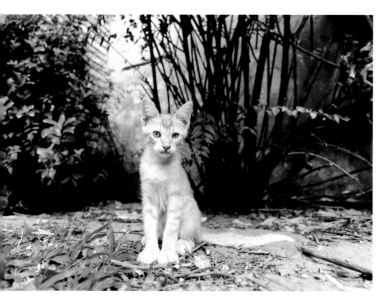

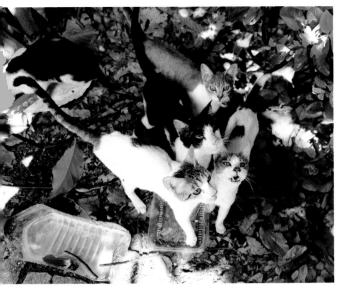

As we finished up our lunch of chivitos—delicious Uruguayan sandwiches—Jessica received a phone call alerting her to an empty home where cats had been left without care after the death of the homeowner. "This is every day, five times a day. There is nowhere to take them . . ." she lamented. We drove to the empty home constructed of concrete and aluminum, where we heard a faint rustling through a cracked door.

A group of emaciated cats emerged, cautiously greeting us. Their faces were gaunt as they stepped across crunchy leaves and past empty food dishes. They were friendly, filthy, and famished.

We filled empty containers with water and searched the vicinity for more cats as Jessica purchased a bag of organ meat from a nearby butcher, which the cats sank their teeth into immediately, growling. "They can go to a vet later this week," she said, "and we can bring them food tomorrow. But sadly, there is nowhere for them to go today."

There's a gnawing pressure that comes with being an animal rescuer: exposed to tragedy over and over again, one quickly discovers that there is no bottom; there is no end. It becomes critical to recognize one's limits, to ask for help, and to forgive oneself for not being able to do everything alone, or all at once. Driving away with Jessica, we shared in this struggle and brainstormed what we could do.

That evening, we collaborated to tell the story of the five frail felines, and what happened next surprised us both: enough funds were raised to cover not only their care but the cost of sterilizing hundreds more. Within days, the cats received vet care, and within weeks, they were healthy enough to be adopted! The remaining funds supported the launch of a series of spay days across the city.

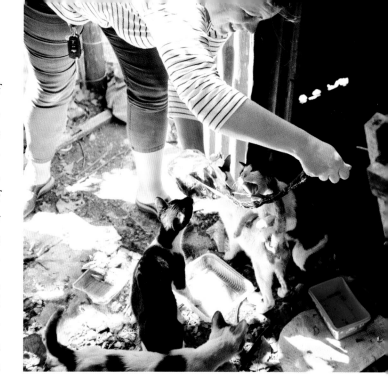

Rescue is an unending roller coaster of sorrow and optimism, crisis and progress. But amidst the breakneck speed of it all, it's crucial to occasionally take a breath and examine the good that has already been done. Everywhere you look, there is evidence of the progress being made, and Jessica proudly pointed out the areas where the lives of cats have been improved through acts of kindness. We pulled over at Faro de Punta Brava, a lighthouse that was once a breeding ground for dozens of felines until they were sterilized and placed into homes. Now, only a small number remain who prefer not to be bothered by humans, living wild and free.

We sat upon the concrete breakwater, taking in the view. Jessica peered peacefully at the horizon before looking down at her phone, which was buzzing with a string of alerts about more cats in need. In just one year, she'd gone from a concerned citizen to a full-time rescuer.

It was golden hour, and the sun was casting a soft, ethereal light across the glistening beach. In the background, the city skyline swept the horizon. In the foreground, the accidental rescuer sat strategizing, a contented cat by her side.

SAUCE

In the outskirts of Las Piedras lies a safe haven for cats and farm animals. "It's a special place for cats who are in danger," said Irene Hernández, founder of Agrupación para la Protección y Cuidado de Animales. "We created this place on our farm, where we live and coexist with the animals."

As we walked between bright purple buildings, we reached a field of flourishing felines lounging in the grass while chickens pecked the fertile ground around them. Several small barns and

platforms constructed from native wood offered cats a choice of places to spend their day.

Irene has spent the past decade working miracles with animals. "Most of them are up for adoption, but we know that many of them will never find an adoptive home," she said, leaning over to offer pets. "So we try to be the closest thing—to make them feel safe and loved."

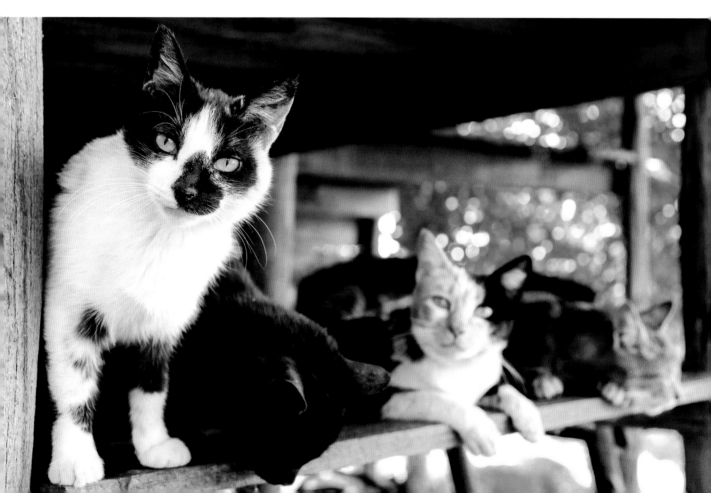

OFFICIAL LANGUAGE: Thai

CAT: แมว / Mæw

THAILAND

KOH LIPE

Life feels simpler on the tranquil Thai island of Koh Lipe. With no airport or pier in sight, this remote haven is refreshingly untouched by industry; the only way to visit is to take a peaceful journey aboard a long-tail boat through the stunning turquoise waters of the Andaman Sea. We stepped ashore onto soft, powdery-white sands and into a paradise where people and animals live harmoniously.

The relationship between cats and humans on Koh Lipe is one of community more than owner-ship. Open-air restaurants make suitable stays for felines, and many shopkeepers on the island appreciate both the company and the utility of these adorable rodent-hunters. As we took a seat at an outdoor eatery serving Thai and Chao Ley food, a sweet young cat rubbed affectionately against the bamboo chair legs. "This is Cindy," said the owner with an amiable smile. "She usually lives at

Naang, who wears a large metal bell, lounges outside a local shop.

the fruit stand across the street, but she comes over in the morning when I start to cook. They only have fruit, but I give her fish and rice!"

Although there is no veterinary clinic on the island, the cat population is kept a manageable size thanks to visiting veterinarians who conduct an annual large-scale sterilization program. "Because not too many are being born, locals know they can care for the ones who are here," said one resident. It's plain to see that many of the cats have received care over the years; after receiving their spay or neuter and rabies vaccination, cats are branded on the hip with the year the surgery took place.

While some local cats drift between spaces, a cat named Usa has firmly anchored herself at a beachfront dive shop for more than a decade. As we approached the shop to check out rental kayaks, we spotted two furry legs poking out from underneath a handwritten sign, pawing at a broom. "When we sweep the floor . . . that's playtime!" said the shopkeeper, laughing.

The chunky white-and-brown tabby was unfazed by the agenda of anyone around her. Regal and sassy, she flopped in the entryway, flicking her tail and swatting at customers' feet. On her hip, the number "54" was branded; Koh Lipe follows the Buddhist calendar, and 2554 is equivalent to the Gregorian calendar year 2010, when she was spayed.

"There used to be a dive shop dog, but she kicked him out . . . so we got a dive shop cat! She's the boss here," said the shopkeeper, who vehemently defends her presence. "One time a tourist touched her belly and she bit him. He should know—the belly is a trap. The guy yelled at us and said if he gets sick he'll sue. I said, 'I'm more worried about her getting sick from you, because I know she's healthy . . . but I don't know where you've been!'"

We laughed heartily and knew we'd found the kayak shop we wanted to support. We took our boat into the crystal water, where I blissfully soaked in the views, not knowing that Andrew had something special up his sleeve. When we returned from our expedition, I had a smile on my face and an engagement ring on my finger—and Usa was the first to see it.

During our stay, we only saw one cat who hadn't been spayed. At a small laundry shop where garments are hand-washed and strung to dry, an orange-and-white tabby lay in the entrance, exposing a belly dotted with swollen pink teats. "Babies?" I asked the woman washing linens, and her face lit up as she invited us to a secret spot where four kittens were being reared.

Tucked between stacks of wood and aluminum, their tiny corner of the world was humble but provided all they needed: shelter, protection, and proximity to the mama's food source at the laundry shop. The mother cat hopped inside the hideaway and began to groom her little ones, who were plump and

healthy aside from one with a crusty eye. "His eye," said the woman, and offered me a wet cotton pad. I scooped up the winking baby, his belly soft and full as I held him in my hand to compress the eye and wipe away the residue. Two deep blue eyes peered back as I returned him to his mother, who received him with eager licks.

As we bid farewell to the ginger family, I was comforted knowing that where the population is balanced, there is enough to go around for everyone: a space for each being to be sheltered, fed, and considered. The few kittens born each year on Koh Lipe are born into a community that sees them as a part of it, and the babies were in the best hands possible: their mother's paws.

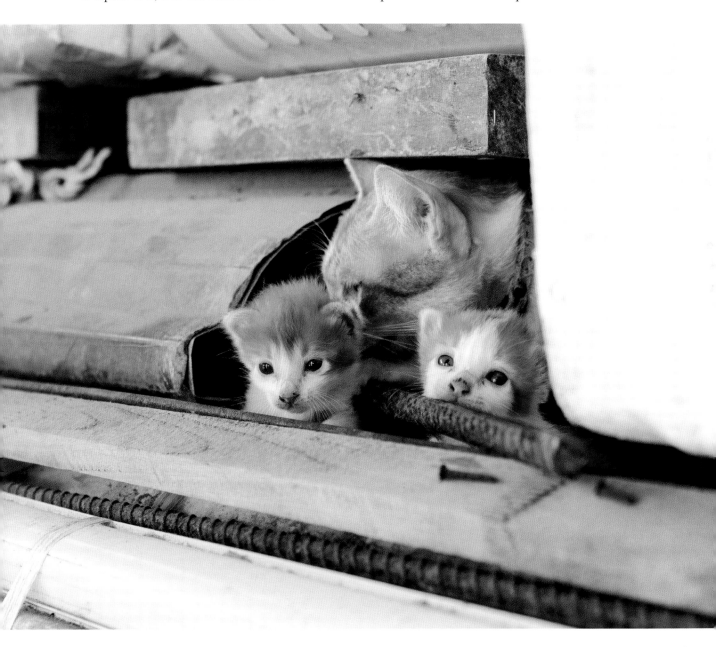

CHIANG MAI

On an evening stroll through the heart of Chiang Mai, moonlight illuminated the city's abundant Buddhist temples— the entrances to which are often adorned with statues of the Singha, an ornate lionlike creature representing protection. Under the guard of these mythical feline guardians, crepuscular cats emerged from their hideaways to gather at the gates for dinner. In the twilight hours, it's customary for monks to distribute leftover rice to cats, ensuring that no food goes uneaten and no animal goes unfed. The ritual embodies the Buddhist principle of ahimsa: kindness, compassion, and nonviolence toward all sentient beings.

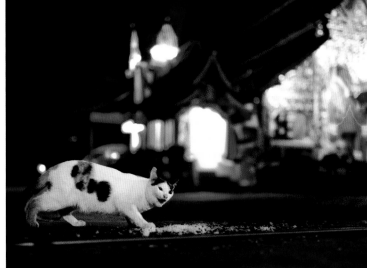

For animal lovers, a visit to Chiang Mai is not complete without a visit to Elephant Nature Park, a harmonious sanctuary dedicated to the ethical treatment of elephants. Founder Lek Chailert has dedicated her life not only to rescuing elephants from logging, tourism, and other exploitative industries but also to saving the lives of cats. "To be honest, a cat is one of my favorite animals," she told us. "They were the first animal I ever really got to know." Thousands of cats now find safe haven at her sanctuary.

Cats wander along the water where elephants bathe, lounge in the dedicated "Cat Kingdom," and sun themselves on aptly named ATVs. Many don red collars or purple dye to signify recent medical treatment. While she loves caring for the animals, Lek wishes it weren't needed

at all. "If people just have respect for life, and let animals be happy and free, then the sanctuary should never have to exist," she said, pausing in thought. "I ask that people be kind to animals."

Lek, whose sanctuary provides a vegan Thai meal to visitors daily, believes compassion is something to extend to animals of all species. "Big animals and small animals are not different. To look after elephants and cats, the only difference is the size," she said. "To take care of them—their emotional needs, their sickness—is similar. People ask me how the animal feels, and I say: 'Listen to your heart.' We want a safe place, we want a comfortable place. Same with elephants, same with cats. We all want the same thing."

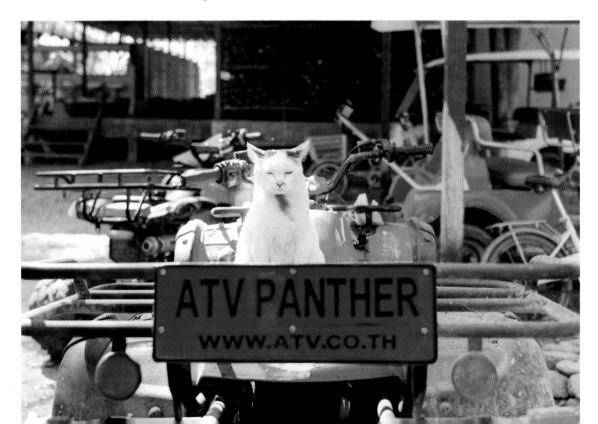

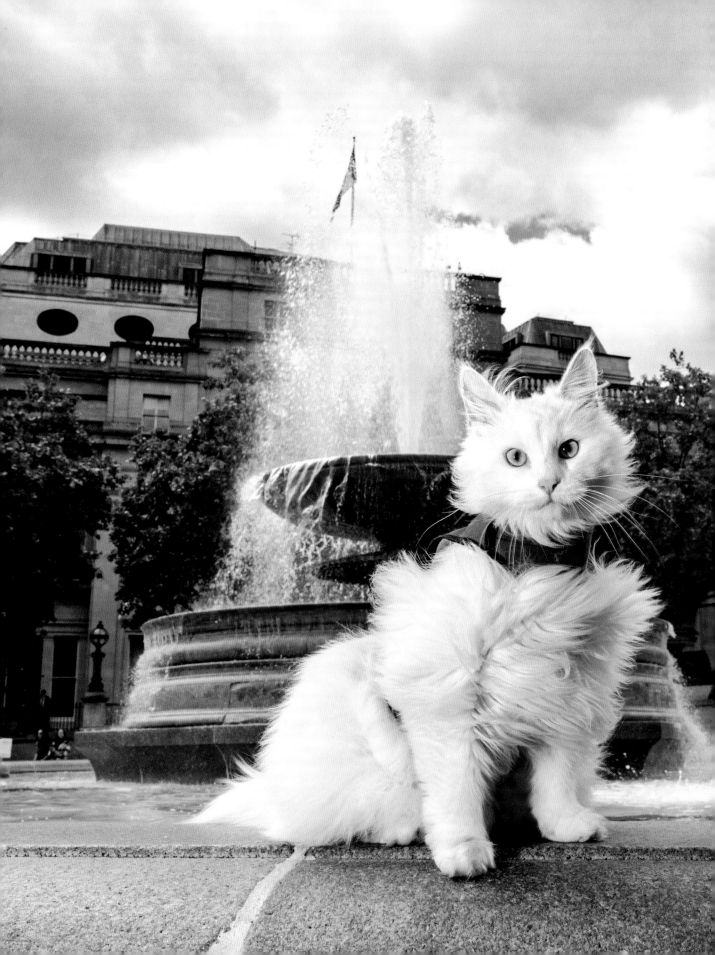

ENGLAND

OFFICIAL LANGUAGE: English

CAT: Cat

LONDON

You won't find a cat who has seen more of London than Sigrid, the cycling cat. Along with her chauffeur, Travis Nelson, the five-year-old cat has traveled more than 3,000 kilometers in the comfort of a bike basket, and she loves every minute of it. Each morning she stands by the door, begging to put on her custom purple harness and get clipped into the basket for a ride around town. "She hates when we are at a stoplight or in traffic—she wants to go fast! She wants to see things," said Travis.

When we arrived at Trafalgar Square, Sigrid was walking the base of Nelson's Column, a nineteenth-century monument with four massive bronze lions on its sides. Regal and content, she observed the busy square without a care in the world, hardly noticing the group of onlookers gathering around her. "She's kind of indifferent about attention," Travis said. Because she is deaf, the booming sounds of buskers didn't bother her a bit, and she leapt from statue to statue with the poise of a wildcat, eventually ending up on the ledge of the Jellicoe fountain.

As we walked through the crowded streets of Piccadilly Circus, it was clear that Sigrid wasn't the only one happy with this arrangement. "People are so excited to see a cat on a bike. Everyone is always waving and asking if they can pet her. She makes people smile."

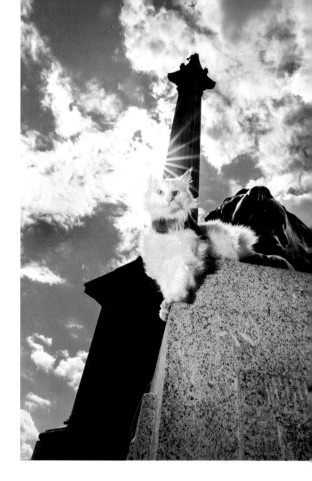

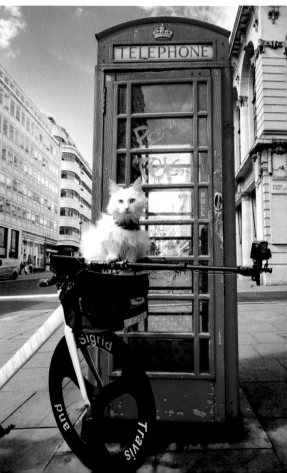

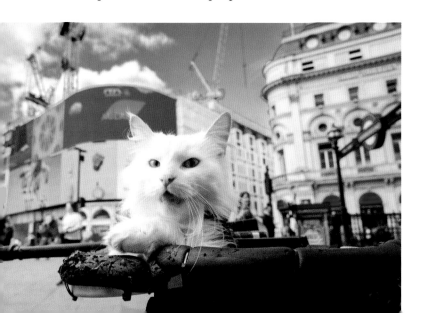

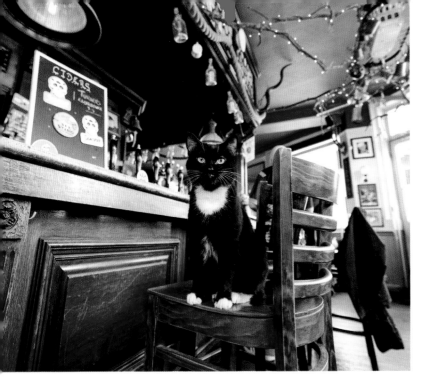

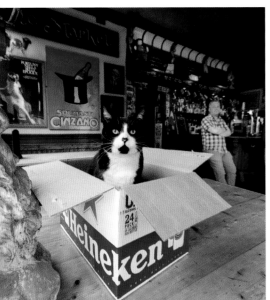

Sigrid is just one of many cats you'll find out and about. Pop into a local pub for a beer or a bite, and you just might encounter one of the many friendly felines living in these popular British public houses.

"A pub should be an extension of your living room, and a cat is perfect for that," said Josh Freeborn, manager of Tapping the Admiral. He gestured to Nelson, a black cat with a white bib and mittens. "We're a locals-led community pub with lots of regulars, and Nelson is part of that atmosphere and culture. Everyone knows and loves Nelson. He'll sit in the center of the table surrounded by dirty glasses, perfectly happy.

Just down the street at Old Eagle, a group of men stood around the bar drinking lager and telling us stories about the pub cat, Churchill, who sat in an empty beer box. "You can stroke him if you'd like, but not too much or he'll swipe ya—" a man warned.

"—Just like the real Churchill!" his friend interrupted, and they all erupted with laughter.

While pub owners and patrons alike develop bonds with pub cats, it's the cats' aptitude as hunters, not their affection, that prompts many pub owners to adopt. I asked the owner of Seven Stars what people think when they see a cat in the doorway, and she looked at me sideways. "What do you

mean? Every pub has a cat . . . or else they have mice!" A black cat in a frilly collar walked toward her, and she reached down to give him a pet. "His name is The General. He's the resident mouser."

"It's a sign you don't have rodents," Freeborn agreed. "It's very

common, especially in the smaller neighborhood pubs, where there aren't tourists or busy roads. It's safe for the cats, keeps rodents away, and, of course . . . everyone likes them."

Pubs aren't the only businesses in town with paws on their tabletops. At Tooting Market, two-month-old kittens Bec and Broadway were settling into their new home after being adopted by the bustling indoor market. "People love to see the cats," said one shop owner as patrons gathered around the table to greet the new kittens. "They are so popular."

"Before our first cat, this place was infested with mice. Well, that's London," laughed Robert, who manages the care of the facility. "For now, the kittens live in the flat with me next door, but I bring them over once a day to visit. The first day they were bothered by the noise of the vegetable delivery; it makes such a racket! But now they love it here."

The vendors of Tooting Market love the cats, too. "You can tell who all the cat people are, because we cut holes into our shop doors so the cats can come inside!" said Ali, who owns a colorful sweets shop where she cares for a tuxedo cat named Chester. "At night, when the shutters come down and the market is quiet, Chester loves to go out and explore. But during the day he's right here in this basket. I guess you could say I'm a mad cat lady!"

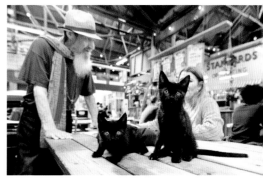

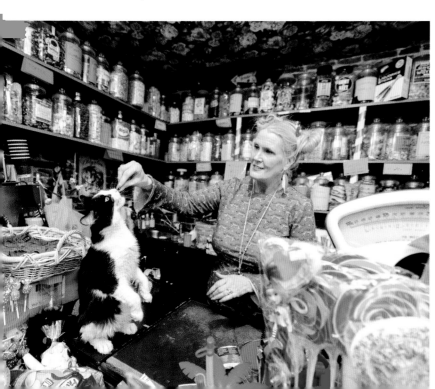

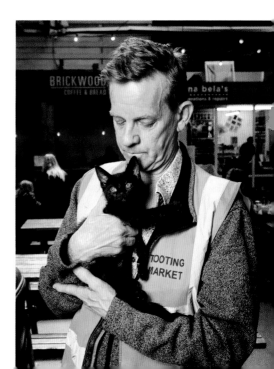

Undoubtedly the most magnificent place you'll find a cat in the city is at Southwark Cathedral, the oldest Gothic cathedral in London. The architecture is absolutely breathtaking, from its high arches and ornate stone carvings to its intricate stained-glass windows and golden altar. Standing in the nave—the grand hall of worship—we could feel that we were in the presence of something truly divine. And that's when we saw him: Hodge the cat.

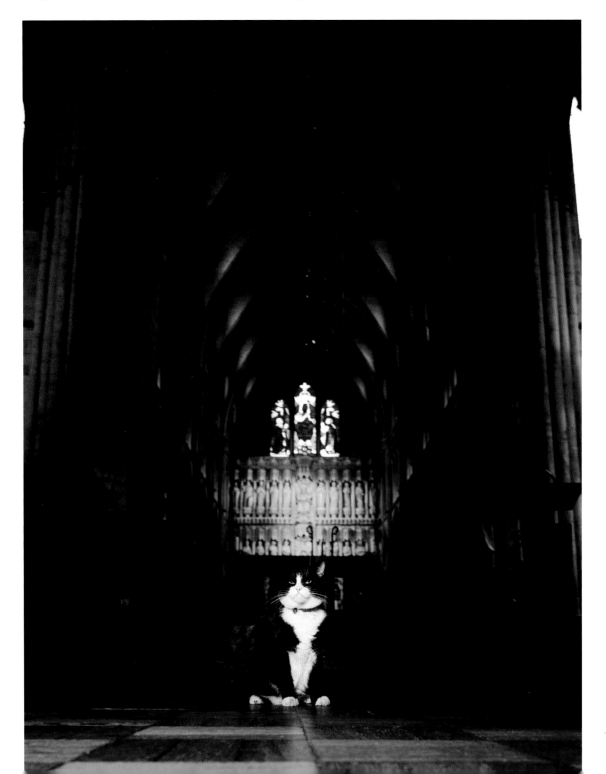

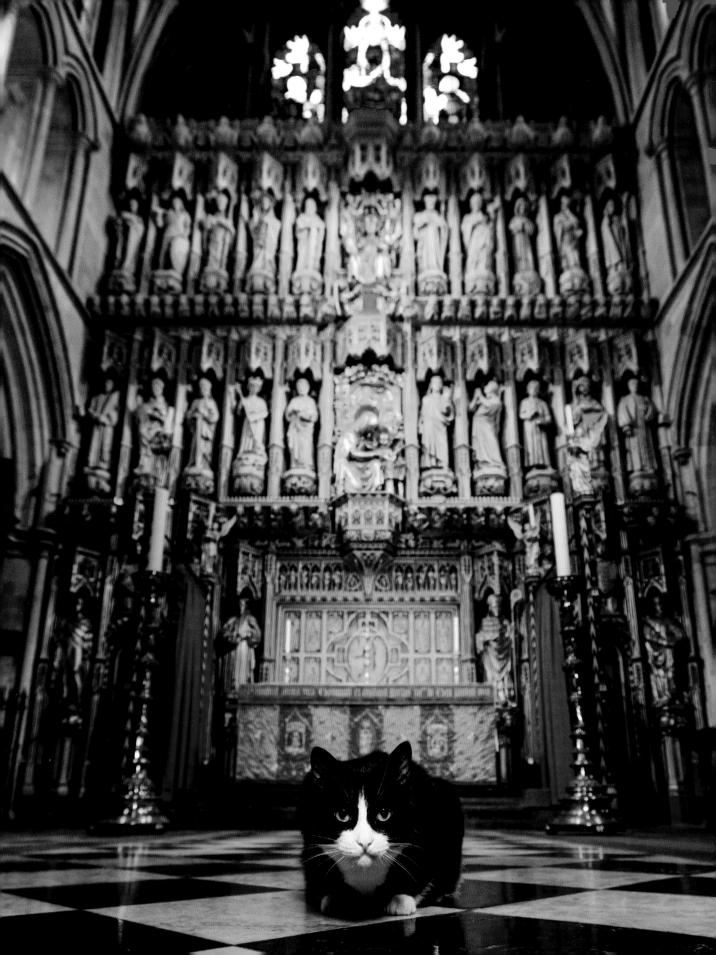

The seven-year-old tuxedo cat has a knack for attracting newcomers to the congregation. "He's a great missionary cat," explained the Very Reverend Andrew Nunn, the dean of the cathedral. "Folks who wouldn't usually come to a church will come to see him, and then find that they want to say a prayer or light a candle. He seems to have an innate sense when someone is sad, and he'll sit with them."

Southwark Cathedral wasn't always home to a cat, but that changed in 2008 when a small tabby began to show up in the doorway. They named her Doorkins Magnificat, and she came to be deeply loved by countless visitors—including Queen Elizabeth! But when Doorkins fell ill and retired to a staff member's home, the team reached out to a local sanctuary to inquire about bringing in a new cathedral cat. "They said, 'Look, we've had this cat for six months and nobody wants him.' So I went there to meet Hodge, and I was like, 'Yeah, he's alright, innit?'" recalled Jon Dollin, who works for the cathedral and runs Hodge's popular social media pages. "We arranged a day for him to come, and it happened to be that that was the day Doorkins died."

According to Dollin, when the church decided to hold a memorial service for Doorkins, "it caused uproar in the Church of England. There were bishops that thought it was ridiculous. But after the service we had national newspapers and celebrities speaking out in support, and these bishops were then scurrying around, saying, 'Okay, fair enough!' Because it's about acceptance, and giving a home to someone who needs one. That's what we did with Doorkins, and what we're doing with Hodge."

Hodge enjoys full rein of the massive campus, including the bishop's throne, a luxurious padded chair which is designated only for the bishop . . . and, apparently, the cat! "He'll even climb to the pulpit and sit there as if he were ready to deliver a sermon," joked the dean. I asked what he thought Hodge would say if he *were* able to speak to the congregation. He paused for a moment and then responded: "I think he would say, 'You can find a home here.'"

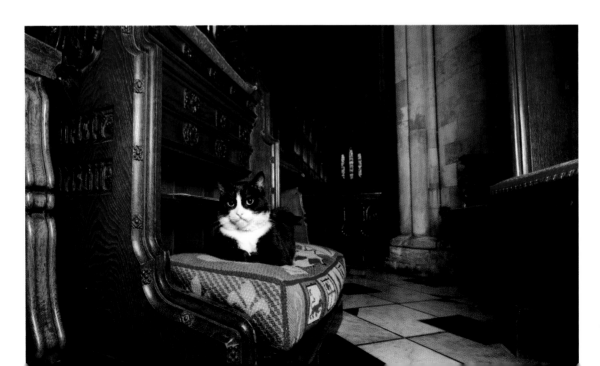

For Londoners looking to adopt, there is no shortage of wonderful organizations to visit. I'd long heard of England's impressive cat welfare standards, but nothing could have prepared me for what we saw when we visited Battersea Dogs & Cats Home, London's largest animal shelter.

The amenities at Battersea's cattery include a sterile yet enriching glass-fronted bedroom for every cat, complete with a staircase to a multilevel perch where cats can choose between a private dark area or a window seat. The organization places a great emphasis on freedom and choice for cats, and that ethos is reflected not only in its spacious accommodations but also in its adoption policies.

"For our younger cats, we do ask that they go to homes with outside access so they can show their natural behaviors," explained Bridie Williams, cattery team leader. "We see a lot of cats coming to us with behavioral problems like redirected aggression, destroying furniture, or soiling . . . People don't necessarily realize that the behavior they're showing is actually due to the frustration of being kept indoors. It's almost impossible for us to create in our homes the same enrichment of being outdoors. So then we look for homes with gardens, and they improve."

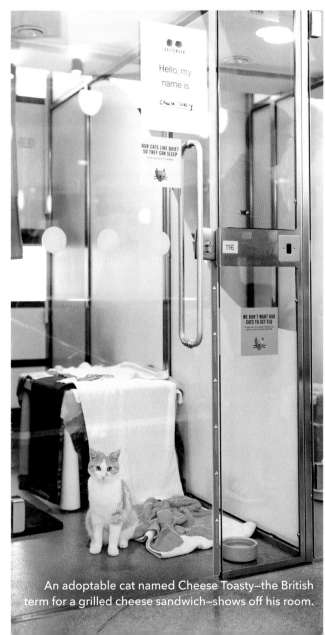

An adoptable cat named Cheese Toasty—the British term for a grilled cheese sandwich—shows off his room.

BATH

Winding through rich green limestone hills, we made our way to the historic city of Bath. The city, a UNESCO World Heritage site, is known for its ancient Roman bathhouse and its beautiful eighteenth-century Georgian architecture, and we took in the sights as we made our way to Bath Cats & Dogs Home, where more than a thousand animals find homes each year.

When we arrived at the open-admission shelter, the staff graciously showed us to a spacious outdoor area with a long stretch of catios, each housing an adoptable cat. Inside each screened enclosure, a small flap led to a private indoor room, but few cats were choosing to spend the beautiful day inside.

"This is such an impressive setup! But do you also have cats in cages, or—" I began to ask, to which all three staff members enthusiastically interrupted with a resounding "No!" as if the question itself were preposterous. None of them were familiar with any shelter in England that houses cats in cages, as this wouldn't meet the minimum shelter guidelines. What seemed normal to them seemed absolutely aspirational to me, and it was wonderful to know that somewhere in the world, these resources not only exist but are the standard.

Cat flaps allow for garden access.

Next we walked into the cat enrichment garden, a large enclosed outdoor area where volunteers can bring cats to play, much like taking a dog to a dog park. A young calico named Miepie was leaping over logs, rolling in the grass, and sniffing the feline-friendly herbs like thyme and St. John's wort, which were planted along the edges. With enthusiastic glee, she climbed up a huge, live tree and clung to a branch over my head, looking down at me with a sparkle in her eye. I could no longer help myself; my eyes welled with tears. I'd cried at shelters before, but this time, I was crying from overwhelming joy.

Indoor-outdoor enrichment is important to the organization, and they aim to provide the best of both worlds not only in their shelter but also in their adoptive homes. Charlotte Wotton, cat behavior assessor, takes great care to find homes that are right for each cat's individual needs and background. "If they're a handover cat, I'll meet them in their home for an intake appointment to get the full history, so that I know about their previous environment and how far they liked to roam. If a cat isn't road savvy, we don't place them in a busy area. We try to find that perfect match."

In the quiet countryside, a ragdoll cat named Nami found a tranquil haven thanks to Charlotte, who is a true expert in feline matchmaking. "In her old neighborhood, there were lots of cats, and she was bullied. Her IBD flared up because she was stressed there, so we found her a calmer space and she's much better now." The adopters invited us into the large garden behind their two-hundred-year-old cottage, where Nami likes to lounge in the sun and look at butterflies. This picturesque scene encapsulated the good life they aim to give the cats: the gentle breeze blowing through Nami's fur as she stood in a field of flowers, safe and loved.

KINGS LANGLEY

We concluded our trip in Kings Langley, where we sat along the Grand Union Canal watching cats frolicking in a flower field as narrow boats passed by. Owing to the lack of natural predators in the countryside, the cats coexist in relative peace with their wild neighbors, according to guardian Michelle. "We do have foxes here, but they've got a bit of respect for one another since they're similar in size. There are hedgehogs of course, but they just roll in a ball." She chuckled. "Sometimes they'll have a standoff with a swan, but the swans won't back off, so the cats are sensible enough to walk away."

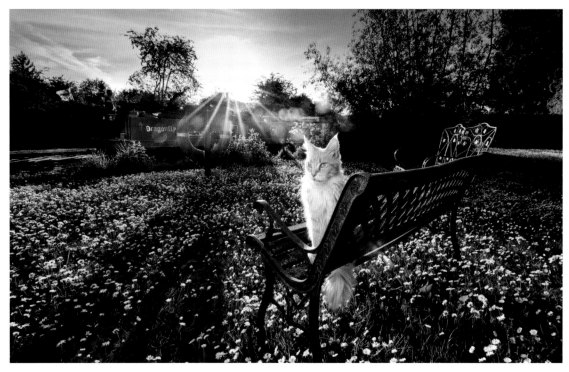

With such varied sights and smells to take in, these nature-loving cats were hardly interested in the feather toys we'd brought, and were much happier to watch a dragonfly or bat at a tall blade of grass. Why settle for manufactured wonders when you can have the real thing?

INTERLUDE

UNITED STATES

As we traveled, I found myself starting to look at my own country in a new way. I've worked in cat welfare in the United States for most of my adult life, and I'd simply assumed and accepted that what cats face here was the norm. With broader context, I began to ponder: What characterizes the American feline experience?

The US has arguably the most robust animal shelter system in the world, with more than 4,000 brick-and-mortar shelters. This can be a tremendous benefit, as there is always a place to bring an animal in need. But the ubiquity of these facilities makes it all too easy for healthy cats and kittens to be scooped from the street and placed in shelters, even if it means they are put to death by the hundreds of thousands every year due to a lack of capacity for care.

The American spirit is one of independence, often valuing the individual over the collective, and emphasizing private property over community space. It's no surprise that to find a kitten or cat in the yard elicits such strong feelings in our citizens; we're either concerned that they're lost and want someone to help them or irritated that they're on our lawn and want someone to take them away. I've come to find that we have an almost disempowering reliance on municipalities to resolve the inevitable fact that cats live in our communities—as they have for centuries and will continue to do.

"It's taken for granted that bringing an animal to the shelter is always the right answer," said animal sheltering expert Kristen Hassen. "In America we tend to have a higher comfort level with institutionalization in general; we have sort of asserted that not only is putting animals in cages the norm but it's the correct thing to do. I think those of us who love cats have to start asking ourselves why." I felt curious about this myself. How is it that in a country with massive resources and a strong love of animals, cats are at higher risk of euthanasia than almost anywhere in the world?

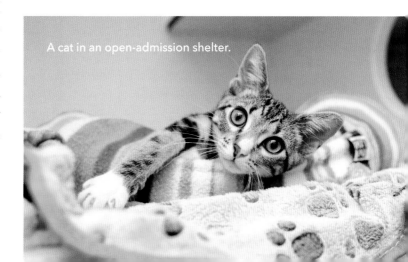

A cat in an open-admission shelter.

To understand the history, I spoke with Dr. Kate Hurley, director of the UC Davis Koret Shelter Medicine Program. "Our sheltering model originated with removing packs of dogs from the street who were considered a public safety threat. Animal sheltering emerged to say: 'If we're going to kill these dogs, let's at least try to find them homes first.' But this didn't apply to cats until we started perceiving them as indoor animals around the 1960s." In the mid-twentieth century, the invention of cat litter revolutionized where we keep our companion cats . . . and how we think about the cats we see outside. Suddenly, the American tolerance for community cats vanished; their existence was perceived as a pity to resolve or a nuisance to clean up. Dr. Hurley continued, "I think what we did that was so harmful was that we took a dog model and applied it to cats, and it cost tens of millions of lives." To this day, it's community cats and their kittens who comprise the vast majority of lives lost in US shelters.

Many Americans don't realize just how many kittens are born outdoors. Each spring and summer, hundreds of thousands are plucked from the street by caring people who don't know that the mother is likely nearby . . . or that most shelters aren't equipped to care for newborns on-site. Building resources to save these kittens has been my life's work, from creating educational Kitten Lady materials to funding lifesaving care through our nonprofit, Orphan Kitten Club. But it wasn't until I traveled internationally that people started to ask me a fundamental question: "Why are orphaned kittens such a big problem in the US, anyway?" It turns out that in much of the world, to see kittens outside doesn't automatically suggest that they have been cruelly abandoned and need to be brought to a service provider, so there just aren't as many motherless kittens. Instead, many cultures have greater literacy around the existence of community cats, and it's known that when those cats aren't sterilized, kittens are born.

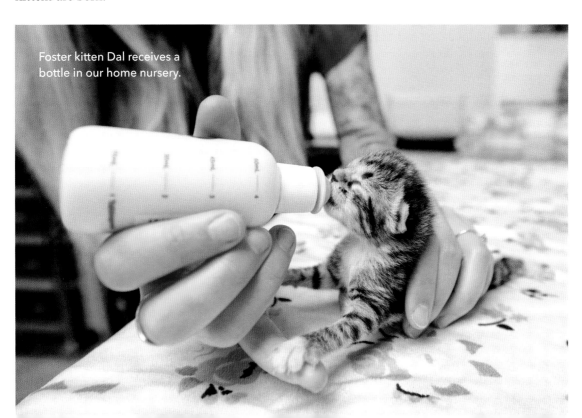

Foster kitten Dal receives a bottle in our home nursery.

It isn't lost on me that American culture—which can have a somewhat cynical lens—leads many of us to believe that it's actually a bad person out there sprinkling neighborhoods with discarded kittens and cats. But as we wipe this faulty notion away, we bring into focus a simple fact: we have shared our land with felines since the founding of our nation. If cats can be widely understood as part of our communities, then perhaps we can also recognize the profound influence we can each have in effecting positive change if we simply take compassionate action.

"Animal sheltering is changing. We're now empowering everyone to be a part of the solution, and showing how we can embody collective responsibility," said Kristen, who is an industry leader in reducing euthanasia. She's right. In the time since I became involved, I've witnessed an incredible shift toward programs that reduce the burden on shelters and encourage everyday people to play a role in meeting animals' needs, like home-to-home adoption, fostering, community cat sterilization, and colony care. As we realize the influence individuals wield, ordinary citizens become lifesaving superheroes!

So what characterizes the life of an American cat? It seems their lives are as variable as the human American experience itself: some churn through our institutions, some live comfortably, and a small number even become literal superstars. This dissonance has long fascinated me. On the one hand, we struggle to rally public consideration for the vast swaths of cats in shelters; on the other, our celebrity-obsessed society creates a pathway for individual cats to ascend as pop culture sensations.

"Now that cats are a cultural icon, all we have to do is bridge the gap between the love people feel for cats and saying: 'I want to help,'" said cat expert Jackson Galaxy. As feline fanfare buzzes, we have a truly unique opportunity to energize prospective advocates and bring them into the fold.

One small cat showed that celebrity can be used to champion a cause. Lil Bub, a humble kitten found in a toolshed in Indiana, grew to be one of the biggest feline superstars in American history. Despite being born with a rare condition called osteopetrosis, she became a Billboard-topping musical artist and even hosted her own talk show, interviewing such prestigious guests as First Lady Michelle Obama. "Her celebrity allowed for an important conversation about special-needs pets," said Stacy Bridavsky, director of nonprofit organization Lil BUB's Big FUND. "This was a cat people wouldn't normally see—because she

Lil Bub and her dude, Mike Bridavsky, pose for a selfie with a fan at a cat welfare convention. "People are inspired by her pure determination," he said.

would have been euthanized in a shelter—so she invited a dialogue about who we might be overlooking and how we can help them. She showed that all cats have intrinsic value."

Out from the surge of feline representation and awareness, a new community of cat lovers is finding each other. At New York City's first cat café, owner Christina Ha shared, "When we opened Meow Parlour I was so surprised that cat people weren't introverted after all . . . They just didn't have a place to be together." Now, cat cafés, cat welfare events, and social media serve as launching pads from which we can learn, grow, and collaborate to make the nation safer for cats. "It's about finally giving people the space to come together, and the power to know they can really make a difference. We plant the seed and see how it grows."

There's never been a more exciting moment to be a cat advocate in America, as we witness in real time the incredible strides we can make when we embrace our collective strength by participating in fostering, community cat care, and other volunteer programs that lighten the load for shelters. What was once a rigidly structured approach to cat management is now evolving into a spirit that aligns more closely with America's stated ideals of civic responsibility: ask not what your local shelter can do for you but what you can do for your local shelter.

As Andrew and I scanned our tickets and took off for more feline-focused adventures, I found myself eager to continue growing in my own knowledge . . . each stamp in our passports representing a wealth of new experiences and ideas to bring home.

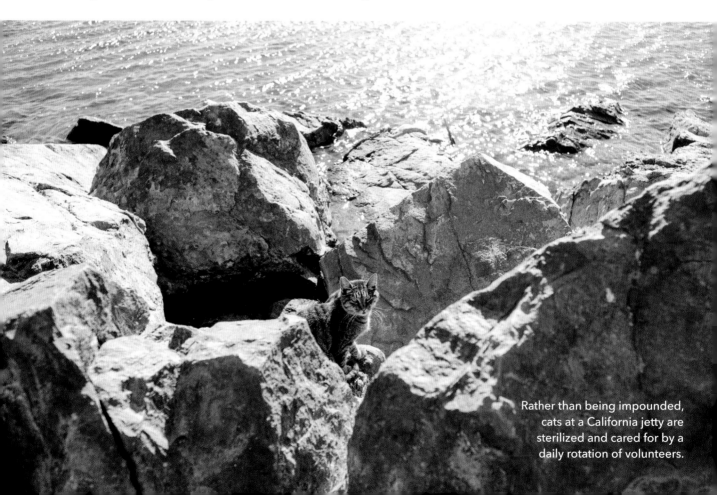

Rather than being impounded, cats at a California jetty are sterilized and cared for by a daily rotation of volunteers.

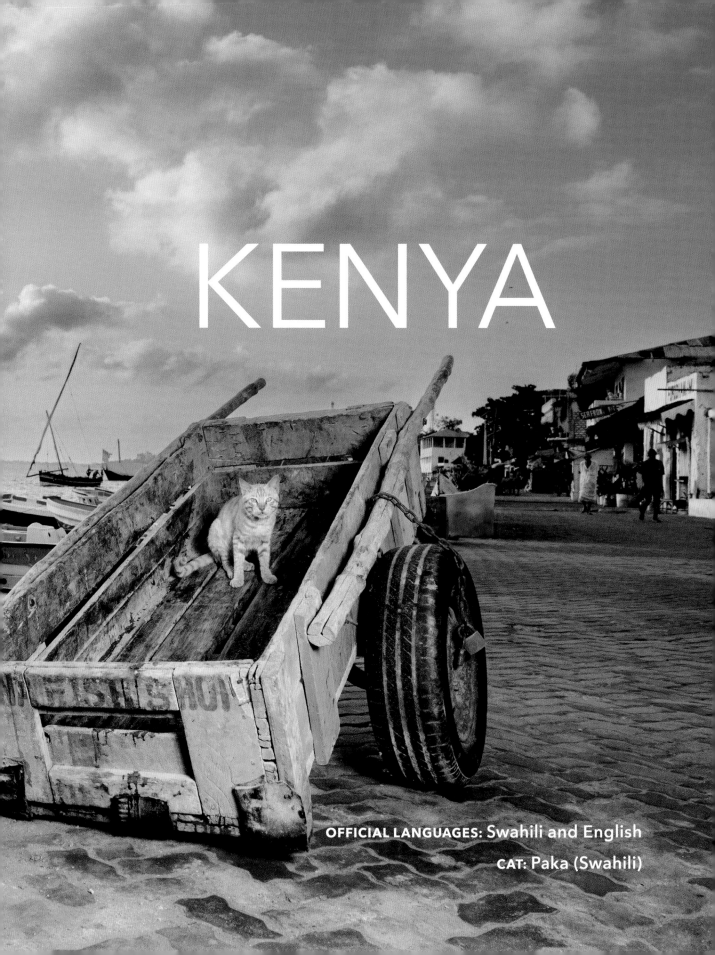

KENYA

OFFICIAL LANGUAGES: Swahili and English

CAT: Paka (Swahili)

NAIROBI

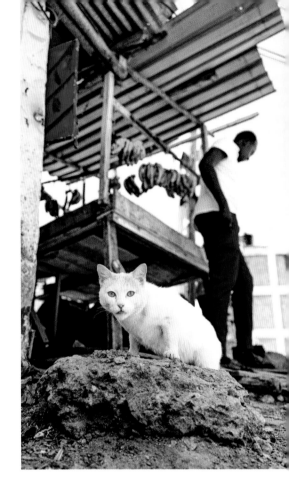

Beautiful, environmentally rich Nairobi is the only capital city on earth with a national park inside its borders. The proximity of the protected wilderness area, located less than five miles from the central business district, makes it possible to spend the morning watching wild giraffes, rhinoceroses, hippopotamus, impala, zebras, baboons, and even lions, and return to the urban center in time for a midday meeting. While the abundance of wildlife makes Nairobi one of the most special cities in the world, it also presents unique challenges concerning the welfare of community dogs and cats.

"Rabies is a big problem in all of Africa, but especially here in Nairobi because of the park. Monkeys can easily bite dogs and cats at night, so rabies prevention is essential," said Brenda Ambitho, whose organization, Strayville Animal Rescue, is tackling the issue. As we explored the Jamhuri neighborhood together during a walking vaccine clinic, a family of vervet monkeys watched overhead, swinging from balconies.

With a large group of volunteers, we searched for cats in need of preventive care at the many produce stands and open-air shops that lined the roads. "Most of the shop owners are Maasai, so they are really animal friendly," explained Brenda. The Maasai, one of the largest tribes in East Africa, are tradi-

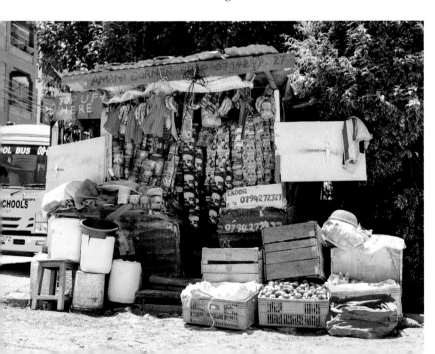

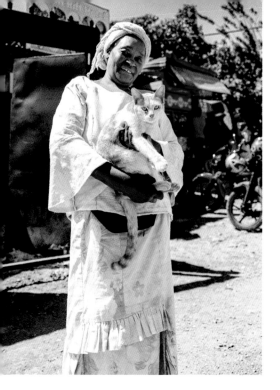

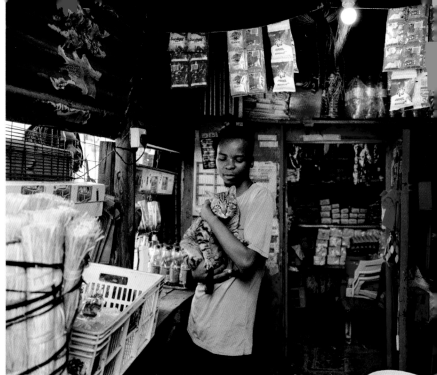

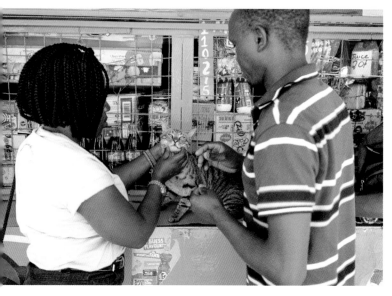

tionally nomadic pastoralists with a close connection to livestock and wildlife. "They are herders, but because they live in town and can't have large animals, they often have a love of small animals like cats."

At a brightly colored shop selling snacks and household necessities, a young Maasai man named Baraka introduced us to his cat, Michael. He placed the tame tabby on the counter as Brenda readied the vaccines with her veterinarian, Dr. Malakwen Rotich. "They love Michael here," she said as she held him for his injection. "Most of the cats in this area are neutered now, so if a new cat comes, the Maasais call me to come help."

While some advocates focus on prevention programs, one woman has transformed her house into a cat sanctuary—which she shares with over four hundred felines and a full staff of caregivers. "It started with one cat, Miu. She was so small I used to put her

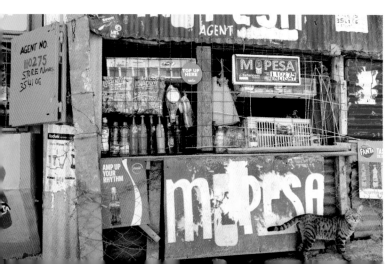

in my shirt! After her, any others I saw who needed help, I just helped. I had twenty-three in no time," said Rachel Kabue, the cofounder of Nairobi Feline Sanctuary, as we sat together in the spacious catio that hugs her home. "Now, it's starting to wear on me. It was okay until people started to find out, and now everyone wants to 'donate' a cat. 'Donate.' Can you believe it? My life has changed a lot," she sighed.

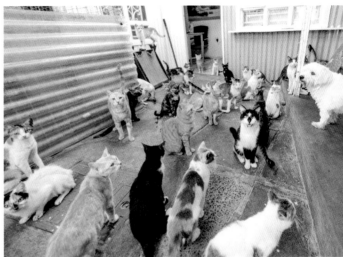

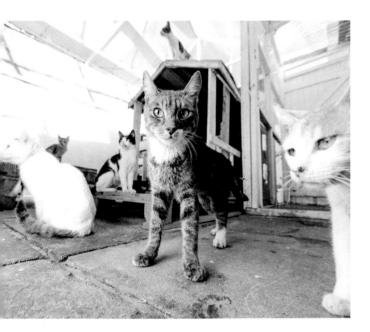

Across town, KSPCA has been a national leader in animal welfare for more than a century. At their Nairobi shelter, massive open-air enclosures offer roomy outdoor enrichment for the cats, whose coats are often stained from rolling in the red, iron-rich dirt. As we stepped inside, we were greeted by a symphony of happy meows. "They're friendly because they come here and see that this is paradise," said animal welfare officer Ian Kiringa. He laid out a meal of rice and minced meat and added, "If I can't eat it, it shouldn't be fed to a cat."

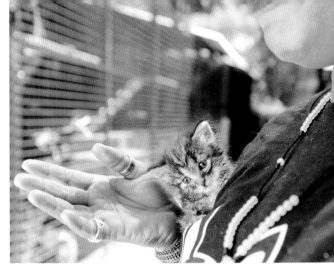

"This is my calling," said a KSPCA employee as she cradled three-week-old Mira in her arm.

Seated on a bench with a snaggle-toothed tabby in his lap, Ian shared, "Whether it's the animals, the environment, the humans, or even the wildlife, you cannot separate these things. It's the interrelation between the species and the environment that matters. Humans create trash that hurts nature. The cat eats the trash. The person sees the cat at the trash and throws the stone, which tells you the mental state of the people. These are not separate things; it's all one. Like One Health—but one welfare. It is connected."

With the rise of apartment living, cat adoption has become increasingly popular in Nairobi. "So many people are moving to apartments now, and if they want a companion, they get a cat. The problem is that when you move a lot, your cat can get lost in a new setting," explained Muthoni Gichobi, a local cat welfare educator. Muthoni teaches that cats should journey outside only if sterilized and be acclimated to the area very gradually, as she did with her cat Kina, who is trained to return home in time for dinner. "Personally, I moved to this apartment because there are trees. My cats love it—they come back a bit dirty, they find lizards. Before they lived in a concrete jungle, but now there is more for them to explore."

In a top-floor apartment, local photographer and book enthusiast Bill Muganda is creating beautiful art with his feline friends. I'd long admired Bill's photography project, Kenyan Library—a collection of comforting, warmly lit images inspired by the admiration of cats and literature. As he welcomed us into his stylish suite, the sound of piano came from the stereo as an orange cat named Atlas waltzed past a tall stack of books, illuminated by a sunbeam.

Over a comforting cup of Kenyan tea, we exchanged stories and book recommendations. "Isn't it amazing how cats can connect people who would otherwise never have met?" he asked, and we agreed wholeheartedly. "Getting my first cat was accidental. Ten years ago, I was cooking and my first cat just walked into my kitchen. Now I can't imagine a home without a cat; they help me with my mental wellness infinitely," Bill said. "They have honestly changed my life."

LAMU

The island of Lamu may be small, but its significance as a site of Swahili cultural heritage is profound. With well-preserved architecture, traditional customs, and breathtaking natural beauty, this community is celebrated as a living testament to the old Swahili way of life. A distinct facet of life in Lamu, both in the past and today, is people's unique relationship with cats.

The presence of cats in Lamu likely dates back to early seafarers, who traded along ancient routes and brought along furry hunters. Centuries later, families of felines still line the shore at high tide, eagerly awaiting their portion of the fishermen's catch. When the tide recedes, they bound onto the damp sand to forage and find respite in the long shadows cast by wooden boats.

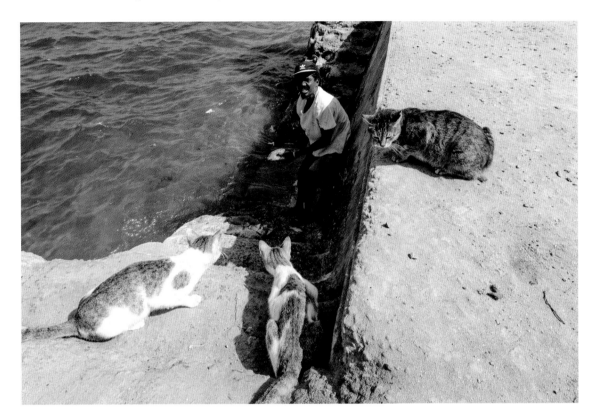

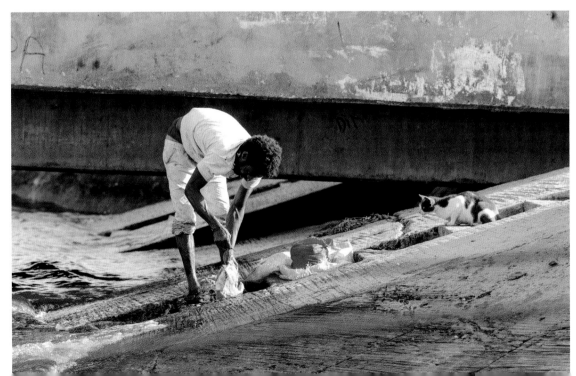

Having evolved on such a small landmass, many Lamu cats have unique characteristics. "Pure Lamu cats are lean, with long legs, small, bony heads, and large, pointy ears—these are the ones who descend from cats on sixteenth-century merchant ships from Egypt," said a knowledgeable fisherman as he tossed them small offerings. "Now a lot are fatter, because they have bred with Europeans."

There are no cars on the island of Lamu, and while much of it can be explored on foot, the primary modes of distant travel or transportation of

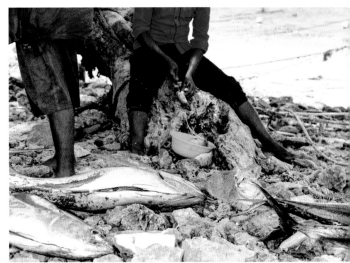

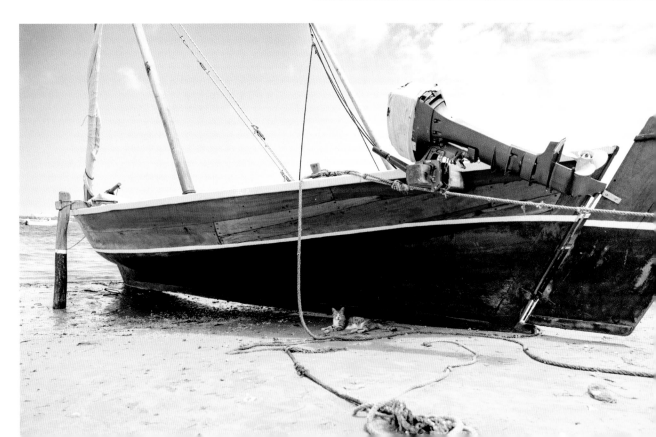

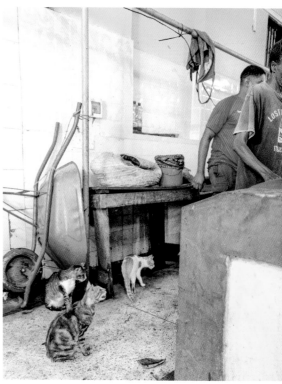

A Sokoke cat awaits a fish. The Sokoke is a natural breed that originated in coastal Kenya.

goods are boat or donkey. These small, docile equines can be spotted all over, trotting along the sunny shoreline and and sharing in the company of cats. "Every house has a donkey and a cat," a local explained. "The donkey is the transportation. The cat is the security!"

Since Lamu is a community of Islamic faith, many locals state that showing kindness to cats is a part of their religious expression. "When taking care of the animals, God will bring you something back which you don't know. God will give you a big blessing," said Sal, a local who we met buying fish at the central market. Outside the entrance, kittens nibbled on the offering. "If you know the cats, God knows you."

Wandering the narrow residential streets felt like a feline scavenger hunt as we searched for cats and admired the island's beautiful architecture. Nearly all homes are constructed of locally harvested coral stone, and many boast impressive entryways where cats like to lounge. At one entrance, we noticed a small colony congregating around a carved wooden door and stopped to say hello.

A man named Costa emerged and affectionately introduced each of the cats by name. "When we eat something, we give to them. They love fish, rice, chapatis . . ." he laughed. He gestured to the orange female in the doorway and shared that she was pregnant. "This one is the husband.

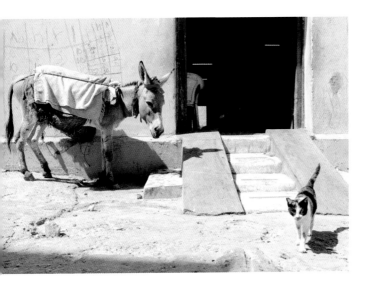

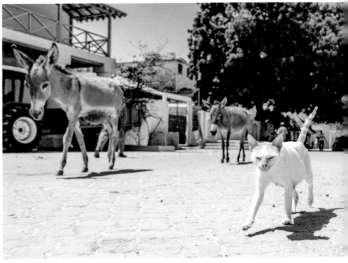

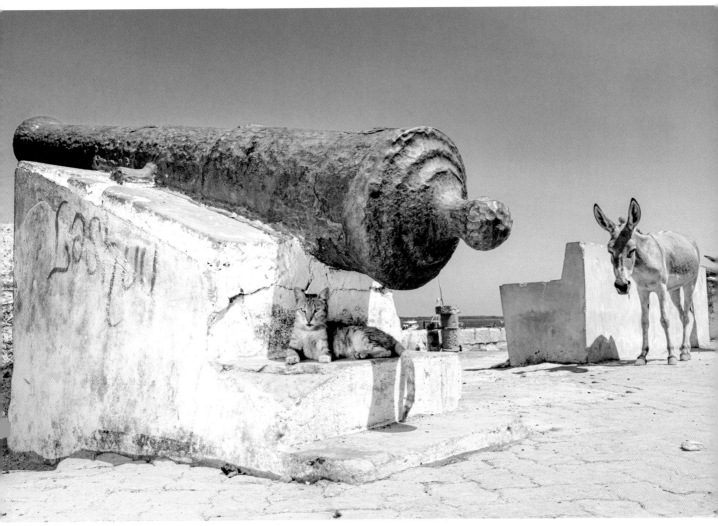

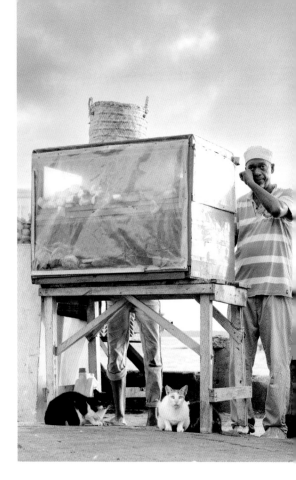

We just took him to be castrated. Better castrated, because they'll give us problems," he said as the neutered black cat reached up to him for pets.

With just one feline veterinarian, only a handful of humane traps, and no vehicles for transportation to the clinic, treating the booming population is a constant labor of love. But the small team at Lamu Animal Welfare Clinic doesn't let that stop them: each morning they roll a cart through the community to collect those who have yet to be neutered. Veterinary assistant Saidi Shukran has become an expert at catching cats with a gloved hand and placing them into a trap so that they can be rolled to the clinic for sterilization.

While most residents express gratitude for the services, the team sometimes encounters locals who don't understand what they're doing. Ouside of one home, an argument broke out between the trappers and a group of residents. "Don't take my cats! Release them!" a man cried out, visibly distressed to see the cats

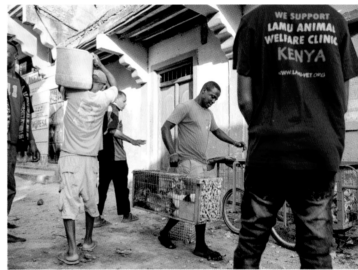

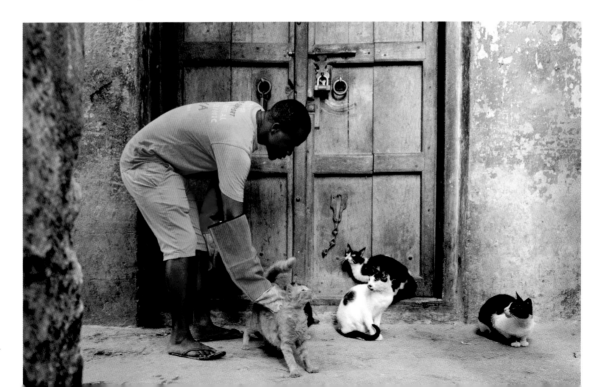

being captured. After a long conversation in Swahili, the man seemed to calm, and nodded his head in approval. "Okay, I understand. You take them so no jiggy-jiggy? Okay." Saidi placed the cats into the cart and continued down the road.

As we made our way back to the clinic with a group of adult cats and one little sickly kitten, Dr. Njema Maina told us how meaningful his veterinary work is to him. "My joy comes from seeing an animal that was weak or was not in the right state of health come back to the right state of health after treating it. I get big joy—I get a lot of happiness in seeing that."

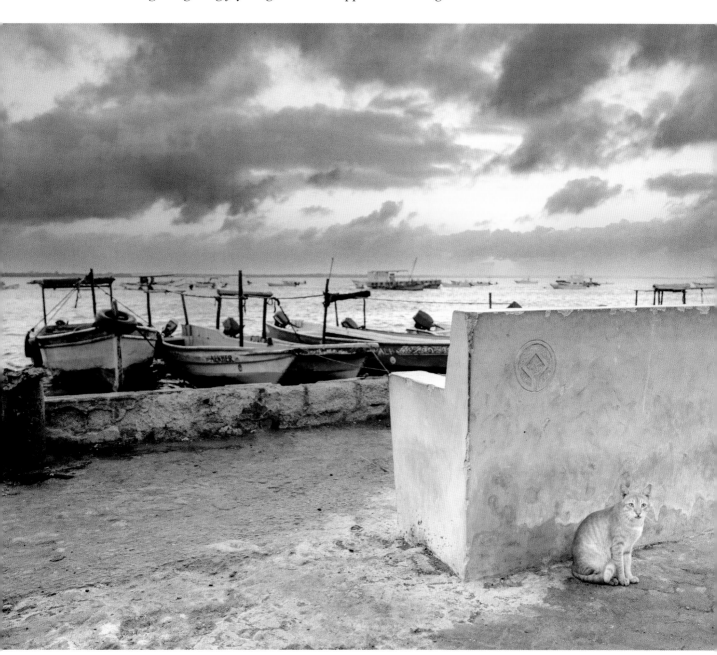

ARGENTINA

OFFICIAL LANGUAGE: Spanish

CAT: Gato

BUENOS AIRES

A picture may be worth a thousand words, but some stories are about that which you cannot see. In the gorgeous public parks of Buenos Aires, tales of overcrowded cat populations are now distant memories thanks to the determined work of local advocates. At the gates of a botanical garden in Palermo, we met with members of Hacé Feliz a un Gato (Make a Cat Happy) to discover how they've managed to reduce the numbers of community cats from hundreds to a mere handful.

"In the beginning we were counting three hundred cats or more in the park. It was madness," said founder Eugenia Pascal. "Every step you took there would be cats with mange, cats visibly in poor shape; you could hear them breathing from far away. I thought to myself, this is so embarrassing. As a people, it's shameful. So I showed up in 2008 with a bag of kibble and said: 'We've got to get organized.'"

Since then, she has operated the organization out of a closet-sized shed in Jardín Botánico Carlos Thays. With space for just two stacked kennels and a small amount of supplies, it may be the smallest animal shelter on earth—but they use it strategically, relying on foster parents to move cats out of the park and into homes.

Throughout the beautifully maintained garden, volunteers discreetly feed the few remaining feral cats. A skeptical tabby named Khalo, who they call "king of the bush," ate under the protective cover of greenery, while a stealthy cat named Lilith gingerly worked her way down from the top of a lavish greenhouse for her morning meal.

"Who's this?" I asked, noticing a cat who seemed uncharacteristically friendly. Eugenia looked closely and shook her head. She didn't recognize the cat.

"She's new," she said, disappointed. She greeted the cat, then lifted her into a carrier. With no city shelter that accepts cats from the public, the garden has become a de facto dumping site, and the organization is regularly finding and rehoming those who have been abandoned there. This new arrival was social and sweet, rubbing her face against the bars as she was placed into one of the temporary kennels so that she could begin her journey to adoption.

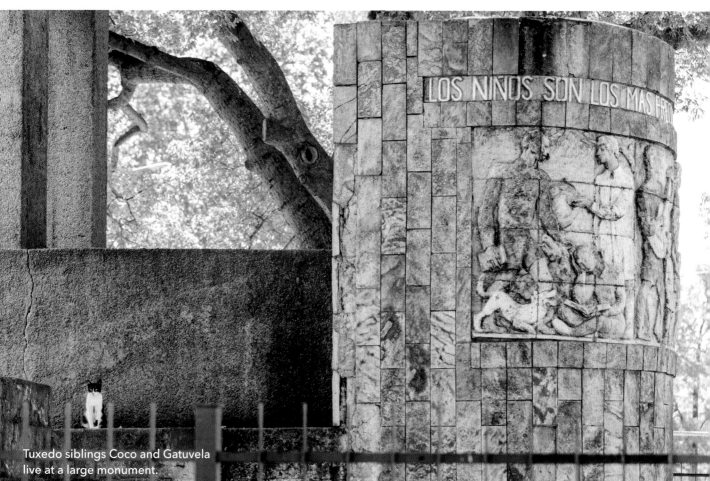

Tuxedo siblings Coco and Gatuvela
live at a large monument.

Walking past a tall monument, Eugenia paused and showed us a photograph from 2008 in the same spot with close to fifty cats in the frame. She looked past the image and smiled at the nearly empty space proudly. "We just have to keep going."

A trip to Buenos Aires isn't complete without visiting Recoleta Cemetery. Celebrated for its detailed architectural tributes to some of Argentina's most notable figures, like Eva Perón, the grounds were also home to a large family of cats for nearly two decades. But in recent history, thanks to sterilization and adoption programs, the population has plummeted—leaving just one cat to reign over the cemetery grounds.

Armed with cameras and water bottles, we spent a very hot day strolling the labyrinth of graves in search of Alfredo, eventually finding him peacefully napping on the cool tile in the security office. "He sleeps here during the day," a guard told us. After his siesta, he escorted us on an afternoon stroll past solemn statues and marble mausoleums, a guardian over the resting souls and the long line of cats who preceded him.

OFFICIAL LANGUAGE: Arabic

CAT: قطة / Qittah

UNITED
ARAB
EMIRATES

DUBAI

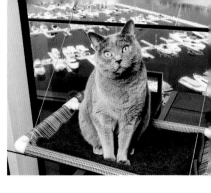

Driving into Dubai, our jaws dropped as we craned our necks to take in the impressive sight of the city's modern, glistening skyscrapers. Known for being both a populous business center and a popular site for luxury

travel, Dubai is a marvel of a city with opulent offerings, world-class infrastructure, and a wonderfully multicultural blend of residents and visitors from all over the world. Dubai's indoor cats enjoy lavish amenities, looking down over man-made canals and luscious palm trees from their high-rise accommodations. But the cats who find themselves astray, and those who care for them, must navigate the uniquely challenging conditions of life in the City of Gold.

Along the coast, the deep blue Persian Gulf meets a long stretch of white sand and a miles-long walking path where cats can be seen basking in the sun as joggers pass by. How these cats came to live there is any-

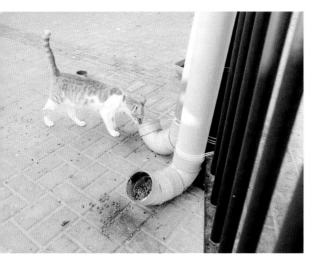

one's guess: some say that developers brought them there intentionally for rodent abatement, some say that they are abandoned former pets, and most agree it's a combination of both. But what is certain is that—like the skyscrapers themselves—the presence of these wandering cats is a relatively new phenomenon for a city that was, fifty years ago, mostly an uninhabited desert.

Along the beach, incognito PVC-pipe feeding stations serve the local felines. "Feeding outdoor cats is illegal here," said a resident. "But you still see people doing it . . . very discreetly."

The rapid development of Dubai has brought immense change to the area, and over the course of half a century, the human population has grown by more than thirty-five times. It's no wonder that cats can be found congregating around the city's high-end restaurants and sprawling souqs; feline populations inevitably thrive in symbiotic partnership with human settlement.

Watch closely and you'll find signs of kindness: from the Gold Souk vendors who leave out water dishes to the workers who share their fish, compassion is an

inevitability of human proximity, too. "We pull the fish out of the water with a net," said a dock-worker at a seaside souq. "And we share with the cats and their ba-bies. Very tasty."

But in a city that prides itself on being a pristine paradise, the pres-ence of cats can cause reputational dissonance for businesses and gov-ernment. "Perception is everything here," said one local rescuer. "There are the sparkles and glamour, and

then there's the reality." The reality, according to numerous cat advocates, is that without any government resources for animals, pest control is regularly contracted to remove the cats.

"Pest control employees are human, need to keep their jobs, and the ones we've dealt with feel bad. They don't want the blood of these cats on their hands," she continued. "So relocation happens quite often to remote areas. In wealthy areas, the perception has to be perfect; in remote areas . . . no one complains."

Out of view of the posh malls and grand towers, many cats have been relocated to the vast labor camps that provide basic housing for migrant workers. "Once you see it once, you see it a hundred times. If they see a cat in an area with money, the cat will be gone that day. That's Dubai," said a man from Uganda who lives in the labor camp and spends his evenings caring for the area's hundreds of cats. "They bring them here, where I am the only one helping," he sighed. "I am doing as much as I can."

Across town, a man who was born and raised in Dubai is welcoming a revolving door of sixty to seventy foster cats into his breathtaking arabesque villa. A gorgeous arch set over large white columns lines the doorway where lucky cats lounge, and inside there is ample space to accommodate dozens of cats at a time. "We knew when we moved from an apartment to a home that it would become a zoo," laughed the rescuer, who saves street cats with his wife. "Now it's time that's our biggest enemy, not space."

Standing in his kitchen, he shared the disillusionment he and other cat rescuers face in the city. "Everything in Dubai is about being flashy. I get pinged by a lot of men looking for a fluffy cat to gift to their girlfriend, for instance. I will send them photos of the most basic Arabian Maus just to see what they say, and they never write back." He laughed ruefully. "We have to be this way, because people will abandon them later. It breaks my heart."

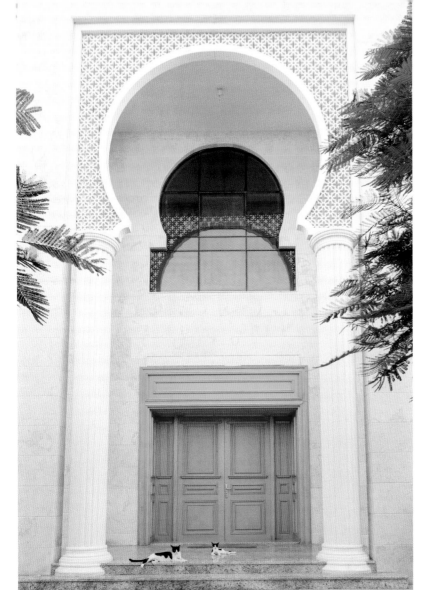

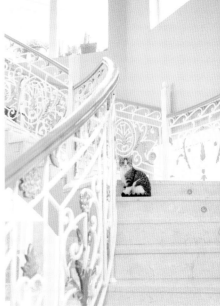

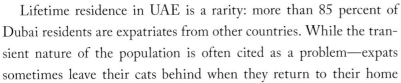

Lifetime residence in UAE is a rarity: more than 85 percent of Dubai residents are expatriates from other countries. While the transient nature of the population is often cited as a problem—expats sometimes leave their cats behind when they return to their home countries—the diversity of the community also presents wonderful opportunities to share resources and build camaraderie. "Maybe we take different paths, but we share the same goal," said an expat from the US during a dinner party where animal rescuers from Egypt, Lebanon, Romania, Uganda, Italy, Canada, Australia, England, the US, and UAE gathered to connect over their experiences. "The diversity of this country will really open your eyes. It's a beautiful thing."

One group of expats is proving that harmony with stray animals can be achieved—even in a luxury development. The women have formed a coalition under the name Petooti Cats and are finding as many adopters as possible for cats around the area; for the cats who can't find homes,

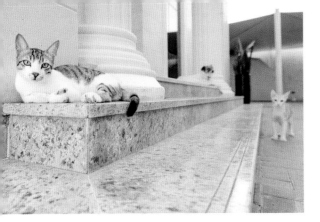

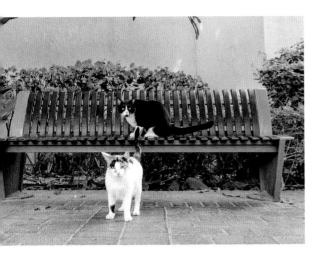

they visit to provide daily care. "I bring him a toy to play with every day because he is such a hunter," said an Italian expat as she teased a black cat with a feather wand.

With few adopters and so many cats, finding homes for all of them is not possible. "I wish we could find them a home together," said an American expat of Kali and Zorro, a pair of felines who can always be found at their favorite bench. "Zorro is her husband," she laughed. Although the feline duo haven't found a home, theirs is a rare case of cats being permitted in a high-end area; with lots of convincing, the local developers and business owners have accepted the cats' presence as long as they are cared for.

"This is a nice area with restaurants and businesses—cats can't be having babies or looking sick, because people will complain," said an expat from Australia on why their group has been so successful: by going above and beyond to keep cats healthy and loved. "But there are catch-22s; because they are friendly and cared for, sometimes it gives the impression that this is a sanctuary. So that's why our work is never done here. There will always be more cats arriving."

The future of the city's policies for cats is unwritten, but one local rescuer expressed her hope that the community will embrace the guiding principles of Islam as a guidepost for its treatment of cats. "If you follow the Islamic teachings of the Prophet Muhammad, we should treat any living beings with kindness. Prophet Muhammad says: 'A good deed done to an animal is like a good deed done to a human being, while an act of cruelty to an animal is as bad as cruelty to a human being.' My parents taught me that on the day of judgment, animals would be present, and they will speak to say: 'This person was unkind,' or 'This person fed me when I was hungry.' We will be judged by how we treated others."

TÜRKIYE

OFFICIAL LANGUAGE: Turkish

CAT: Kedi

ISTANBUL

There may be no place on earth with more cats—and more cat lovers—than Istanbul. Strolling the streets, we were astounded by not only the prevalence of felines but also how they seemed to be embraced as citizens. From the ubiquity of food and water dishes placed thoughtfully along the streets to the heartwarming interactions we witnessed, kindness toward cats seemed to be human nature in this historic city that spans two continents.

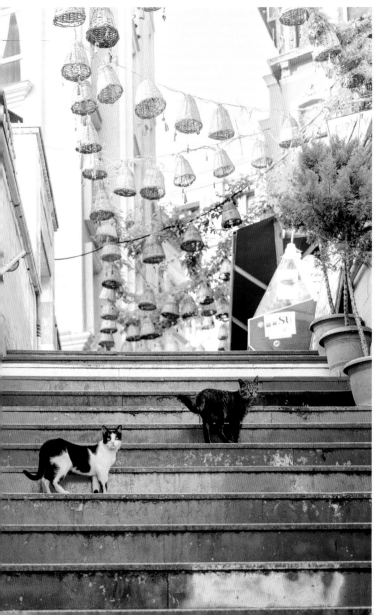

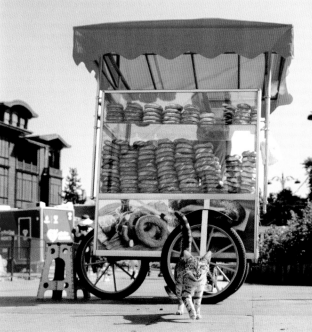

In the Spice Bazaar, we encountered a senior calico living in a shop that sells floral teas, jars of saffron, and vibrant rolls of Turkish delight. "Everyone loves her. She had a tumor, and we collected money from all the shops so we could do the surgery," said Deniz, an employee. "We call her the Turkish Garfield because she is a little fat," he laughed as his coworker offered a back massage to their esteemed feline colleague.

Outside a Karakoy café, a sweet tabby strutted under a canopy of grape leaves. "Her name is Bonjour!" the business owner volunteered, waving us into the back to meet the babies she was raising in a storage area. He scooped a can of cat food onto the interior floor, proudly demonstrating his love for the feline family.

At the entrance to a government building, a plump black-and-white cat blocked a woman's path . . . but rather than step over, she knelt beside the grooming feline and humorously bargained with her in Turkish, eliciting laughter from other pedestrians.

Along the Bosphorus Strait, a cat waited patiently as a fisherman cast his line in the waterway where Asia and Europe converge. Every fourth or fifth catch was offered up to her, and she gratefully nibbled on intercontinental fish until she'd had her fill. The sharing of seafood seemed customary everywhere we went, even in the markets.

Cats live in Galata Tower gift shops and in the garden of the Archaeological Museum.

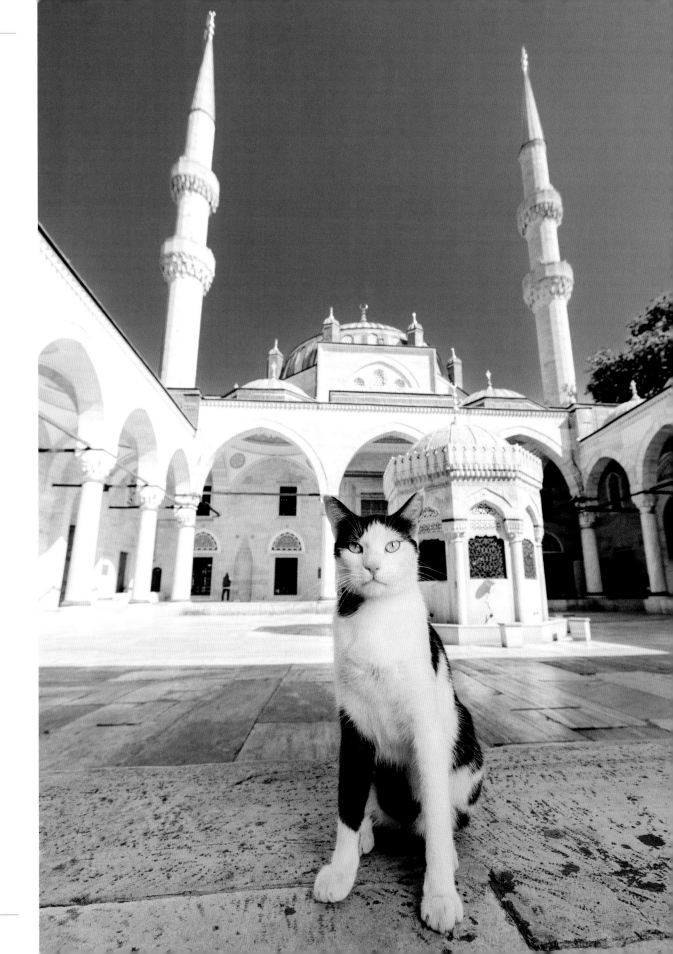

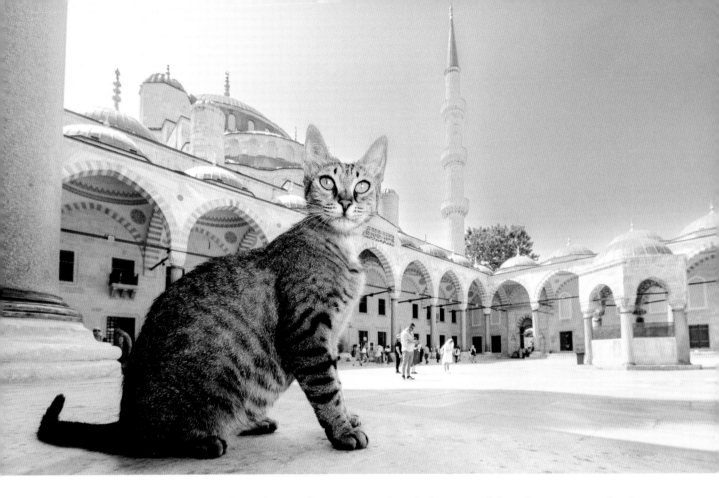

There are more than three thousand mosques in Istanbul, many of them home to cats. In the sahn, the formal courtyard, cats lounge in the shade and drink from the public fountains where locals perform wudu, a purification practice that involves cleansing the body before prayer.

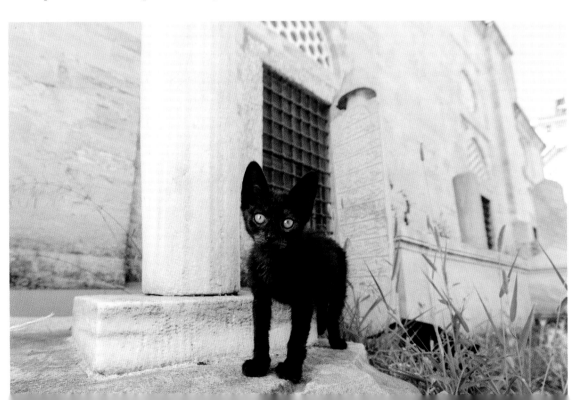

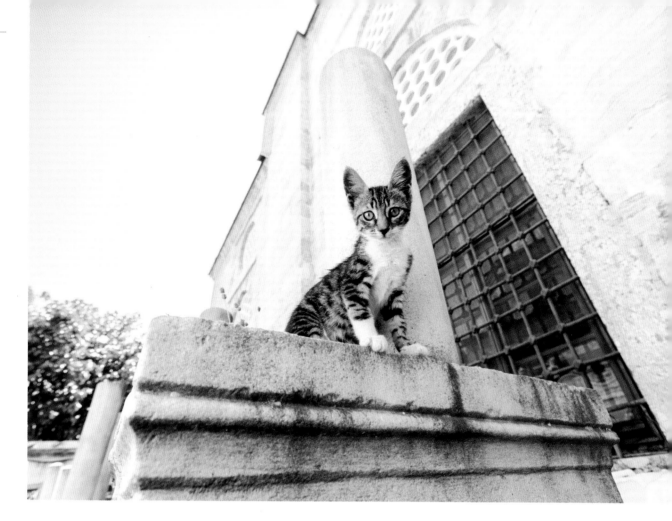

At Mihrimah Sultan Mosque, maintenance worker Hayriyre Arslan has taken to rescuing kittens in the historic sixteenth-century mosque's cemetery. "It's safer for them here," she explained of the dozen babies she is raising behind a locked gate until they're big enough to roam freely.

In their private sanctuary, the little ones bounded in the tall grass and played hide-and-seek behind the gravestones, energized by the food Hayriyre generously provides. "If I need three meals for myself, I eat two so that they can have the other," she told us. Behind a stack of prayer mats, a mama cat nursed her newborn kittens. This lovely outdoor shelter may be the only kitten nursery on earth located at a place of worship!

Outside Ayasofya, also known as Hagia Sophia, visitors gather to marvel at the Byzantine-era masterpiece as families of felines leap around the ancient stone pathways of its expansive courtyards. It's impossible to step into the hallowed halls of this architectural wonder without being greeted by welcoming meows.

Deep within the awe-inspiring interior, an enormous dome soars overhead. Intricate mosaics depict religious figures while chandeliers dazzle with ethereal grandeur, and many tourists are eager to photograph the most exquisite feature of all: Pakize, the resident cat.

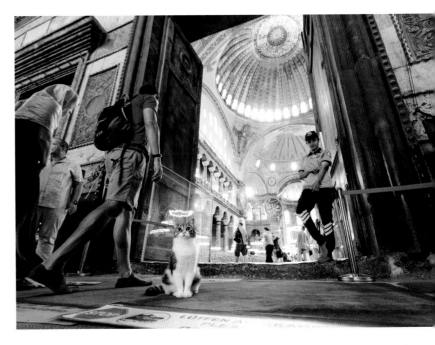

"Pakize loves visitors very much. She is a complete host," said Ayasofya employee Birsen Özdemir. The outgoing young cat greeted guests in the doorway, galloped across the carpets, and graciously accepted adoration wherever it was offered. "She will not get off tourists' laps, and always stands in front of their cameras!"

Pakize, originally a street cat, wasn't adopted intentionally. One day, she simply marched inside the historic landmark and made it her home. Now the unlikely resident enjoys more than 7,000 square meters (approximately 75,000 square feet) of living space and as much human affection as she could ever want. "Pakize's love of Ayasofya is strong," Birsen said as she fed the lucky tabby.

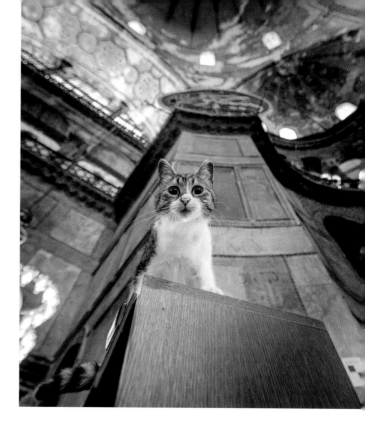

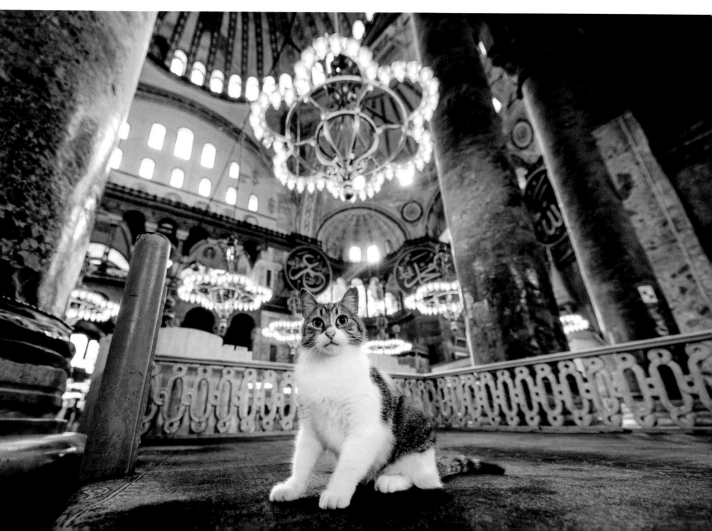

While there are countless happy stories from around Istanbul, local rescuers caution not to depict the city as a paradise for cats. "Cat people in other countries think it's heaven, but that's only half of the story," said Sarper Duman, a professional pianist who rescues sick and injured cats from the street. "Everywhere you will see people feeding cats, but rarely will you see people taking them to the vet. For Turkish economy, it's not easy. Even if someone loves animals, if they don't have financial power, they can't help."

The struggle of sickly felines couldn't have been clearer; in our short time there, we encountered multiple cats who needed medical intervention. In a construction area, Sarper and I worked to catch a cat in need of emergency surgery and a partially blind kitten who needed treatment. A local woman cried in gratitude; she had wanted to help them for weeks but couldn't afford the care.

Sarper hasn't always had the means to help. "One day I was walking home and I heard a cat screaming from a trash bag. I took this cat with me and we made operation, although this was very hard for me financially," he said, recalling that he sold some of his possessions in order to help the brown tabby, who he adopted. "Finally he healed. One day my piano student asked me to make a video of a song, and Pianist Cat came to sit on the keys while I played. It was cute, so I thought maybe I'll share it . . . and suddenly everything changed."

Sarper's video went viral. Before he knew it, a global audience of millions watched along, eager for more music videos with his cats—and to hire him for piano lessons! Sharing the story of his unexpected success, Sarper performed a song on the keyboard while Pianist Cat gently licked his face. "He is my beloved child. I like him so much."

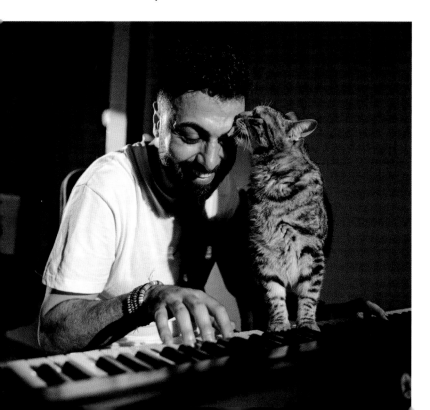

Thanks to the support of his global online community, Sarper is able to share both the beauty and the struggle of Istanbul's cats and to procure funds that have enabled him to save hundreds of felines with medical needs. "My cat gave me this chance, so I want to give a chance to all cats," he said. "What's the difference between my cat and cats on the street? All of them have special feelings. All of them deserve the best life."

"I don't like to think there's not hope. There is always hope," said Sarper.

İZMIR

One of the Mediterranean's most well-preserved archaeological sites is Ephesus, an ancient city that was once a hub of culture and trade. Now, the captivating ruins serve as both a historical site and a boundless playground for the few dozen ear-tipped cats who call it their home.

"The cats of Ephesus are very famous," said a tour guide. Tiered, semicircular theaters once used for dramatic performances are now venues for charismatic cats to strut onstage, inspiring cheers of admiration from tourists. At the Library of Celsus, a grand facade with towering columns served as a stunning backdrop for tabbies lounging on carved stones.

A short drive away, modern life goes on at a sanctuary offering protection to animals of all species—from

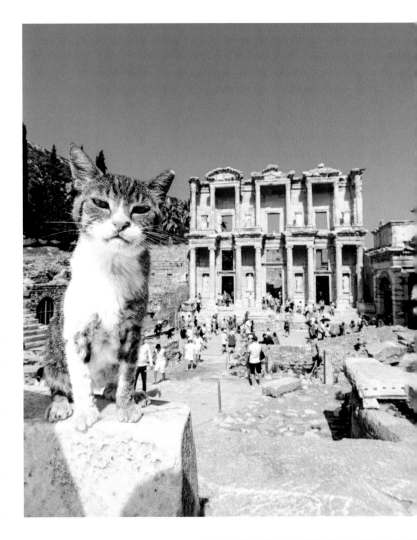

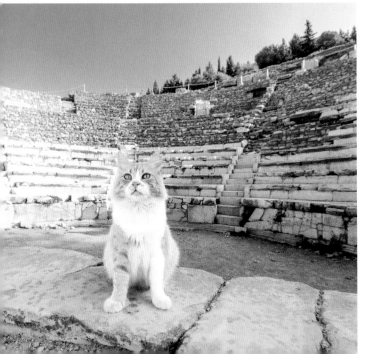

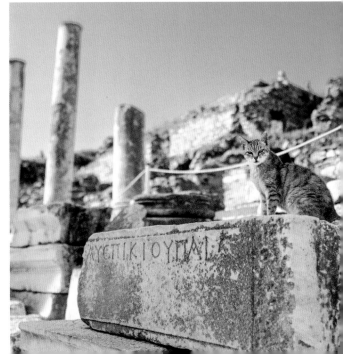

donkeys and cows to cats and dogs. "We do our best to save those who no one sees, who no one wants," said Figen Akgül of Angels Farm Sanctuary, where hundreds of cats saved from earthquakes, fires, and cruelty now live in peace.

A white-and-brown tabby, Halime, brushed against the leg of a rescued camel named Güllü, who returned the affection with a gentle sniff. "All the cats are friends with the other animals," said Figen, who hopes their farm will inspire others to see the value in all living beings. "I think the friendship between animals should be an example for others."

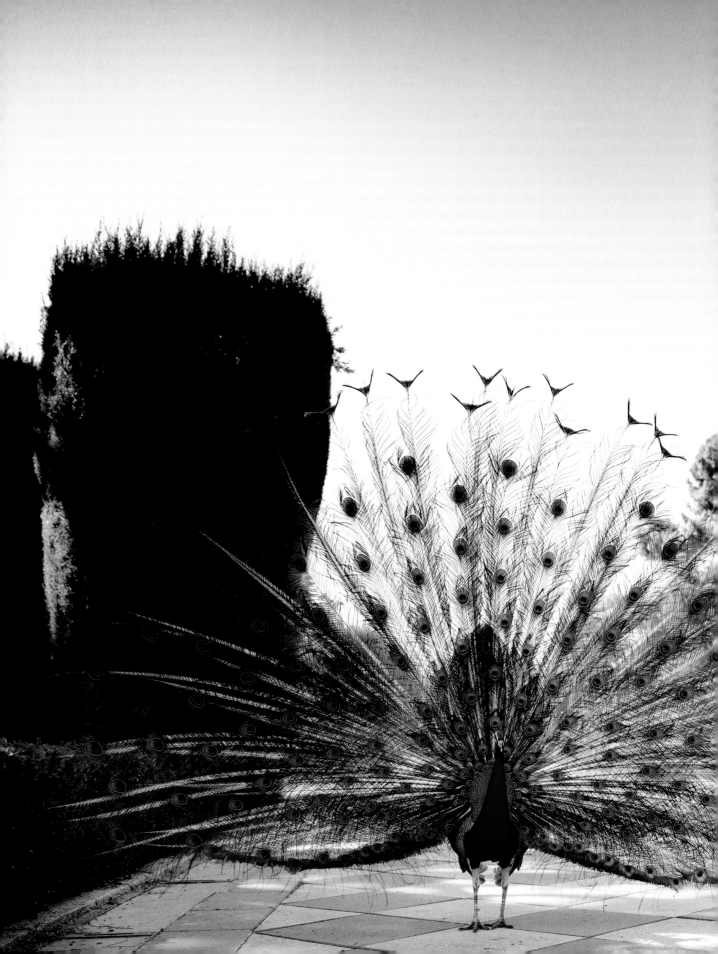

SPAIN

OFFICIAL LANGUAGE: Spanish

CAT: Gato

MADRID

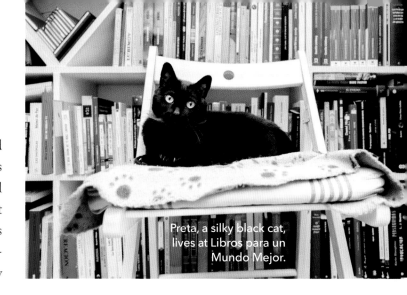

"Why do they call people from Madrid 'gatos'?" We asked many people this question during our stay in the beautiful capital city of Spain and were usually met with laughter and a long pause; while it's true that people native to Madrid are referred to as "gatos," few people actually know why.

Preta, a silky black cat, lives at Libros para un Mundo Mejor.

"Maybe it's because we are sassy," laughed one person. "We're independent, and like to go out at night," guessed another. "It's probably because we enjoy a nice siesta," joked a third. But one local knew the correct answer: "In the Middle Ages, a soldier from Madrid climbed a wall to claim the city, and they said he looked like a gato." Legend has it that the eleventh-century king of Castile gave the name "gato" to Madrid's citizens from that day forward.

The most populous city in Spain, Madrid has gorgeous historical buildings, exceptional museums, and thriving nightlife. But if you're looking for a peaceful oasis away from the hustle and bustle, look no further than Parque del Buen Retiro, a breathtaking park that is home to more than fifteen thousand trees, countless brightly colored peacocks, and a few dozen well-loved cats. As we strolled the checkerboard walkways surrounded by manicured bushes and birds rattling their iridescent feathers, I felt as if I'd fallen down the rabbit hole into a magical wonderland.

Behind an ornate metal gate is a large stretch of greenhouses where cats can be found living among the brightly budding flowers grown inside. "The greenhouse is the best place for them, because it's like the tropics in there. It's a nice place to stay warm," said a volunteer.

The park is an animal lover's dream by design; while it was once overrun by over 450 felines, it is now a happy haven for far fewer thanks to the volunteer efforts of Asociación de Amigos de los Gatos del Retiro. With strong animal protection laws, government-funded spay/neuter services, and compassionate citizens who are given a special identification card that allows them to work with the cats, it's clear that this public-private partnership is functioning to the advantage of all.

A new countrywide law even recognizes cats and dogs as members of the family. "It used to be that if two people broke up, they would split who gets the microwave, who gets the couch, and who gets the cat—the cat was considered an object," said local cat advocate David San Martín. "Now, a cat is like a kid. You either agree to share time with them, or you talk to a lawyer."

While strong laws lay the foundation, it's everyday citizens whose hands are doing the work of helping cats, and David says occasionally he even has to go beyond the law to help a feline in need. "Recently, a man had a kitten in his engine and he wouldn't give me access. So I broke the glass and entered to get the kitten. Now I have to pay a fine, but at least the kitten is saved!" Later that day, he got a plea to help another kitten stuck in an engine, and together we drove with his volunteers to the site of the car.

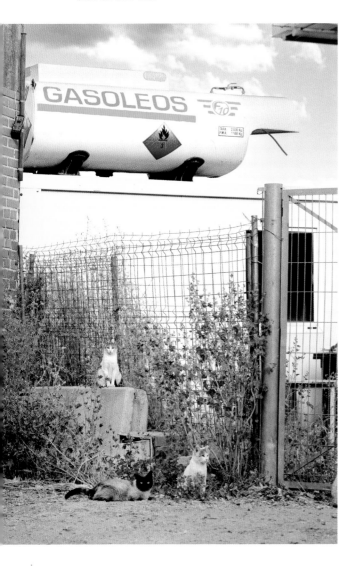

Loud cries from under the hood of the parked vehicle indicated that a kitten was distressed. The volunteers quickly wrapped the car in a large net—a strategy they've discovered after frequently being called for these types of emergencies. After much coaxing, the kitten escaped the engine and ran into the net. "Es una niña!" smiled volunteer Loreto, announcing that the kitten was female before placing her in a carrier and sending her off to a foster home.

Madrid has a variety of organizations dedicated to helping cats, and collaboration between

Madrid's free sterilization services enable volunteers to help colonies around the city.

"Cats remember you helped them," said Eva.

them is key. At La Gatoteca, a bright and modern cat café, shelter cats are given a spotlight to attract potential adopters. "I have a feeling of greatness when we go to the pound and they are so scared, and they hate you—and now look at them. They are social, loving, and playing," said owner Eva Aznar, whose optimistic outlook keeps her pushing ahead. "We have five million humans in Madrid, so I hope we will never run out of homes."

For the cats of Madrid, the future is bright thanks to the hardworking community of human "gatos" who are advocating for them. "What I want people to see is that you don't have to wait for a big organization to help you," said Veronica, a local woman who is sterilizing and caring for the cats in her neighborhood. "You can do little things, just as neighbors, to make a difference."

At La Asociación para la Liberación y el Bienestar Animal, cats promote sterilization and show off their ear notches, called "muescas."

NATIONAL LANGUAGE: English

CAT: Cat

AUSTRALIA

MELBOURNE

Australia is a richly biodiverse country with a large number of unique endemic species; millions of years of evolution in an isolated environment led to a distinct indigenous wildlife population. But in the late eighteenth century, British colonization introduced a host of threats to wild animals, including habitat loss, hunting, and non-native species. Cats, who were first brought over less than 250 years ago, are now the subject of a hotly debated issue among animal lovers: how to handle the roughly six million who now call Australia their home.

We met with Amber Nadinic, a dedicated caregiver to orphaned baby animals like kangaroos, wombats, possums, and yes—even kittens! "I've had umpteen cats, but they are all kept inside," she said. "It's our responsibility to manage cats. But we should be capturing and sterilizing, not poisoning. The poison is horrible, and impacts the wombats, the kangaroos . . . everyone. The biggest misconception is that cats are the greatest threat to wildlife, when it's people who cause the problems."

In an effort to protect wild animals, the Australian government outlawed trap-neuter-return (TNR). But from Amber's perspective, this policy is only increasing the number of kittens being born outdoors. "I'm getting requests left, right, and center to help kittens found in the suburbs. You would hope over time things would be getting better, but at the end of the day, if we don't TNR it's not going to end." As the little kittens bounded around her living room, I asked her how many were currently in her care, and she joked, "I prefer not to count!"

Workers at a local city shelter expressed a similar sentiment. "We have more cats coming in than we can find homes for. Just today, we had twenty cats coming in from councils . . . from people who just call to report a cat in their neighborhood. The majority are healthy and don't need intervention, but here they are," sighed a shelter employee who wished to remain anonymous. "The big thought is that if you let cats roam, they'll harm wildlife. But they are already roaming, and if you don't prevent them from breeding, there are just . . . more of them."

"The fact that there are native wild animals living out in the bush is unfortunately used as an excuse for killing thousands of cats in densely populated areas where there are no threatened species," said Nell Thompson, an animal management consultant who works with shelters throughout Australia in an effort to decrease euthanasia. "There are very big populations of semi-owned urban strays impacted by these laws."

For the wandering cats of Australia, it's all about circumstance. We met with a shy orange cat named Bob who lives in a lush suburb of Melbourne, where he was fortunate to find care. "Bob found his way here. He was very skinny, so he must have been roaming awhile. Poor thing, you can't let him starve! Well, if you're going to stay here . . . then let's grab a tray and you can eat," said Bob's caregiver, who refused to report him to the council and instead opted to sterilize him. "It's expensive to desex, but oh well. I don't want a hundred little cats here."

Down the way, we encountered a private airfield where Fergus, a fancy fluff ball, roams freely. Fergus's long fur blew in the wind as he posed in front of a small airplane hangar like a supermodel. "We need more barn homes like this," Nell said. "If we're going to trap all these cats, we need some solution for them other than death. So many workplaces can have a cat, just like this."

By law, all cats in Australia must be microchipped and registered, whether they live indoors or roam the neighborhood. "If a cat is outside and they aren't chipped or registered, then they will go to the shelter," explained Karen, a hairstylist whose cat, $prinkles, joins her at the salon each day. "He earned the dollar sign in his name because he's cost me thousands in vet bills," Karen laughed. "He's microchipped, but he stays fully inside. He's our feather duster."

With such large numbers of cats entering shelters, it's critical to increase adoptions, and that's exactly the aim of PetRescue, a national charity connecting adopters with animals in need throughout Australia. In her suburban home, we met with PetRescue's CEO Vix Davy, a strategist with a knack for finding solutions to big problems. She shared that the majority of cats in Australia are born to urban strays, not pet cats—but that current policy makes it impossible to sterilize these prolific populations.

But despite the tension around free-roaming felines in Australia, Vix is a firm advocate for outdoor enrichment for her cats. A clear glass cat door in her window is unlocked during daylight hours, and her cats are trained to return when a device on their collar beeps to signal that dinner is waiting. "It's very popular to let cats out during the day. This is a more traditional neighborhood, and people here wouldn't dream of keeping their cats inside," said Vix. Most cities in Victoria have cat curfews, which aim to prevent cats from wandering during the evening, and some are beginning to enact twenty-four-hour regulations with steep fines.

"I think about my kids, and how they'd probably be safer if I never let them out of the house . . . but I think that might impact their mental health, yeah? By trying to keep them safe, are we just restricting their natural lives?" We watched as her cats, Kofi and Felix, climbed trees and rolled in the grass. In that moment, I came to understand the challenging situation in which Australian cat rescuers find themselves: the numerous laws regulating the freedom of movement for cats and outlawing TNR programs, the ubiquity of outdoor access, and the federal government's eradication plan all intersect to create an overwhelming pressure on the shelter system that is palpable in the words of every rescuer we met.

Like so many others, Vix believes the best approach to solving the crisis is to focus on supporting the desexing of urban strays. "We need to stop doing things because they sound right, and start doing things because they are right."

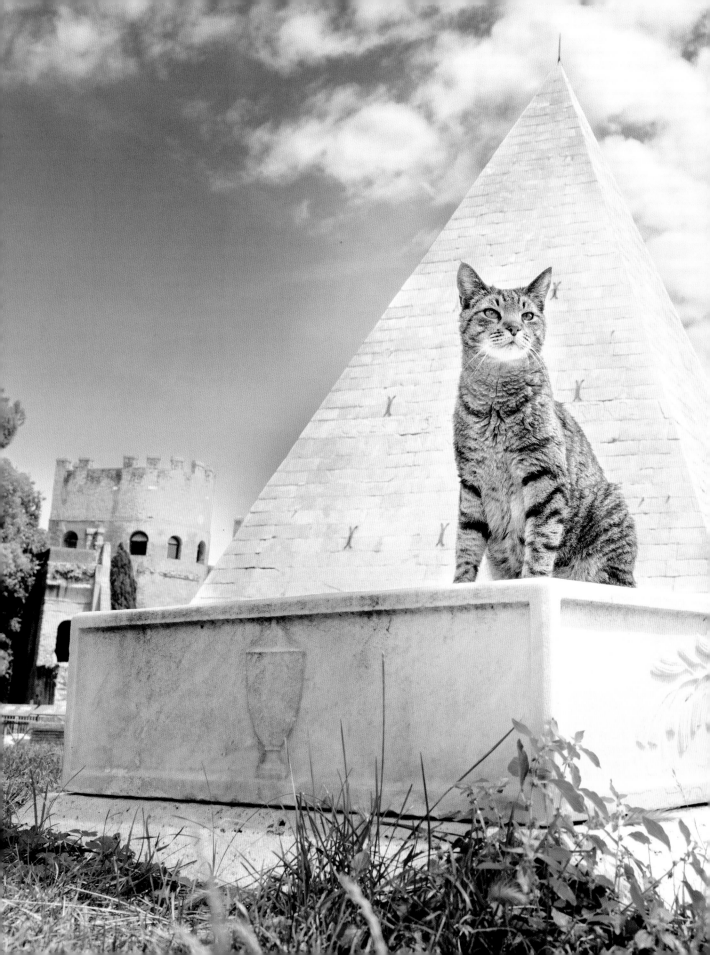

ITALY

OFFICIAL LANGUAGE: Italian

CAT: Gatto

ROME

Each year, millions of people travel to Italy's capital city to admire its world-famous historical sites, places of worship, and archaeological ruins. But it isn't just tourists and history buffs who flock to these celebrated landmarks: quiet, peaceful, and expansive, Roman ruins provide cats with shade, plenty of places to climb, and just enough proximity to humans to suit their needs. And so it is no surprise to encounter an abundance of felines prancing through the vestiges of the Roman Empire.

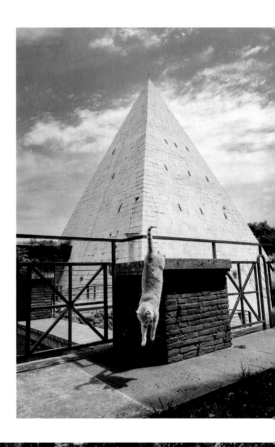

Our first stop was Piramide Cestia, a stunning pyramid built between 18 and 12 BCE and constructed of white marble, which is both the tomb of Caius Cestius and the home of several friendly cats. We marveled at the beauty of the cats lounging around the iconic pyramid, then walked just steps away to the Non-Catholic Cemetery, where more can be found lounging on the graves under a thick canopy of Mediterranean cypress. The immaculately landscaped cemetery is the resting

place of illustrious poets like John Keats and Percy Bysshe Shelley, and tucked away discreetly in the hillside you'll find Gatti della Piramide, a group of volunteers who care for all the cats who live between the two sites.

Our next stop was Largo di Torre Argentina, a large archaeological ruin in the center of the city famous for being both the site of Julius Caesar's assassination and the home of Torre Argentina Cat

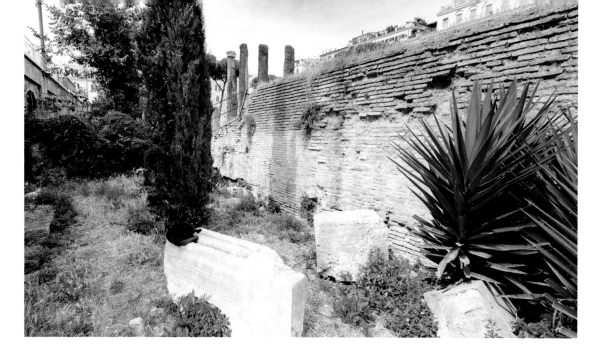

Sanctuary. Leaning over the street-level railing, we looked down into the grand square, where high columns mark the sites of temples as old as the third century BCE. Although parts of the grounds are off-limits to humans, dozens of cats are permitted to live there.

We stepped down to enter the underground cat shelter, which is obscured beneath the sidewalk. Inside, cats with special medical needs are cared for by volunteers; outside, unsocialized cats freely walk the ruins. "The feral cats like it here because no person has permission to go in the sacred area," explained Laura, who has volunteered with the cats since the sanctuary's founding. "So it's very quiet, and they can have a private life."

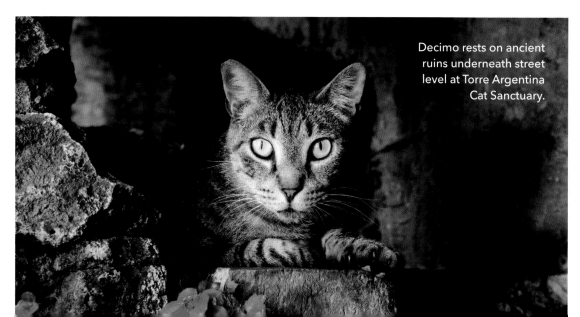

Decimo rests on ancient ruins underneath street level at Torre Argentina Cat Sanctuary.

"We were squatters in the beginning, I have to be honest," said Laura of the organization's early days. "In the nineties the municipality didn't want us here, but there were petitions online because this is very popular. There were five hundred cats living in the ruins when we started. So we got permission to stay; they had to recognize how much we helped."

The main focus of the program, by far, is to sterilize the street cats of Rome. Since its founding, more than eighty thousand cats have been spayed and neutered thanks to the sanctuary—a profound impact that not all community members understand. "We have to fight against the culture to explain that sterilization is a good thing," says Laura. "We have to help people understand: this is to stop proliferation."

Patrons can sponsor the care of blind cats like Cesan, Donatella, and Feola through the "adoption at a distance" program.

After plenty of walking, we stopped in for lunch at one of the most enticing restaurants in the city. Romeow Cat Bistrot isn't your ordinary eatery—it's a dining experience where six friendly cats join you for a beautifully plated meal of Italian dishes, from homemade ravioli to a plant-based cheese board. "The cats are the real owners here," laughed owner Valentina de Matteis. To eat such elegant, flavorful food in the company of rescued cats was an absolute joy.

"Italian people often don't love vegan food, but because of the cats they come and say, 'Wow, vegan food is good!'" says Valentina.

In Ostia Antica, a large archaeological site by the coast, we walked for ages through what remains of the well-preserved ancient Roman port city where more than a hundred thousand inhabitants lived in the second century CE. Now it is unoccupied, aside from two dozen feline residents who find shelter among a labyrinth of crumbling brick buildings. Shy cats slinked through holes in the walls to be excused from our company, while confident cats leapt onto time-worn artifacts to make themselves available for pets. Each day, a rotation of volunteers arrives to care for the colony.

Just outside the archaeological area, a small group of rescued cats live in a courtyard behind Castello di Giulio II, a Renaissance military castle built to

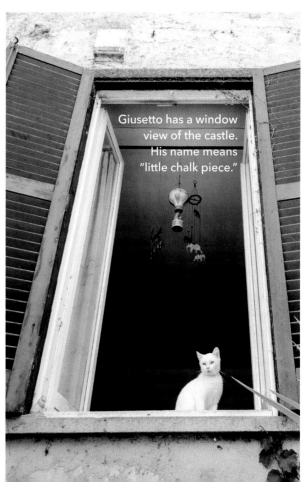

Giusetto has a window view of the castle. His name means "little chalk piece."

"When Kim came here she was very thin, and now . . . she's a teapot cat," Mary said of the torbie.

guard the port of the Tiber River in the fifteenth century. "I've lived here thirty-two years," said Mary, a cat lover who lives in a historic home across from the castle. "In that time, I've found homes for over a hundred cats."

Few people know local felines better than Daniele, a prolific trapper who has dedicated his life to helping Rome's street cats for nearly

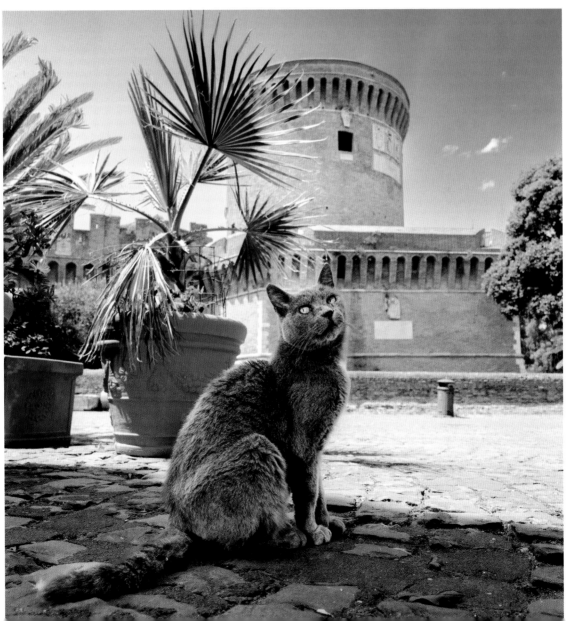

thirty years. Each night, he rides his motorbike all over the city to care for cats living in the ruins. "Italy is a totally no-kill country since 1991, but that's why we have to focus on sterilization," Daniele said. "Because if you have no kill, and you have no sterilization . . . boom. Explosion."

We followed Daniele through the grounds of a convent overlooking the Colosseum—one of many locations where he feeds cats. "There used to be dozens of cats by the Colosseum, and now people are disappointed because we fixed them all," Daniele said, rolling his eyes. "People like the idea of seeing a cat in the street and giving them a stroke. But they don't need a stroke, they need food and vaccination.

"There is a deep bond between Romans and cats," he continued. "In some ways they are part of the folklore of Rome. But I don't like the idea that they belong to the landscape, because they are living creatures—they suffer, they need care. Fortunately, the situation has improved so much in the past twenty years that you don't see as many strays anymore."

At each site we visited across Rome, Andrew and I gazed in profound reverence at the beauty and significance of the locations where cats live freely. "Cats don't care about Roman history," Daniele laughed. "If only they knew."

Daniele cuddles Elsa, one of his favorite colony cats.

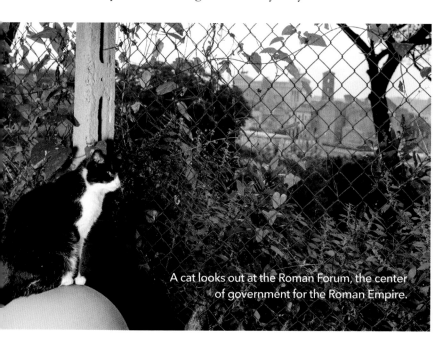

A cat looks out at the Roman Forum, the center of government for the Roman Empire.

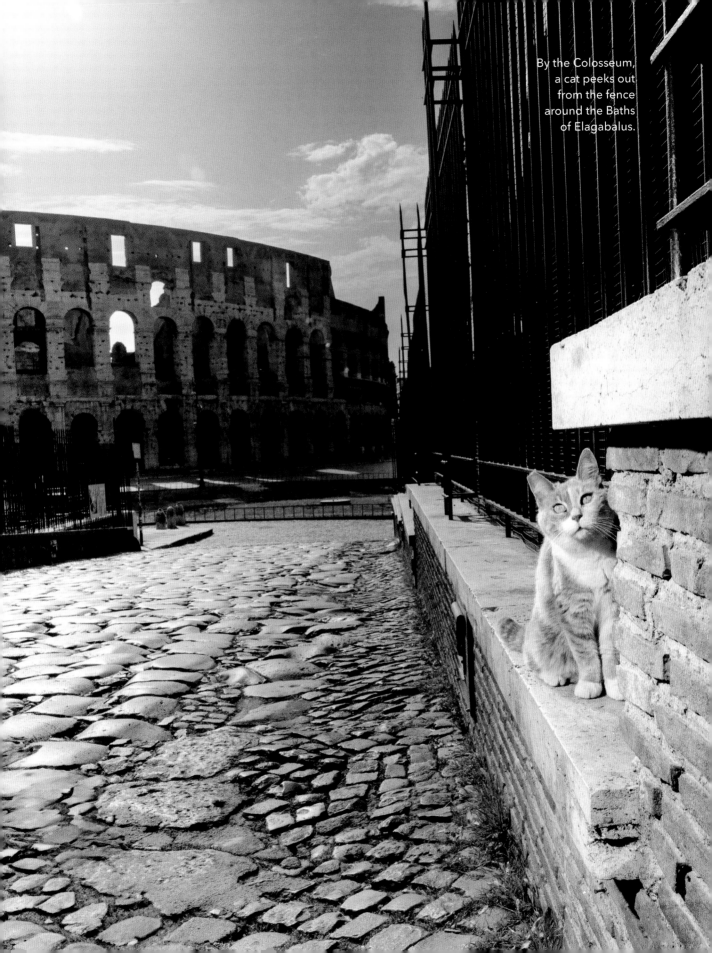

By the Colosseum, a cat peeks out from the fence around the Baths of Elagabalus.

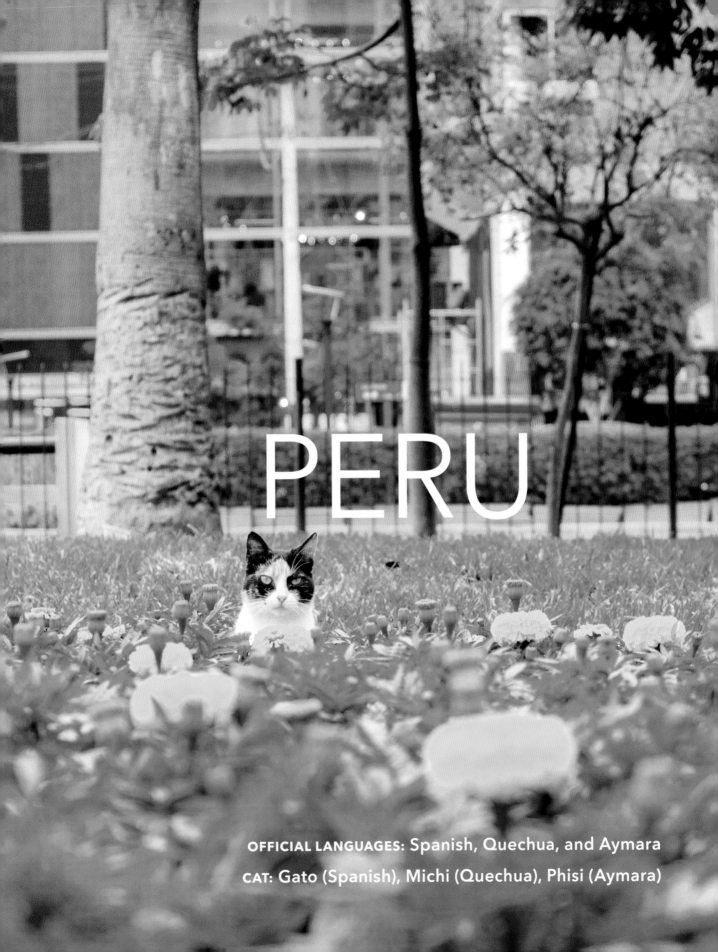

PERU

OFFICIAL LANGUAGES: Spanish, Quechua, and Aymara

CAT: Gato (Spanish), Michi (Quechua), Phisi (Aymara)

LIMA

Vivid blossoms line the walkways of Kennedy Park, a gorgeous town square in the heart of Miraflores. The park isn't just acclaimed for its lush landscaping, street food, and cultural festivals—it's also known for being home to a large number of cats! Look closely and you'll spot pointed ears peeking out from every flower bed. But peel back the allure of petting cats in a park, and a deeper history unfolds.

"Nothing is really what it seems. Yes, it's nice to have a cat park, but the reality is that this is a place where there is a cycle of cat abandonment," explained Alejandra Velasquez, program director of local organization Adoptamiu. "Originally, there were a lot of rats in the park. So in the nineties they brought cats, but then the population became out of control. It's so famous now that people who don't know what to do with their cats will just drop them there."

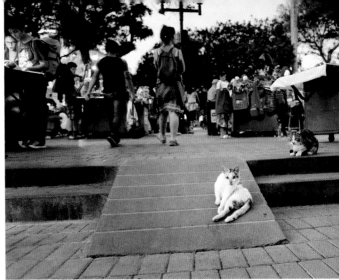

But a new generation of young activists says enough is enough. "Growing up, there was no education of what it is to responsibly have cats. I think the younger generation is really able to communicate these issues in a way that is more agile thanks to social media," said Adoptamiu cofounder Santiago Chávez. The group provides education to individuals, NGOs, and even government officials. "The municipality of Miraflores called on us to give advice about the cats in the park. We told them if they really want to be serious about this, they should do more than just educate about not abandoning—they should promote TNR."

The group steadfastly holds that sterilization is essential for the community cats of Lima, even if public opinion on the subject is mixed. "In the context of a more impoverished country, you have a lot of old ways of thinking," said Alejandra, slipping a bodysuit over a recently spayed kitten to protect her surgical site. "People will see things as big as their worldview will permit them to see. But a lot is changing now, thankfully."

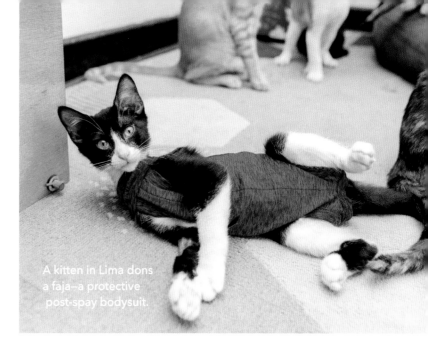

A kitten in Lima dons a faja—a protective post-spay bodysuit.

We made our way to a feline-focused conference, where I'd been invited to teach a kitten care class, and brilliant cat advocates of all ages met to strategize and share ideas. Thanks to a growing and active community of compassionate activists, the future is brightening—for the felines in the flowers and beyond.

MADRE DE DIOS

One of the most biodiverse places on earth, the Amazon rainforest is home to an exceptional range of animal species, including capybaras, giant anteaters, toucans, poison dart frogs, anacondas, monkeys, and many more. While you'll find native felids like jaguars, pumas, and ocelots in the ecologically rich region of Manú National Park, you're highly unlikely to spot domesticated cats. But deep in the Shintuya region, home to the Harakmbut indigenous community and accessible only by boat and foot, one small cat is stunning those who visit the remote hot spring where she has mysteriously arrived and planted her paws.

CUZCO

The name Cuzco is derived from the word for "center" in the Quechua language, reflecting its pivotal role as one of the most ancient cities in the Americas and the capital of the Inca empire, a legacy preserved in its abundant archaeological sites. Prior to Spanish colonization, the only feline inhabitants were wildcats like Andean mountain cats—but the sixteenth century brought immense change to the region, including the introduction of domestic cats.

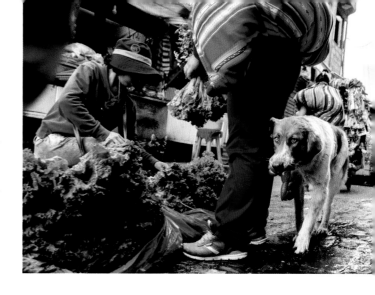

In modern-day Cuzco, both cats and dogs can be found wandering the streets, especially in the markets where fresh meat and vegetables are displayed for sale. Dogs are easy to spot, but their feline counterparts are more discreet, often observing the fast-moving world from quiet corners.

As we approached a restaurant serving plant-based Peruvian cuisine, a tabby tiptoed past to eat from a bowl of kibble. "Green Point at its core was created to avoid animal cruelty

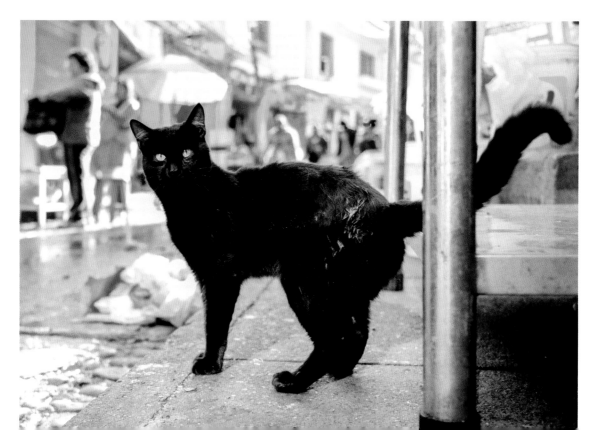

and suffering. Whenever we have a chance to help an animal, we do everything we can," explained the co-owner, who introduced herself as Cat. Along with her husband, the executive chef, the culinary couple has rescued over a hundred animals.

Set in the Peruvian highlands, Cuzco serves as a gateway to Machu Picchu. After taking in the breathtaking views of the "Lost City of the Incas," we made our way to the train station, where we were alerted by the tiny, distressed meow of an emaciated kitten.

With moments to spare before boarding our train, we had a choice to make: leave the scrawny, flea-riddled baby behind or take her with us. Before we knew it, I had a secret kitten under my sweater and was seated in the train car, planning our next move. A quick trip to the vet yielded an airline-friendly carrier and all the certification we needed to bring her back to the States, where she grew up to be a healthy house cat! To honor her roots, we named her Munay Michi—the Quechua term for a cat who is loved.

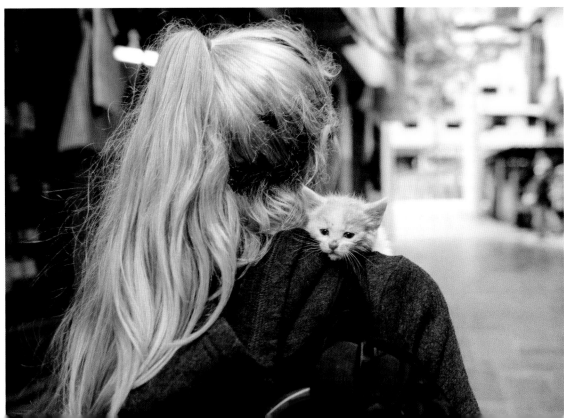

FINLAND

OFFICIAL LANGUAGES: Finnish and Swedish

CAT: Kissa (Finnish), Katt (Swedish)

HELSINKI

On a gray day in Helsinki, we approached Senate Square, the site of some of the oldest and most famous buildings in the city, including the Government Palace and Helsinki Cathedral. "Look for a yellow raincoat," we'd been told by Kati, a local woman who we were soon to meet. Searching the square, I squinted at the steep steps that led to the cathedral and squealed in surprise—it wasn't Kati who donned the brightly colored jacket but rather her feline friend, Dali.

The four-year-old black cat, whom she adopted from a farm, has been going on adventures with her since he was a young kitten. "It's very popular to have a cat in Helsinki, but people are surprised to see him outside. He loves to go out, especially to the forest," she said, sharing that he has been on camping trips as far away as Sweden and Norway. Dali was remarkably relaxed and happy on a leash, and he was even trained to respond to her voice—sitting perfectly as she softly said: "Istu."

But unless they're on a leash, it's unlikely that you'll see other cats outdoors in the capital city. According to Mari Aro, a manager at Helsinki's largest animal shelter, Helsingin eläinsuojeluyhdistys (HESY ry), "There are no feral cats here because of the climate; they wouldn't survive the winter unless they had someone to take care of them." With few cats on the streets, the number entering the shelter each year is relatively low. As a result, the cats who do need assistance are able to be provided with great individual attention and five-star accommodations.

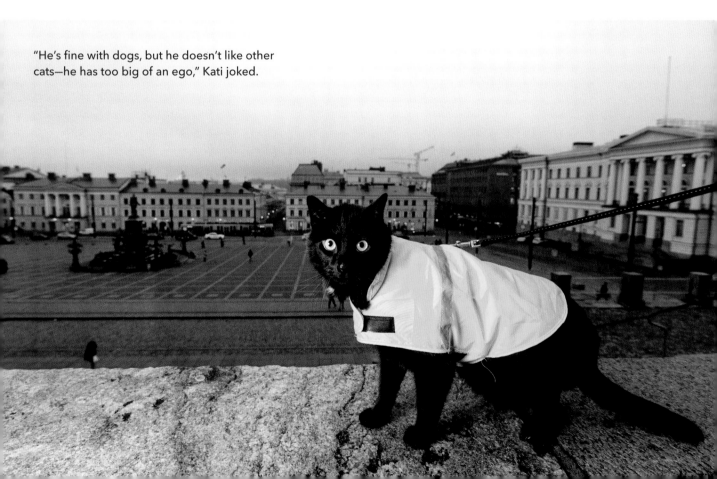

"He's fine with dogs, but he doesn't like other cats—he has too big of an ego," Kati joked.

At HESY ry, we walked through a maze of large, modern suites. Each group of cats is provided with a spacious eight-square-meter room packed with comfortable furniture and tall cat trees. "These are nicer than some apartments!" I gasped as we walked the halls. Remarkably, some rooms were even empty; there are often twice as many prospective adopters in Helsinki than there are cats! I found it incredible to see what is possible when cat rescuers aren't stretched for space or time: kittens are kept with their mothers for fourteen weeks, foster homes aren't needed, and even adoption application processes are lengthier and more in-depth to ensure the cats are perfectly matched with an ideal home.

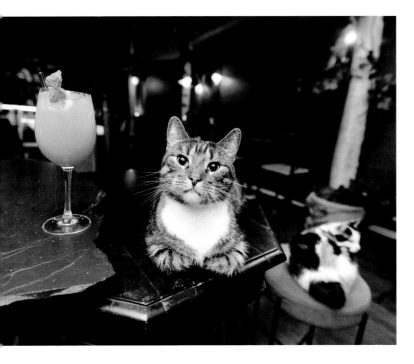

For those seeking the company of a cat, a visit to Helkatti offers the perfect opportunity to snuggle and play with friendly felines. More than a cat café, Helkatti is a place where you can drink cocktails and eat local foods while your lap is warmed by a cuddly companion. Colorful spreads accompany hearty rye breads, which the cats just might try to steal from your plate if you look away!

The most special thing about Helkatti is that it's one of the few places in the world where you can book an overnight stay with cats. "During the pandemic, the Finnish government offered

funding to businesses that came up with unique ideas to stay open. So I thought, why not turn Helkatti into a small hotel?" said business owner Tiina Aaltonen. As the last customers left, she set up a bed in the center of the café, leaving us to enjoy the space alone—aside, of course, from the dozen cats who piled atop the bed with us. After a chilly day in the city, nothing could have been cozier than lying under the covers, our bellies full of bread, dozing off to the tune of old jazz records and rumbling purrs in surround sound.

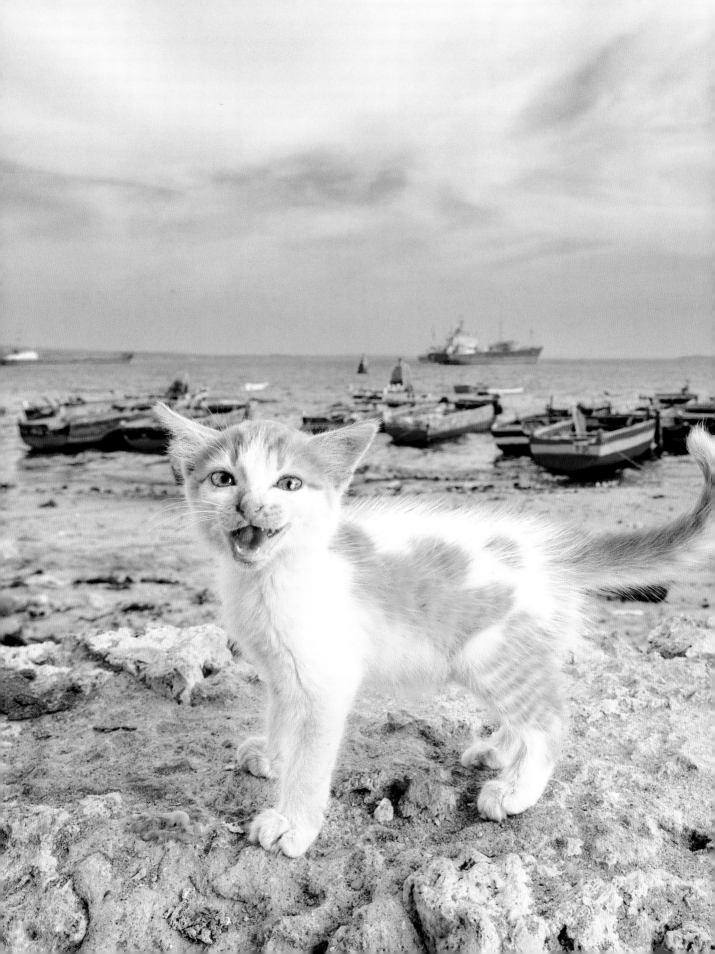

TANZANIA

OFFICIAL LANGUAGES: Swahili and English

CAT: Paka (Swahili)

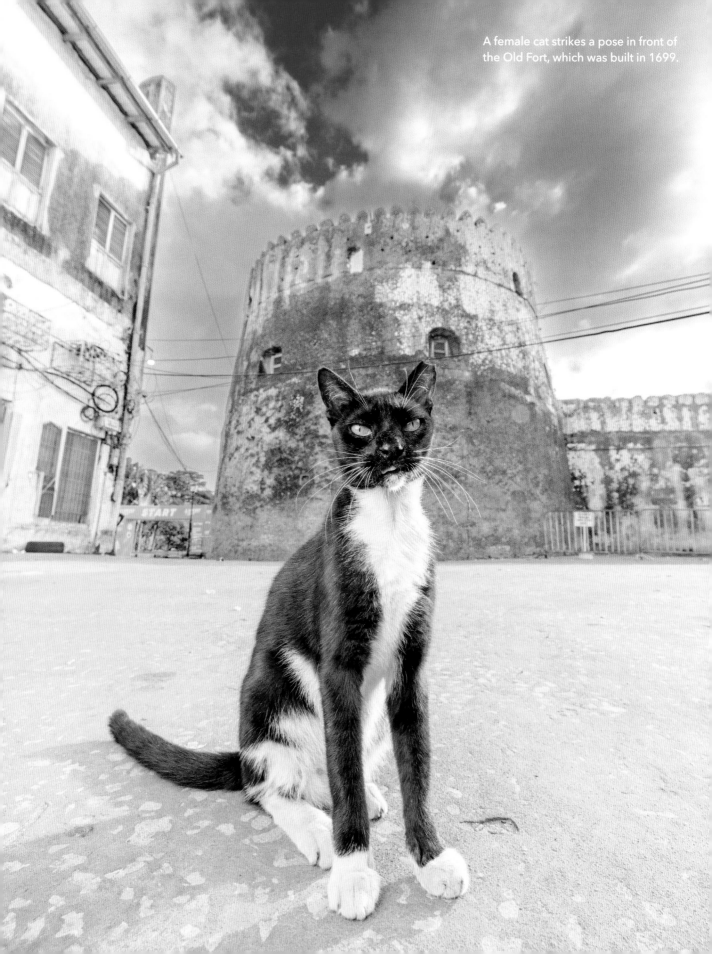

A female cat strikes a pose in front of the Old Fort, which was built in 1699.

ZANZIBAR

It's impossible not to fall in love with Zanzibar, where the water is warm and so are the people. "Zanzibar has always had a reputation of being really polite and welcoming," explained local animal empath Mussawir Hassan. "If you have nothing and you come here, people will help you with a place to stay, something to eat. So cats

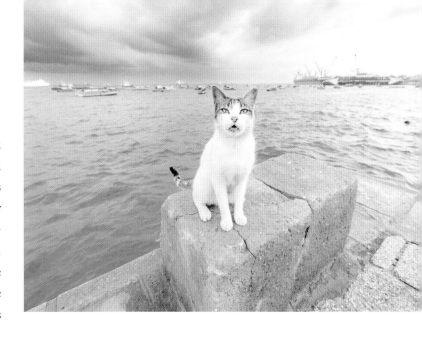

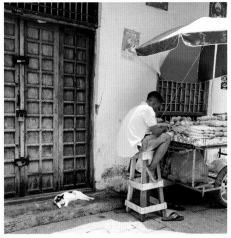

here are generally friendly, too, because people are kind to them." As we made our way into Stone Town, a historic gem along the coast, we felt instantly embraced by a community where humans and cats alike are treated with hospitality.

Sharing community with felines is a core part of Zanzibari life. When the sun is high, sleepy cats lie against

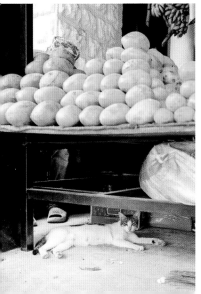

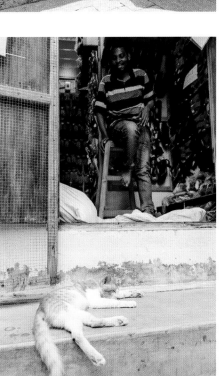

239

the island's iconic wooden doorways and nap in the shade of carts selling locally grown fruits and cashews. Passersby are careful not to disturb their slumber, stepping carefully past them as they rest.

In the afternoon when the cats awaken, so do their appetites! The evening food market in Forodhani Gardens is meant to attract hungry humans, with local favorites like freshly pressed sugarcane juice and Zanzibar pizza, but its heaping offerings of sizzling seafood also entice many cats to participate in the nightly social gathering.

Most of Zanzibar's cats don't have a traditional home with one adopter; as many locals explain it, the cats live in the neighborhood, and the neighbors are the adoptive family. On each street, people contribute what they are able: a bit of milk, bread, or some leftover fish. Upon a set of concrete stairs, one kind man gave his daily offering, scooping handfuls of dried fish onto a sheet of newspaper to feed the area colony.

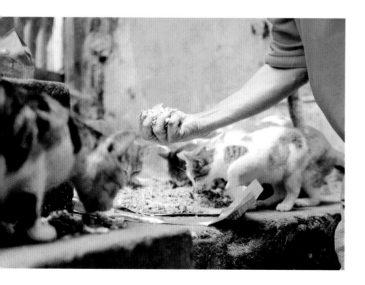 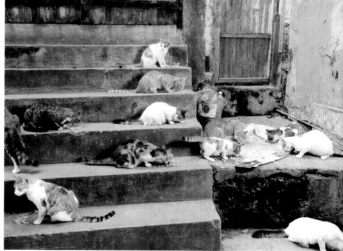

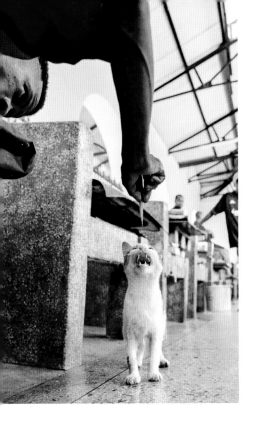

With so many potential caregivers, it seems that Zanzibar's cats have learned how to get their way through loudly vocalizing at anyone who will listen, and meows are commonly heard as part of the island's natural soundtrack. At the fish market, the sound of a raspy yowl reverberated through the building as a boisterous tabby successfully demanded bits of her favorite seafood.

Down the street, a vocal female hopped up onto a motorcycle and meowed at us incessantly, seeking attention and treats. A man exited a yellow mosque and began to shake his head, laughing with a knowing look; he is one of many locals who care for her.

"Does she have a name?" I asked.

"Her name is George Bush," he responded with a cheeky smile.

I don't know what we expected . . . but it certainly wasn't that! We all laughed together, and George ran to her companion to receive pets.

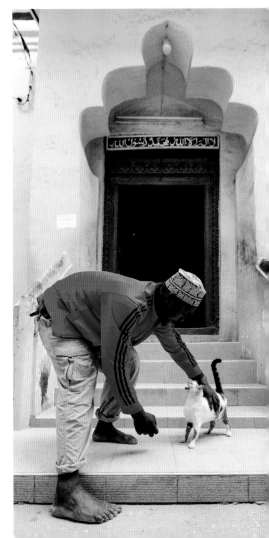

The community-centered approach to cat care does mean that there are virtually no adoption prospects for the cats helped by rescuers. British expat Sarah Freeman founded the island's only kitten nursery, Mama Paka, in which orphaned and ill kittens from the street are rehabilitated. Once they've recovered, they are returned to the neighborhood, where they can receive care from the community.

"Zanzibaris love it. If they find a sick kitten, they want to bring them in, get them well, and then put them back where they'll be fed and loved. But visitors and expats are a nightmare. They ask: 'Why would you put back this healthy kitten?' They don't understand." Sarah does her best to rehabilitate kittens for no longer than three weeks so that they can smoothly reacclimate to life outdoors.

"I have issues explaining kitten rescue in Zanzibar to tourists myself," agreed Mussawir, who works closely with Sarah. "They're happy with the part where we help the kitten, but when we say we will put them back, they really don't like it."

As with any outdoor cat population, the biggest issue is the innumerable kittens being born on the streets. With not enough resources to help them all, local rescuers have to get creative. Sawdust is used for litter boxes, fish is donated from local restaurants, and kitten formula is requested from overseas tourists. Resources must be carefully allocated to those with the greatest need. As we walked with Sarah and Mussawir, we encountered a kitten in a condition that was not ideal but not life-threatening. Mussawir lifted the kitten, examined her, and then made an executive decision: "We'll bring her to another street where I know there are good caregivers. She will be better off there."

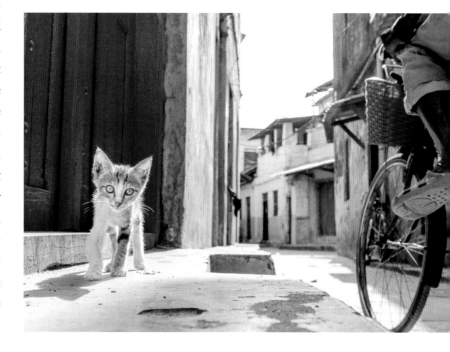

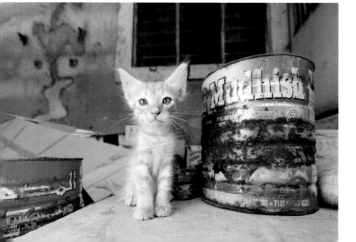

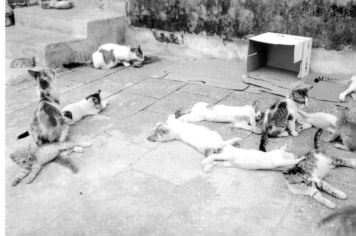

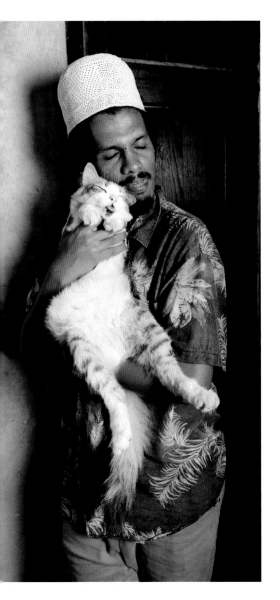

Mussawir and The Cookie Made of Peanut, one of his favorite cats.

Mussawir, one of the island's most dedicated advocates, believes that the most effective methods to help cats are to care for those in your neighborhood and to sterilize as many as possible. "If you want the war to end, strike the armory down," he said emphatically. After sunset, he introduced us to the group of cats he cares for outside his home—each of them with an ear-tip, a unique story, and a silly name like Happy Friday, Chillar Party, or The Cookie Made of Peanut. "I have a soft spot for the older ones," he said as he petted a senior cat with floppy ears. "They've already seen so much in life, and yet they're still here, living it."

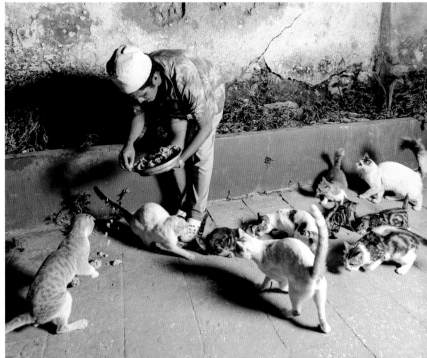

DAR ES SALAAM

Swahili for "Haven of Peace," Dar es Salaam is a tranquil city on the shores of the Indian Ocean. After walking along the Msasani Peninsula, we made our way to the city's largest animal shelter, Every Living Thing.

"I couldn't get from point A to point B without finding an animal in need. I called my mom and told her I wasn't going home," said founder Brittany Hilton, a Canadian expat. Ten years later, her organization has provided sanctuary to countless animals on a large property filled with brightly painted buildings. "I used to work with a lot of shelters and it was draining. So I decided if I have my own place, it will be a happy one: no animals in cages, and even the colors will be happy," she said.

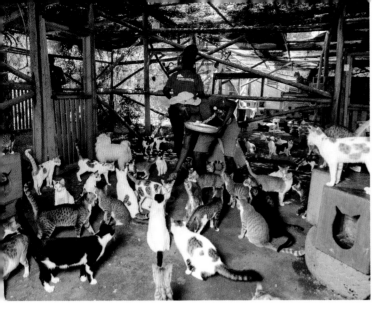

In a massive enclosure adorned with intricate handcrafted climbing structures, volunteers delivered lunch to the feline residents. But accessing food is one of the hardest parts of the work. "Tanzania doesn't manufacture many products for animals, so we have to get creative," Brittany explained, sharing that because their imported cat food often gets delayed at the port, they supplement the diets with dagaa—small dried fish commonly used in East African cuisine.

With a team of local staff and volunteers, the community has embraced the mission wholeheartedly. "Now that there's a resource, people feel there is something they can do to help."

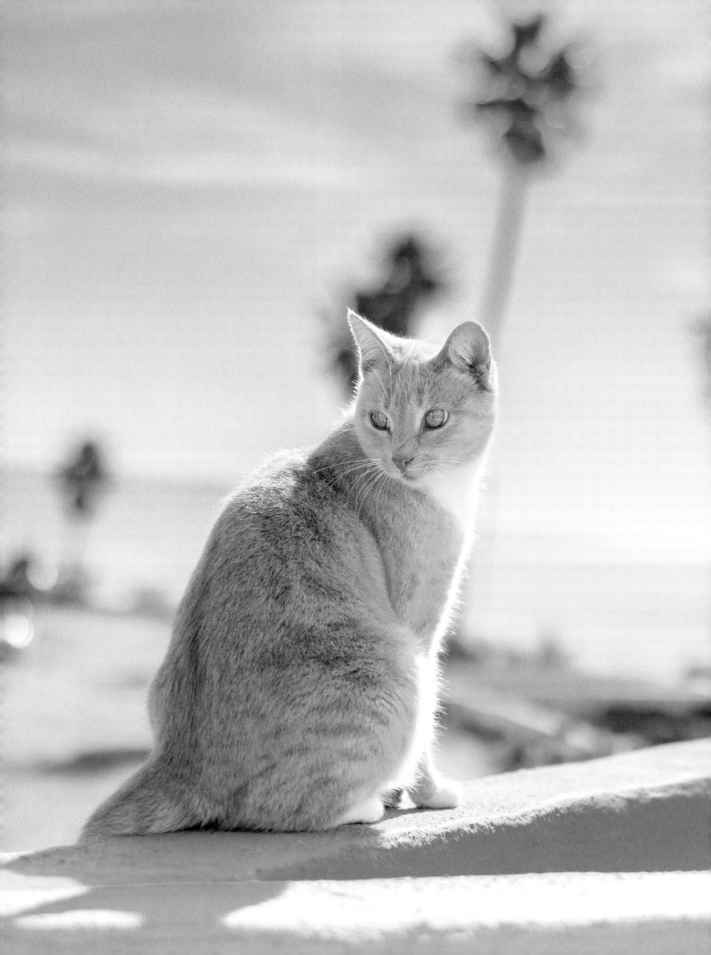

MEXICO

OFFICIAL LANGUAGE: Spanish

CAT: Gato

BAJA CALIFORNIA

There's no better way to start the morning in Mexico than with a warm cup of café de olla, a spiced coffee brewed with cinnamon and raw sugar. As we sipped the sweet beverage at a small family restaurant in Rosarito, the owner walked onto the sunlit patio with a frying pan full of kibble for his most loyal customer. "This is Toñito," he said, lovingly petting a gorgeous flame point with piercing blue eyes. "There was a wildfire in the hills three years ago, and I heard him crying in the road. He was so small and almost dead! I brought him back, washed him, and cared for him. Now he is healthy and very happy."

Rosarito is celebrated for its stunning beaches . . . but if you're planning to head to the water, be forewarned that one local surf spot is patrolled by a ragtag gang of

Toñito enjoys breakfast with his friend Botitas.

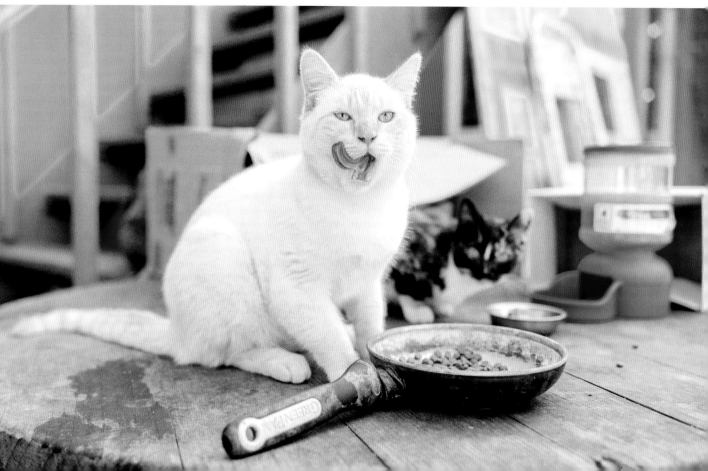

mischievous cats! "We call them the 'gato gang,' because they are like little bandits, absolutely. They steal, they go through the trash, they climb walls . . ." laughed the founder of Viva Los Gatos Baja, who inherited the colony when she moved into a waterfront home. Now the whole squad is sterilized, and while many have been adopted, several remain and receive care by the shore.

Inside, a young tuxedo cat named Pepe was the newest recruit. "I was on my way to surf and I heard him crying in a tree outside of our house. Of course, I had to take him inside."

A short drive north is the sprawling city of Tijuana, which shares a border with the United States. Along the San Ysidro international crossing, felines dart between the two countries at will, some even self-adopting into the gift shops that line the pedestrian footpaths. One handsome cat named Max donned a collar to signify his permanent residence at a piñata store in the nearby Mercado de las Artesanías, where his family was handcrafting the ornate decorations just in time for Christmas.

For holiday shoppers seeking sweet treats, there's no better place to go than Mega Dulces, a massive dulcería selling all types of sweets. An outgoing young cat named Oreo greeted us at the entrance then bounded inside to bat playfully at a display of tamarind candies. "The whole store is

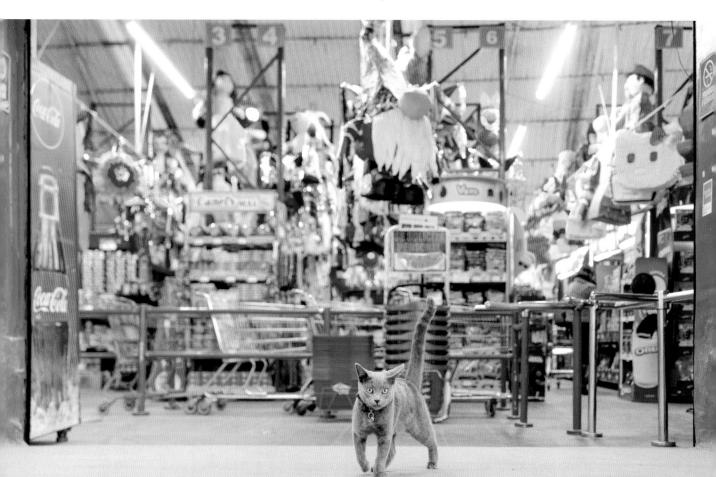

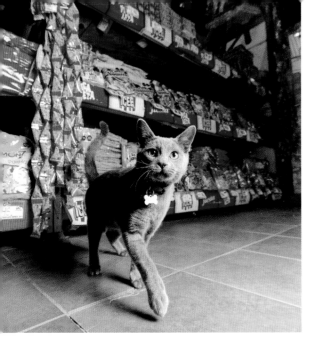

his," joked store manager Jennifer, who adopted him as a shop cat when he was just one month old. "He sleeps on boxes at night, and when he doesn't want to be bothered he just climbs to the top of the shelves. The customers love him!"

According to local advocates, there is an increasing public interest in feline welfare—a trend that led one woman to pursue her dream of opening a cat café. "I realized that the community really wanted something like this," said the owner of Bastet Cat Café, Elizabeth Barajas, who has collaborated with rescuers to find loving homes for more than 1,500 cats on both sides of the border.

Elizabeth is inspired by the city's growing support for cats, which she attributes to new animal welfare laws, a rise in apartment living, and the postive impact that social media has on public education and perception. "In the beginning there was a lot of bad information. Men would say to me, 'I would never sterilize a male cat,' for example. I would just laugh and say, 'We're going to castrate the cat . . . not you!' There was a bit of machismo before, but bit by bit it's changing. People are really starting to understand, and to care a lot."

BAJA CALIFORNIA SUR

The southern point of the Baja California peninsula attracts visitors from around the world with its scenic beauty, luxury resorts, and exquisite cuisine. On a balmy winter evening, we made our way to an organic farm at the foothills of the Sierra de la Laguna mountains, where we encountered a playful tabby named Cilantro. "The cats have a very positive impact on the farm—they keep the crops from being destroyed," explained Gloria, the owner of Flora Farms.

What was once an overwhelming population is now harmoniously balanced. "Now that we've spayed them all, they are like lions," Gloria explained. "With the population steady, they guard their territory and won't let anyone in."

Seated on a throne of hay, a regal tuxedo cat named Fiu ruled over the farm stand. "Fiu is fighting to be the queen of the market. She is very spicy and has a big ego! Fiu is definitely one of our main characters," laughed Mariana, an employee who has come to love the feisty farm cat. "We have so many stray animals in Mexico, but it's in our power to help. We can find a way to all live together."

For some cats, infrastructure development can be a threat to peaceful coexistence. At the marina in Los Cabos—a popular destination for yachts—a large feline family is being displaced by the construction of a luxury hotel. "The cats are smart," said the head of security, his voice echoing through the eerily empty framework as cats darted past and jumped into the trees to take refuge. "They go to a different area when we are working. But there sadly aren't a lot of places left for them to go." According to local advocates, tourist attractions often remove cats from their properties and seek euthanasia.

Luckily, a new day is dawning thanks to the leadership of Armando Martínez, whose visionary approach as shelter director for Los Cabos Humane Society is challenging the status quo. "I am the bad guy to the government because they tell me to come get cats from the hotels and sacrifice, and I say: 'No. We need to work together on this.'" Armando believes that rescue, TNR, and community education are the solution. His approach is working: in five years of his leadership, the euthanasia rate of healthy cats has dropped from 97 percent to zero. "My first day I said: 'We have to stop killing the animals. Give me a year, and I will change it.'"

Armando stood proudly in the shelter's cat room, where a wall of deep square cubbies for holding cats in kennels has been reimagined as an enrichment area filled with perches and ladders for cats to enjoy. "This area used to be kennels for sacrifice," he said of the cubes. Now, the bars have vanished, and his vision is bringing a new reality into focus. "We just had to change the mindset: This area is not for sacrificing. It is for playing."

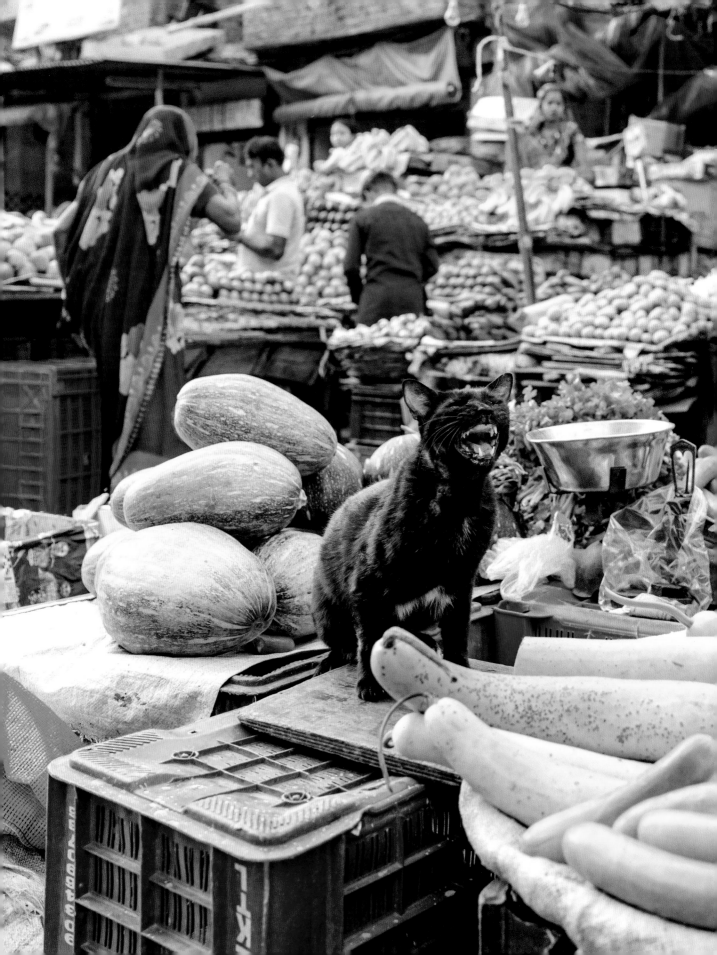

INDIA

OFFICIAL LANGUAGES: Hindi
and twenty-plus others
CAT: बिल्ली / Billi (Hindi)

DELHI

As you walk through Delhi, there is much to take in at street level. The sweet scent of food carts selling guava and bananas blends with blooming jasmine, burning incense, and the fragrant fumes of auto rickshaws driving by. As the city awakens, motorbikes weave through the streets in a hurry, and any driver will tell you that it's dogs and cows—not cats—around whom they will swerve on their morning commute. But look up, and your perspective will shift entirely. A thick canopy of lush green leaves seems to pour from the sky onto the rooftops, and in that overhead oasis, you'll find that it's the cats of Delhi who have a bird's-eye view of it all.

"You won't actually see many cats in Delhi . . . unless you look on top of the buildings," explained Anupriya Dalmia, founder of Dogs of Delhi. Due to the ubiquity of street dogs, who can pose a threat to felines, most cats have made a life leaping from roof to roof. As canine sterilization efforts like Anupriya's have started to stabilize the dog population, she and others are turning their attention upward.

Perspective influences everything, and for the young people of Delhi, mindsets around feline welfare are rapidly changing. "Cats aren't a traditional pet in India, so older generations have never really opened up to them," explained rescuer Saara Gupta as we walked

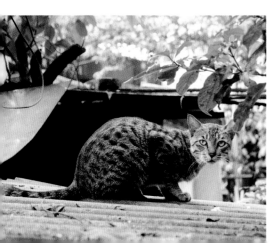

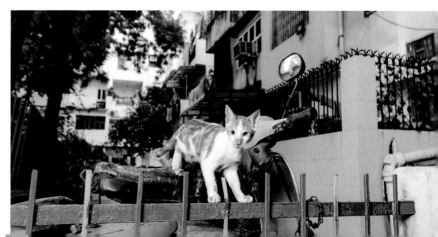

through her South Delhi neighborhood. "My family actually says I'm not normal because I don't want to have kids, and I care about cats. This is a concept that is not yet accepted here."

According to experts, cats have long been relegated to a mythos of bad luck. "The superstition against a cat crossing your path is real here," explained Mansi Tejpal, a social researcher with a focus on animal ethics. "Young people are challenging these notions. What you must understand is the emphasis on staying with family—family is the social structure that binds Indian society. But as people are moving out to urban spaces for better opportunities, they are wanting a companion, and bringing in cats. This is a first-generation concept in India."

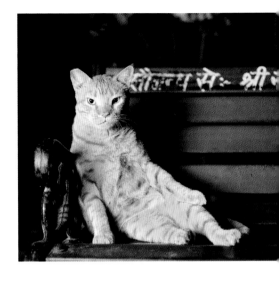

Mansi continued, "As India has become a more multinational space, people have had greater access to knowledge from other cultures—and there has been a large mindset shift between generations." She showed me a photo of a kitten she rescued and smirked. "Honestly, I also think young people like a little rebellion. Having a pet cat is like an 'F you' to the parents, because they do not accept it at all."

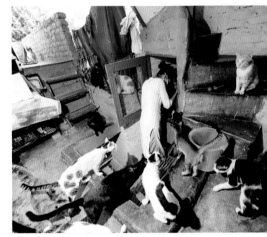

In the Moti Bagh neighborhood, one young woman has transformed her home into a haven for the cat community. Blue tarps stretch over the brightly colored brick walls of the open-air structure, and a tight spiral of steps and ladders leads up three thin flights to where Vaishali has a small bed for

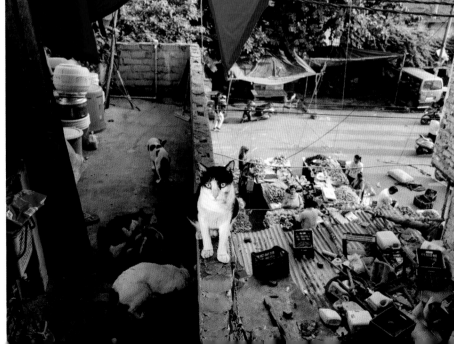

herself, with the rest of the space dedicated to housing cats recovering from surgery. Local rescuers shuffle in and out of her home at will; it is a streamlined community space as much as it is a residence. Upon the balcony, ear-tipped cats perch and look over the beautiful produce markets below, where Vaishali's neighbors sell fresh fruits and vegetables.

While cats may not be commonly seen as pets, many people do show consideration for their feline neighbors, especially in Delhi's marketplaces. At the Sujit Fish Center, workers were delighted to show us their favorite game: tossing food to the cats who overlook them on a high brick wall. "It's like a sport!" a man cheered as he strategically aimed and launched a chicken head up to a black cat, who swiftly snatched it between his claws. Outside, a bowl of milk sat in the center of the market square, attracting a thirsty tabby.

Autumn brings clay lamps and marigold garlands to the marketplaces of Delhi as people prepare for Diwali, the Festival of Lights. In one Hauz Khas market, a tricolor cat named Kittu had a curiously pink face. "She looked inside a bag of powdered color," a vendor laughed, pointing to a row of fluorescent sand, which is used for rangoli art. The curious calico and her orange tomcat friend, Monu, had recently been sterilized and returned to the market.

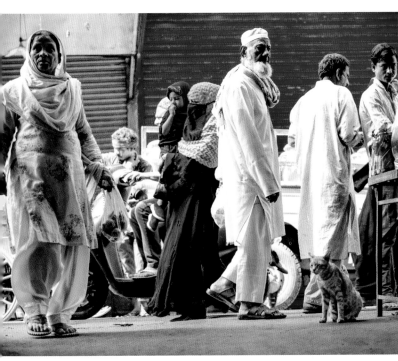

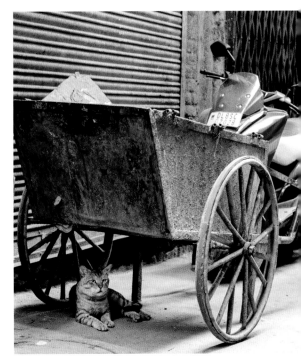

The oldest and busiest market in the city is Chandni Chowk, a sprawling area in densely populated Old Delhi, which will awaken your senses like nowhere else. Flavorful street food sizzles on every corner, rickshaws and scooters blare their horns in symphonic competition, and cats and dogs thread between your legs as pedestrians shuffle shoulder to shoulder. Overhead, a web of tangled cables weaves between buildings, and if you pause to look up, you'll almost certainly find a cat lounging above you.

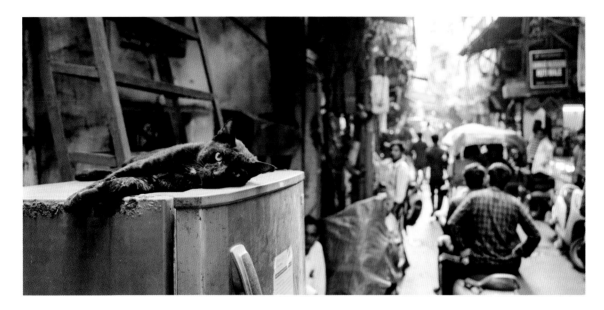

While the larger roads of Old Delhi are packed with people, it's the quieter side streets where you'll often find the felines. These winding, narrow walkways are lined with motorbikes—the primary mode of transportation in the busy city—and it's common to spot a cat warming a bike seat as they rest. When they wake, there's an abundance of food to find, and countless butchers from whom to seek scraps.

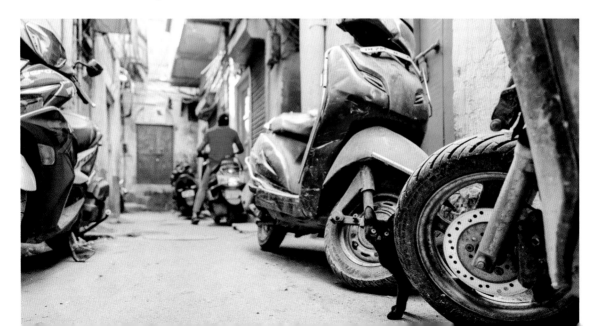

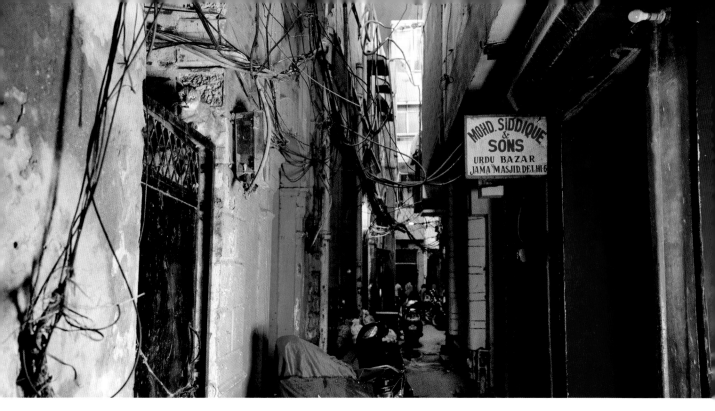

Perhaps the most significant landmark in Old Delhi is the Jama Masjid, one of the largest places of Muslim worship in all of India. As we climbed the steps leading to the iconic seventeenth-century mosque, we glimpsed a tiny tabby tiptoeing through the gorgeous courtyard, which is surrounded by tall red sandstone gates. "Muslims are generally kind to cats here because of the Prophet Muhammad," explained Sumit Singla, an adoption coordinator who visited the mosque with us.

Religion plays a large role in each adoption interview Sumit conducts, due to the beliefs and rituals common in the region. "During certain periods, Hindus will fast, and not have meat

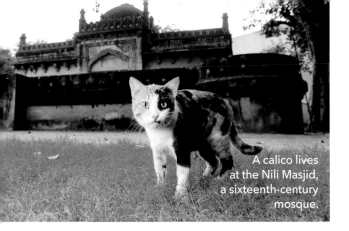

A calico lives at the Nili Masjid, a sixteenth-century mosque.

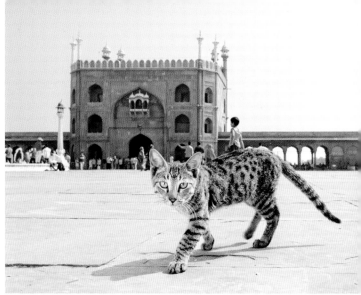

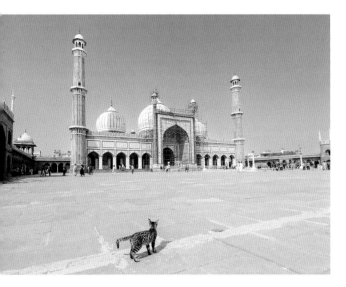

or eggs in the home. When I do adoption checks, I have to ensure the family will be willing to have cat food in the home at that time, and I do sometimes have to reject applications for people who refuse," he explained. Meat is commonly forbidden from Hindu temples, and seeing a cat inside Hindu places of worship is therefore quite rare.

"It's very difficult to argue with religion," added animal rescuer Ankita Agarwal. "There is a concept of purity for Hindus that relates to the consumption of meat, so some people are very uncomfortable feeding a cat. And there is a lot of superstition. Believe it or not, some people believe that if a cat cries, someone in the house will die. I have had to do emergency rescues of cats because of that."

But for young Hindus like Mansi, helping animals is part of their spiritual practice. "Some people ask me: 'There are so many people suffering and in poverty, how can you care about animals?' But I tell them: 'Hinduism says to value every living being,'" she said. "I invoke that we assign divinity to all living beings. Cats are also a manifestation of God. Your creator put them here."

AGRA

Most travelers make their way to Agra for one reason: to visit the Taj Mahal. The famed ivory-white mausoleum is one of the Seven Wonders of the World, and holds the tomb of the beloved wife of seventeenth-century ruler Shah Jahan. But what few visitors know is that the emperor's first wife, Kandhari Begum, rests just outside the gates of the Taj Mahal at the scarcely known Sandali Masjid. While history has largely forgotten his first queen, a family of cats hasn't left her side—and have taken on a legend of their own.

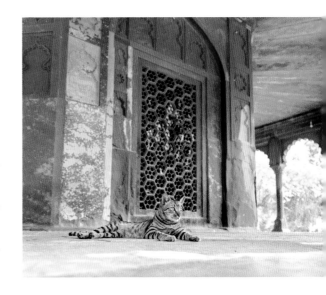

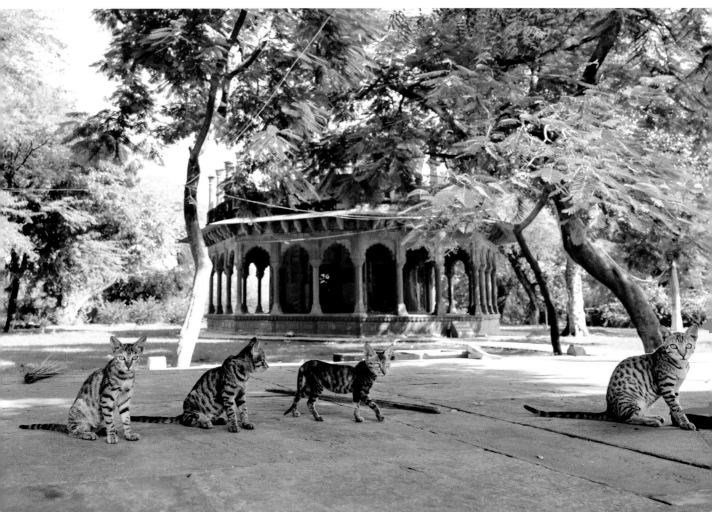

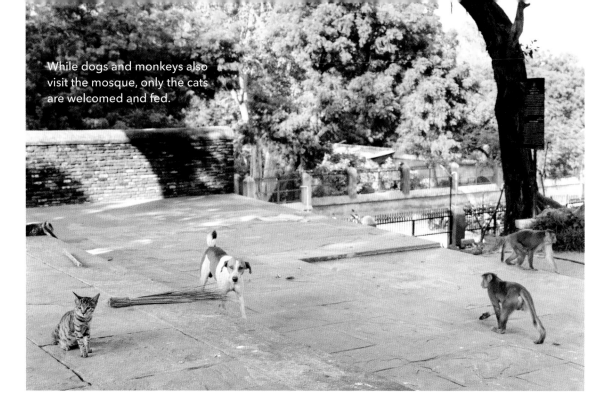

While dogs and monkeys also visit the mosque, only the cats are welcomed and fed.

According to legend, Kandhari Begum loved cats, and so it is fitting that her gravesite is peacefully patrolled by a family of seven tabbies. But for those worshipping at the mosque, there is a belief that the tabbies are jinn—spirits with divine powers—who have taken the form of cats. Believing that kindness to the jinn will bring good luck, locals bring offerings of meat and milk to please the mythic felines.

Beyond the Sandali Masjid, the cats of Agra primarily live on rooftops. Look above and you will spot the movements of monkeys jumping between buildings, the occasional rooftop goat, and the silhouettes of cats slinking along the skyline in the sunshine, oblivious to their view of the famed world wonder.

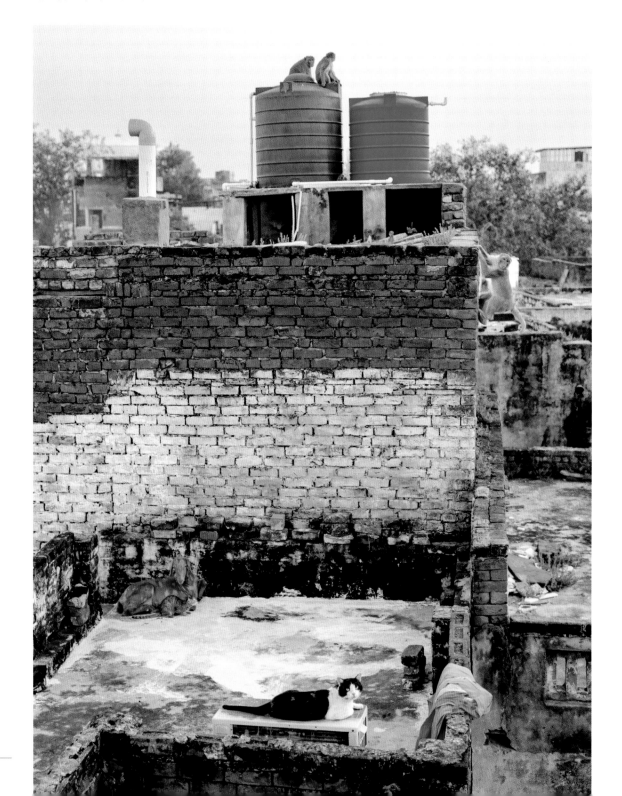

MUMBAI

As we checked into a small rental cottage in the beachside city of Mumbai, we noticed several cats and kittens playing next door. A woman stepped out to fill concrete water bowls in the alley and told us she has rescued animals in Mumbai all her life. "I used to focus on dogs, but the population has reduced so drastically in the past thirty-five years, so now I focus on cats," she said. "They know they are safe here."

The steep decline in Mumbai's dog population didn't occur by accident. "Decades ago, the government used to cull dogs. But NGOs basically said: 'Look, give us the resources to sterilize, and we will.' So, since the eighties culling has been illegal, and the government has provided resources to sterilization organizations with much success," explained Pallavi Kamath of the Feline Foundation, an organization providing spay and neuter services throughout the city. "In a way, the dog NGOs helped people to understand that same concept in cats."

One waterfront neighborhood, Versova, is a local hot spot for cats. The residential area is densely packed

with rows of homes, and felines freely scurry about, hopping in and out of open windows and up steep steps where clotheslines hang. "A lot of cats here have question-mark statuses," Pallavi said. "People will say, 'Oh, that's not my cat,' even though they do care for them. One person feeds, and another plays, and another takes to the vet. So who is the owner of the cat? No one . . . and everyone. The owner is the community."

They say it takes a village, and in the village of Versova, everyone chips in. One man poured bowls of water; one woman tossed fish scraps; one man even invited us down winding alleys to his doorstep, where he welcomed us to meet the cats who sleep in his home. Although there is no access to humane traps in Mumbai, local caregivers don't shy away from catching cats to get them care—they simply lay down newspaper, pour food on top, and swiftly scoop up the feasting felines as they eat. Together

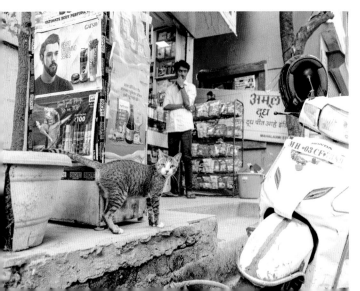

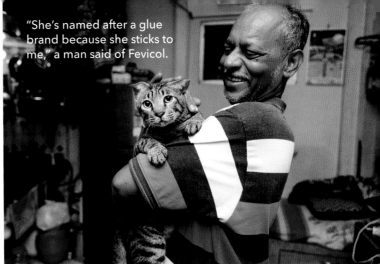

"She's named after a glue brand because she sticks to me," a man said of Fevicol.

we walked with Pallavi for several miles, searching for cats who didn't yet have an ear notch or who needed medical attention, and lifting them into carriers.

We traveled to the clinic piled into a rickshaw, holding on tight to the stacks of full carriers that bumped atop our laps. At the clinic, the cats would go through a program of nasbandi—the local word for sterilization—and one tomcat would receive wound care.

With few adoption prospects, most cats are ear-tipped and returned to the area where they are already known and loved, and neighbors are given resources to provide the best care possible as a community.

"Because of sterilization, dogs and cats actually find a way to coexist here. Some are even best friends," said Lamya Kapadia, manager of Cat Café Studio.

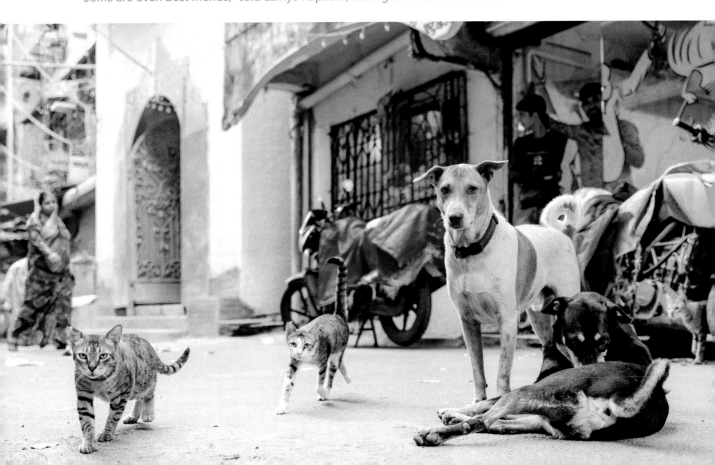

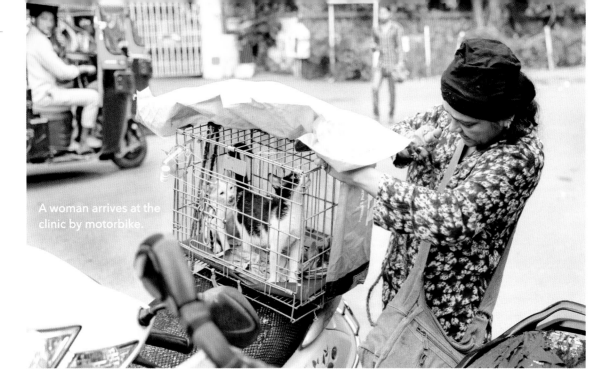

A woman arrives at the clinic by motorbike.

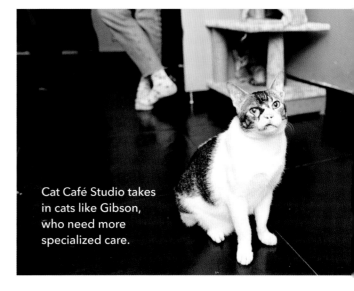

Cat Café Studio takes in cats like Gibson, who need more specialized care.

"We have to find ways to care for those who can't find adopters, too," said Pallavi. "And this is adoption in a way, you're just doing it on the street instead of in a home." For the few cats whose medical needs prevent them from thriving in the community, a partnership with Cat Café Studio provides a long-term home and the potential to connect with adopters.

At the end of our visit, I felt deeply reinvigorated by the empowering, compassionate collaboration I'd witnessed on the streets of Mumbai. Thanks to the community's genuine belief that a better future is possible, rooted in an awareness of what was successful for dogs, a brighter day is hurtling into vision. Like the rescuers themselves, who search the sky for cats leaping between buildings, the future for the cats of Mumbai is truly looking up.

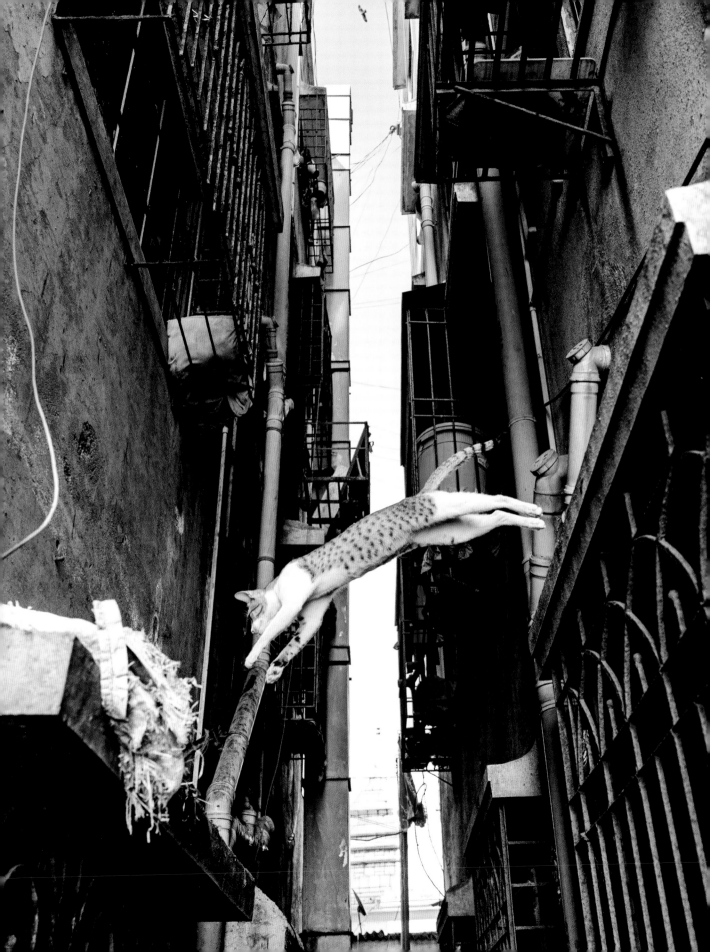

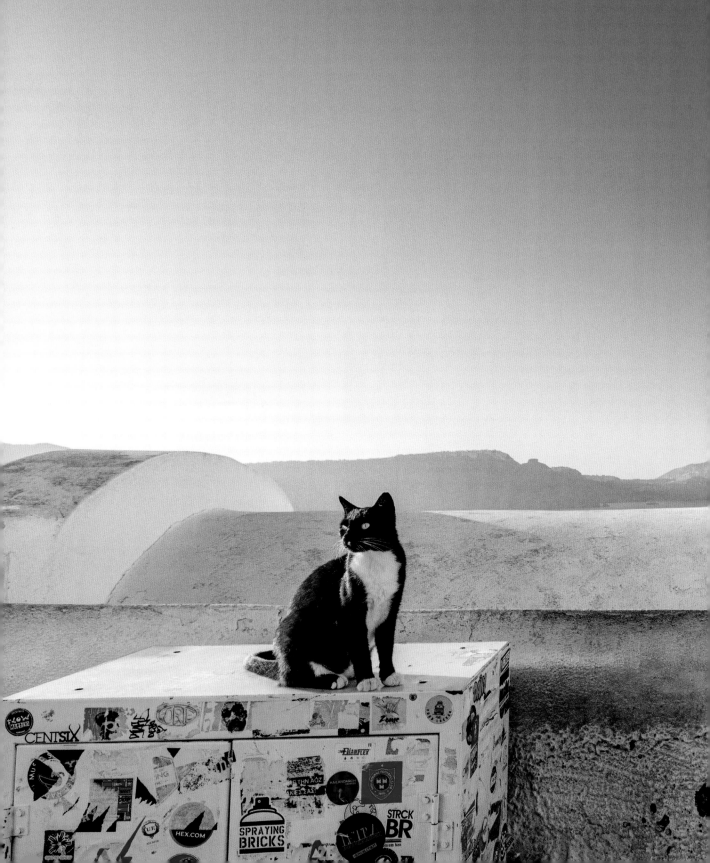

GREECE

OFFICIAL LANGUAGE: Greek

CAT: Γάτα / Gata

ATHENS

An archaeological treasure trove towers over Greece's capital city, and on a sweltering summer day, we braved the rocky hillside to explore the Acropolis. As we stepped up the stony walkways, a fluffy tabby crossed our path, seeming to cheer us on as she made her way to a water station.

Once at the top, we approached the Erechtheion, an ancient temple supported by caryatids—neoclassical columns of sculpted female figures. From beyond a rope, another feminine masterpiece emerged from the temple: a senior gray-and-white cat with a loud, raspy meow. Onlookers gathered to worship her, making offerings of lunch meat and head rubs to the feline goddess.

One of the most celebrated sites is the Parthenon, an extraordinarily intricate Doric temple dedicated to the goddess Athena. Leaping onto a rock, a friendly male cat basked in the sun and obscured the view of the temple, ensuring that visitors noticed his aesthetic perfection, too.

While the cats of the Acropolis watch from above, down the hillside you'll find yourself in a modern city where felines roam freely. We explored Anafiotika's narrow streets under canopies of plentiful grapevines, where people dine on dolmas and dakos and cats enjoy the table scraps.

That these cats are sterilized, healthy, and loved is not happenstance—it is by the design of a large group of volunteers called Nine Lives Greece, which also goes by the Greek name Οι Εφτάψυχες (Seven Souls). "In Greek, they say cats have seven souls, not nine lives, so we use both names," explained cofounder Cordelia Madden.

Each day, four teams of rotating volunteers walk the city to care for more than five hundred cats who they have spayed and neutered. Carrying a bag with water, food, medicine, and even a grooming brush for those with long fur, Cordelia introduced us to the cats on her route. "It's actually a really nice, enjoyable thing to do for just an hour or two a week," she explained as she swept the ground with a dish brush, clearing a space for food.

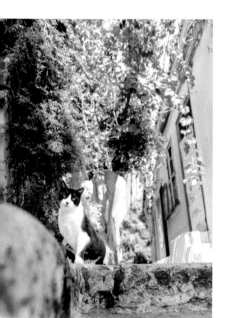

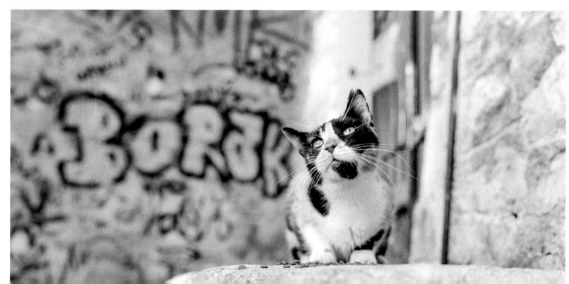

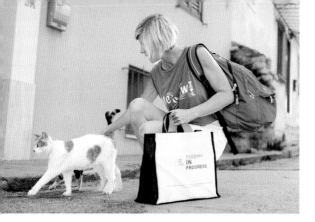

For cats in need of medical attention, a drop trap is used so they can be swiftly seen by a veterinarian. "Business owners realize that tourists like seeing cats looking healthy and cared for, so they are happy to have our help," Cordelia said as she caught a fluffy calico outside a restaurant for a dental appointment.

Nine Lives' impact can be observed throughout the city center. In one souvenir shop, a two-year-old cat named Noah snoozed on a shelf of ceramics. "He has eyes like an angel," said the shop owner, who was able to get him a low-cost surgery through the organization.

In another gift shop, a cat named Nionios was adopted from Nine Lives and has since invited the neighborhood cats to join her. "Nionios befriended Dionne, who brought along Giorgos . . . who brought along another friend . . . The cats tell their friends and bring them here," the shop owner laughed.

"It's amazing to have feeders all over the city, because they can alert us to cats who need help," said volunteer Anna Liliopoulou. Along her route we passed

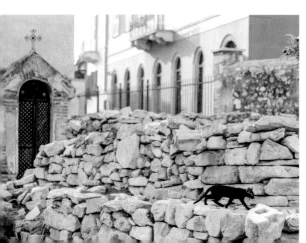

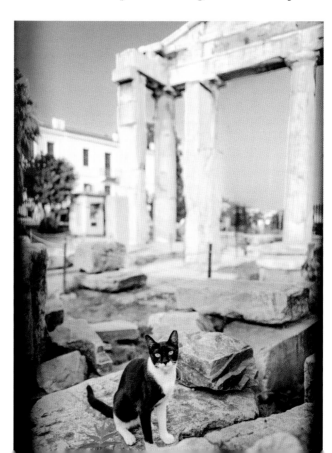

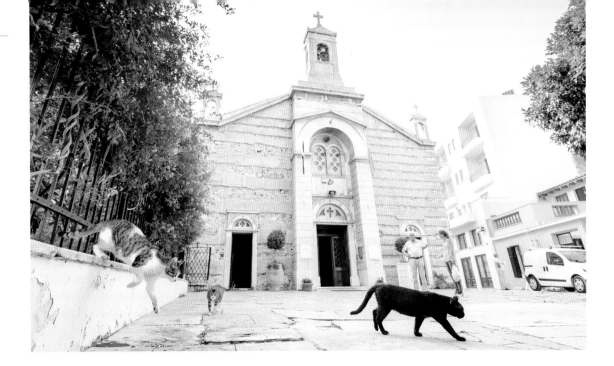

the ancient ruins of Eleusinion and the Roman Agora, where cats live in an area only they can access. "They feel safe, like people cannot get inside their world," Anna said as she placed food along the border.

Slinking along the barrier between ancient and modern worlds, cats revel in the peaceful quiet of antiquity while enjoying contemporary care from a robust community that is set on changing their lives for the better. "I think what's special about this city is that all the elements needed to successfully help the cats do exist here," volunteer Adelle Goodman reflected. "Success is a real possibility."

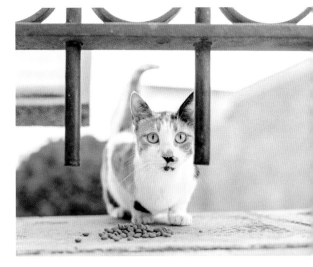

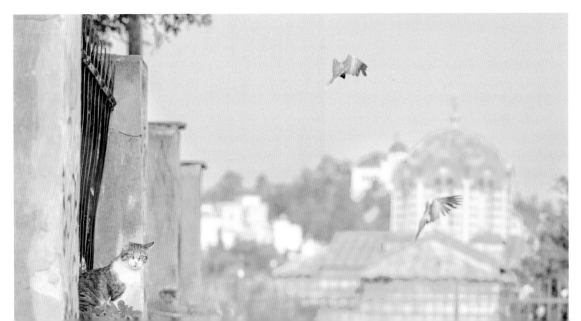

SANTORINI

Greece is home to hundreds of inhabited islands, each with a distinct charm. On Santorini, tourists flock from around the world to have their portraits taken by the stunning white buildings and blue-domed churches that hug the cliffside. But we had a different mission: to photograph felines who call this iconic setting home.

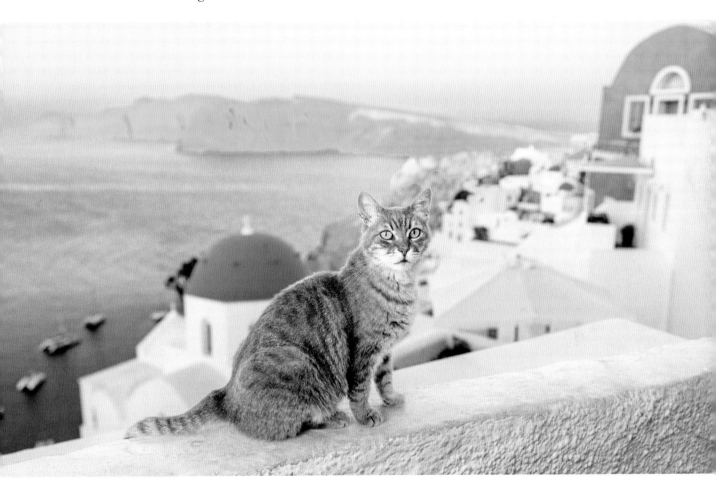

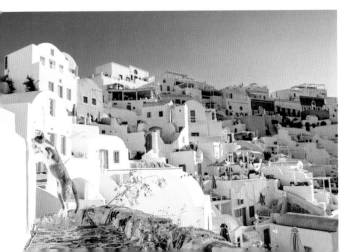

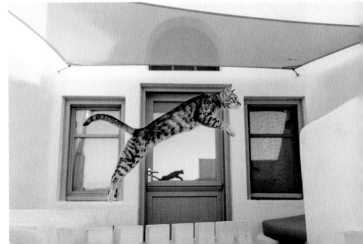

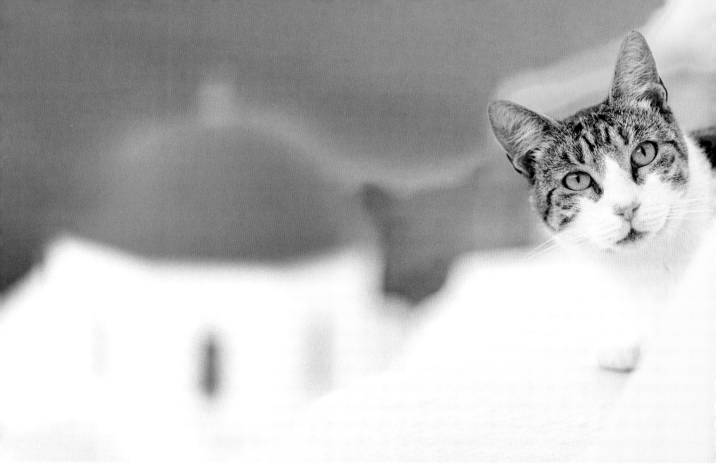

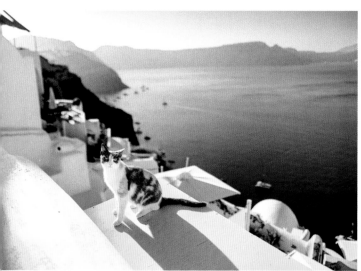
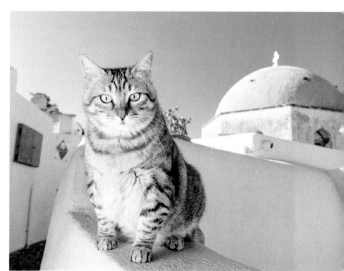

The sun was rising over Oia, and we explored the winding village as tabbies posed before panoramic views of the Aegean Sea and leapt gracefully from ledge to white ledge. As fashionable visitors arrived for early portrait sessions, a local photographer approached us, smiling. "It's nice to see someone taking photos of just the cats," he said as Andrew framed a shot of a silky feline in front of a stunning Greek Orthodox church. "She's the friendliest one on the whole island."

The effects of tourism on Santorini's cat population vary seasonally. "In the winter when businesses and restaurants close, there is less food out for the cats. So we have to create central colonies to feed them," said hotel owner Vily Zacharaki, who cofounded Sterila Santorini to support the island's cats. "In the summer, cats have more resources . . . but the problem is that local volunteers are all busy with work," she said as she petted Dior, one of several cats who live at her hotel.

"Can tourists help in some way?" I asked.

"Anyone who has a car can help," Vily replied enthusiastically. "For instance, I have kittens who need transportation to the vet across town today."

What better way to see the island than to take rescued kittens on a road trip? Before we knew it, the tabby babies were loaded into our rental car, and we were glad to play a small role in their journey.

PAROS

The cobblestone streets of Paros weave through white-washed abodes adorned with magenta bougainvillea vines and cerulean shutters, and around each corner lives a family of felines. No one knows the cats of Lefkes village better than rescuer Isabel Borst. "We started feeding one cat, and it was kind of like joining the mafia," Isabel joked as we walked through the historic village.

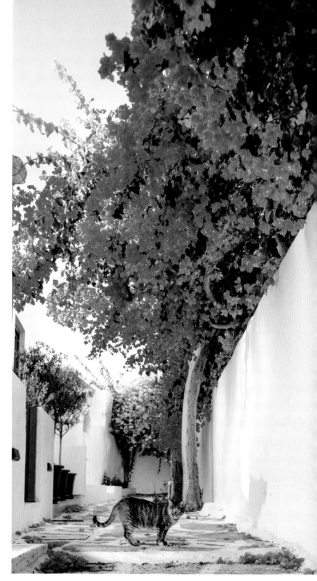

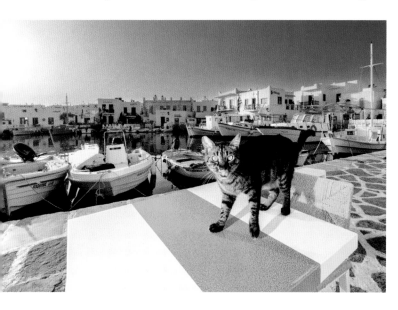

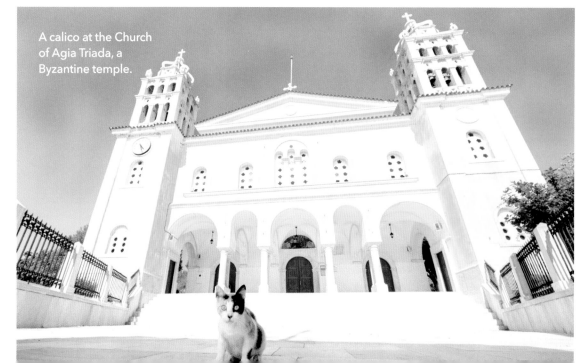

A calico at the Church of Agia Triada, a Byzantine temple.

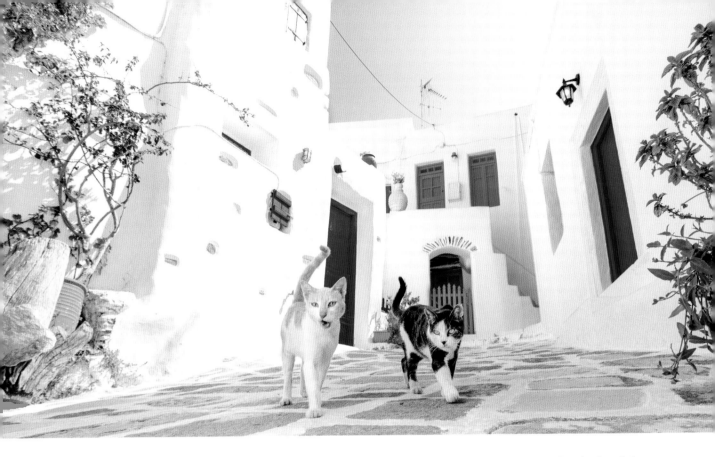

Back at her house, foster kittens chased each other in the yard and lounged in the shade of the covered porch. A lanky kitten named Pollock pounced on a pile of bright pink fallen leaves, his hunting instincts piqued. "It's the cheapest, best toy ever," Isabel laughed.

But while the other kittens played in the yard, a mostly white flame point watched from the doorway. "Supernova had severe sunburn on her ears when she arrived. It's a big problem here: white cats easily get burned, and eventually get cancer on their ears or nose. We generally try to prioritize them because of this," she said, explaining that Supernova already had a ticket to fly to Germany to escape the sun.

In a lovely hilltop home overlooking the village, Isabel's neighbor Mrs. Kaparou is the local godmother of cats. The lifelong resident of more than ninety years speaks no English, nor we Greek, but with enthusiastic gestures she welcomed us into her garden sanctuary, proudly pointing to the well-loved cats in her care.

With the warmth of a family member, she waved us inside her traditional home, insisting that we stay for coffee and meet her most cherished companions. A stripy tabby lay across the terrazzo tile as she prepared a platter of kritsinia and homegrown cherry tomatoes, and she introduced him as Lynkas, holding her hand to her heart.

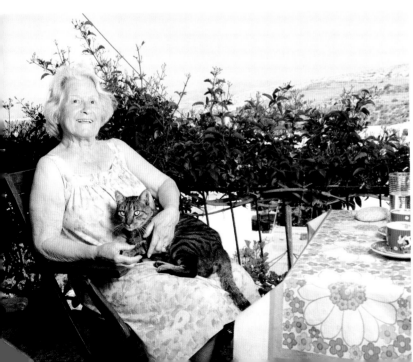

So much can be expressed without words. As we sat together eating seeded breadsticks and petting cats, we connected deeply through smiles, gestures, hugs, and our shared love of felines. As we prepared to leave, I spoke into a translation app to thank her for her hospitality, and I teared up as she took my hand and spoke back. The screen translated from Greek to English: "Thank you for loving animals. You are so beautiful, both of you. And I love you so much."

NEPAL

OFFICIAL LANGUAGE: Nepali

CAT: बिरालो / Birālō

KATHMANDU VALLEY

The scenery from the airplane was spectacular as we flew over the steep, snowcapped peaks of the Himalayas. It seemed impossible that such a large urban area could be found at the center of it all—until suddenly the Kathmandu Valley came into view. Colorful houses and traditional redbrick homes stretch across the region, and as we approached from overhead I could have sworn I saw a cat or two on the rooftops. Upon arriving, we hopped on motorbikes and made our way to the historical city of Patan.

Kindhearted local Sumit Shakya welcomed us into the Newari home owned by his family for more than a hundred years. The Newar people, the indigenous inhabitants of this culturally diverse region, traditionally live in tall, narrow brick structures with wooden latticework windows that have no screens. "We can't keep cats inside; you can see why," he said as he looked out the airy opening into the courtyard. "My cats are out most of the time, and they are loved by the neighborhood also, so sometimes they sleep in the neighbors' houses!"

Only one cat stays inside with him: Hakucha, a paralyzed tabby with big, kind eyes. "Her name means 'blackish' in Newari," he explained; throughout Nepal, many consider brown tabbies to be a type of black cat. "She was a kitten found at a Buddhist temple. Some people would say to put her to sleep, but I am a cat-loving person—so she stays."

In the courtyard of another Newari home, Sumit introduced us to his friend Reshma Tuladar, whose open windows serve as a welcome place for cats to

Reshma and her favorite cat, Kancha, which translates to "youngest one."

receive a meal. "Reshma Didi says she has lots of compassion for animals," Sumit shared; the Nepali term *didi* directly translates to "big sister" and is used to indicate closeness when addressing a woman. We followed her up steeply winding steps onto her rooftop, where tabbies rested on tarps and leapt from home to home.

At the center of many Newari courtyards are chivas—Buddhist shrines erected in memory of loved ones and offered as places of worship for the community. At one chiva, a mama cat named Luna and her kitten Daisy walked the perimeter of the stone structure, then made their way to a small corner store and fell asleep behind the counter. "They were stray, but she got emotional with them, and now they have collars," said a customer, gesturing to a smiling shopkeeper in a beautiful red dress.

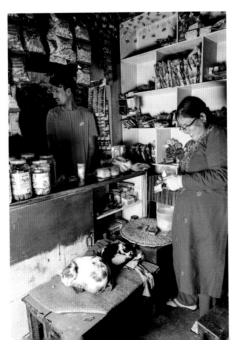

In a neighborhood garden down the way, a man pulled over to distribute a bag of chicken heads to local cats. "They know me; they come when I call. Yeah, I love them," he said with a grin as he mounted his motorcycle.

Compassion is abundant in Nepali culture, but compassion toward cats hasn't historically taken the form of companionship in a home setting. "I was so shocked when I found out you could train a cat to use a litter box and go to the bathroom inside," said Ayush Shrestha as we enjoyed a meal together on a café patio in the shade of Tibetan prayer flags. Ayush, who has lived in Kathmandu all his life, started volunteering with Catmandu Lovers at the beginning of the pandemic, and his perspective changed. "I had no idea cats can live indoors! Now I actually find them very adorable," he said as he petted the restaurant's resident cat, Suri.

Richi Remli, who runs Catmandu Lovers, cheered. "This is what I love to see: people learning!"

An indoor cat, Jerry, poses with Newari wine containers.

Back at Richi's, we were introduced to her adorable fosters, and I remarked that she had a beautiful place. "Not my place—the cats' place!" she laughed. She placed two little black kittens, Bhola and Octavia, into a backpack designed for cats, and we set off on a hike in the lush green village of Jharuwarasi. "We try to safely expose them to the outdoors, because the reality is that most of them will go outside in their future home," she explained.

Bhola and Octavia peeked out from Richi's bag as we hopped over creeks and stepped along footbridges, making our way through the fertile agricultural zone where spring-green fields of turmeric and rice paddies are interspersed with the yellow flowers of mustard and marigolds. Bhola sniffed the air with a calm curiosity, never straying far from the safety of the backpack even when given a chance to explore.

Locals warmly greeted us as we passed by. A woman drying chili peppers introduced us to her calico, Jenny, who was sunning herself on a pile of fabric. Further into our hike we were invited to try out a family's ping—a stunning bamboo swing handcrafted during the great harvest festival, Dashain, and left up for the neighbors to enjoy through the coming Tihar celebrations. We set the kittens down and swung in the sunshine, touched by the hospitality.

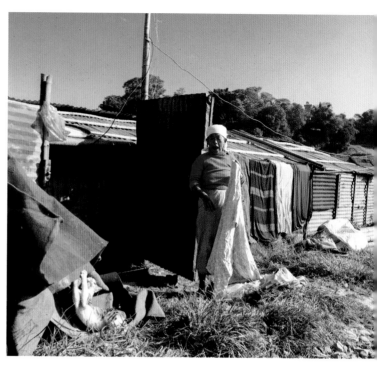

As two friendly farm dogs approach with tails wagging, Jenny makes it clear that she is the boss.

POKHARA

Tihar is an annual five-day-long Hindu festival during which the streets are alive with music, dancing, and colorful rangoli art. Each day is dedicated to the worship of a different being: first comes Kaag Tihar, a day for paying respect to crows, then Kukur Tihar for dogs, Gai Tihar for cows, Goru Puja for oxen, and finally Bhai Tika for brothers and sisters. While cats may not have their own special day, many Nepali animal lovers worship their feline friends alongside their canine companions on the second day of the festival.

"The dog represents all animals friendly to humans, just like the crow represents all birds," explained Ruby Sharma, a local kitten rescuer. "That's why we celebrate Birālō [cat] Tihar, too." To-

gether we made our way to Chadani Shelter Animal Rescue and Care Center, where a group of women strung marigold garlands—called malas—which are customarily placed around the necks of dogs and cats as part of the national ceremony. One woman carried a bowl of bright red pigment called tika, which she gently rubbed onto the

A calico steps through a rangoli mandala, leaving a trail of colorful paw prints behind.

furry foreheads of the animals in celebration. This practice is done for both companion and community animals on this special day, and each animal is given treats.

Back at Ruby's house, an orange-and-white cat named Delight peeked out from around a corner, a string of marigolds dangling from his neck. "Delight was six days old when I got him," she told me. "It isn't possible to get kitten formula here, but they love diluted buffalo milk—they go crazy for it. And look at him now: so healthy."

"Suri aau!" Ruby called to the others, explaining that this is a sweet way to say "Come here, kitty." In came Belly and Oreo, ready to receive their special treats. "Oreo was my first; he was a mother-left kitten. He was crying so loud and was so small. I didn't have a bottle, so I fed him every meal with a spoon! I didn't know anything!" she laughed. "It's because of experience that anyone learns; experience makes us better."

After sharing a wonderful thali meal, we headed to the rooftop with her family to sip spiced cardamom tea. Oreo joined us in his harness, and the sight of the beloved, worshipped cat against the peaks of the Annapurna mountain range was so breathtaking that I found myself taking a

mental snapshot to hold dear forever. "Tihar is to be celebrated by everyone. Festivals here are not a culture of a religion; it is all one Nepali culture," said Ruby's father, Dr. Ramji Sharma. "When it comes to animals, the relationship is very good. This is an open society accepting of everyone. Kindness to all is the most important thing."

Belly, Delight, and Oreo celebrate Birālō Tihar.

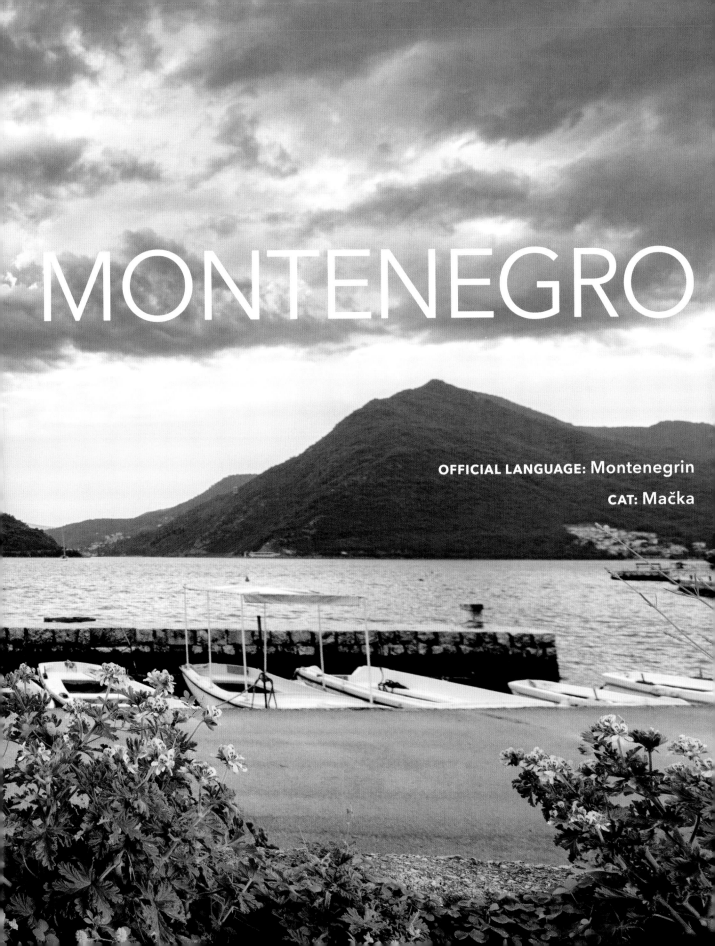

MONTENEGRO

OFFICIAL LANGUAGE: Montenegrin

CAT: Mačka

PERAST

Driving along the Adriatic coastline, we headed east toward the Bay of Kotor, a winding inlet of serene blue water reflecting the monumental mountains above. We pulled into the tiny coastal town of Perast, which has a population of fewer than three hundred humans and several dozen felines. In her stunning sixteenth-century home, Dr. Arijana Gradinčić's open doors offer a haven for cats seeking refuge. "People leave them here because they know I will take care of them," she explained.

The kindhearted doctor has lived in the historic house since arriving as a refugee from Bosnia in 1992, and she takes great care to keep the home preserved and pristine—even with dozens of cats coming and going. In the front, cats prance along stone walls and step out onto the dock, where they hunt for fish in the shallow waters. In the back, cats lounge in a manicured garden with brightly colored flowers. "All year my door is open: winter, rain, cold, hot. Always open," she said. "If I lived in an apartment, I would never have an animal. I just think they need to go in the garden and hide in the trees, so here I am happy."

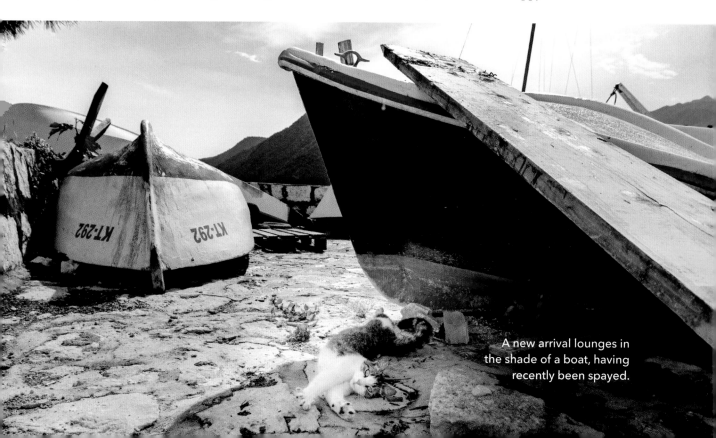

A new arrival lounges in the shade of a boat, having recently been spayed.

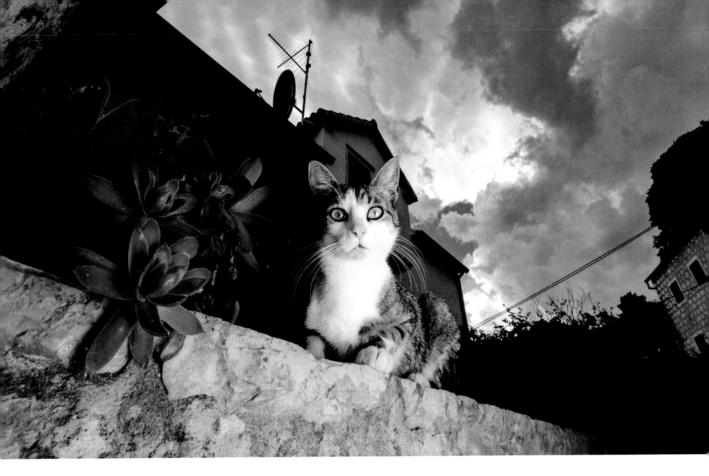

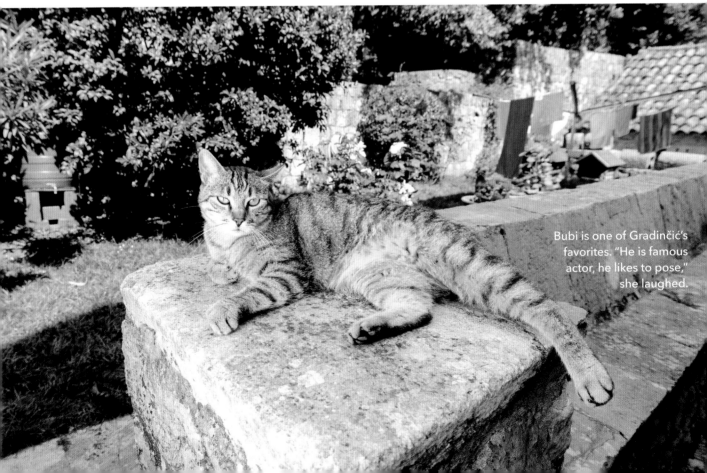

Bubi is one of Gradinčić's favorites. "He is famous actor, he likes to pose," she laughed.

Dr. Gradinčić has a remarkably positive perspective about being the recipient of the town's cats, and seems to be willing to share everything that she has with them— from financial resources to time and love. And while she wishes that cats wouldn't be abandoned, once they arrive, she has no desire to rehome them. "Who will take them? No, no, I keep them. All cats stay with me. Because when I put them in my home, I put them in my heart."

Lepa and Nicolica sit outside the five-hundred-year-old home.

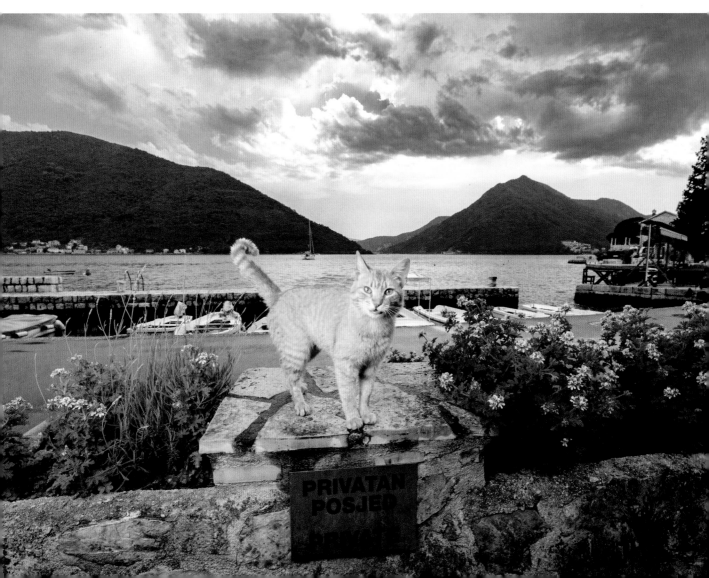

KOTOR

As we arrived in Kotor, I was aglow with eager anticipation—my long-held dream of exploring the so-called City of Cats was finally unfolding! We parked our car along the coast and went on foot, as one must do in order to enter the gates of the ancient fortified city where felines reign supreme.

Legend has it that cats played a significant role in protecting the townspeople from disease during times of plague, preventing the spread of the Black Death by eating rats and mice. Many believe that cats saved the city, and they have been venerated as heroes ever since. Whether the folklore is true, one thing is certain: cats are largely seen as a symbol of good luck in Kotor, and have become an unofficial mascot for the city.

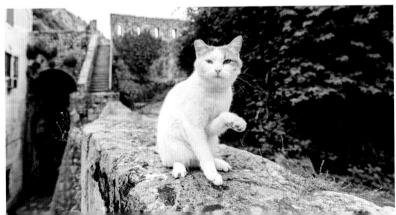

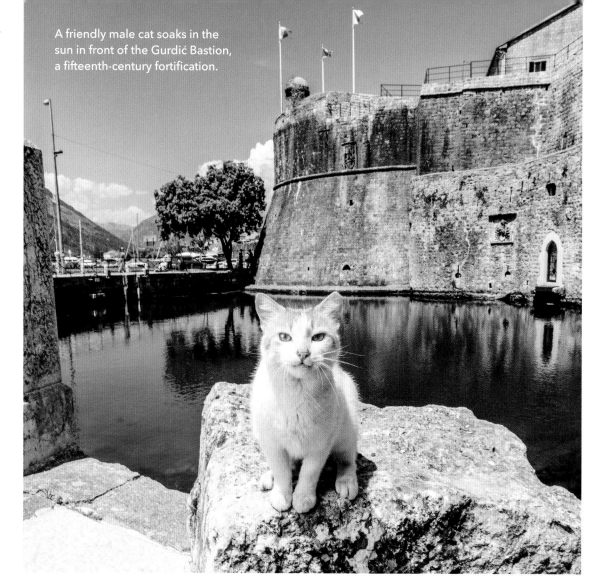

A friendly male cat soaks in the sun in front of the Gurdić Bastion, a fifteenth-century fortification.

You don't have to look far to find cats in Kotor. They peer out from cat-themed shop fronts, prance along rooftops and ladders, and greet you along the cobblestone walking paths. We even met a friendly cat who makes her home atop a thirteenth-century sarcophagus outside a Romanesque church!

Inside the Kotor Cats Museum, two kittens—both named Mička—slept on a pillow by a display of vintage cat postcards. "I rescued them when they were three weeks old," said the museum owner, whose collection of feline artifacts is a popular destination for animal lovers. "They didn't have a mom, so I fed them tuna paste from a tube until they were old enough to eat chopped meat."

While the city is known for its love of all things feline, cats have faced many challenges in Kotor. With no animal shelter, cats are often left within the city walls under the assumption they'll

receive care there—a trend that led to an ever-growing population. Now, an impressive group of animal lovers has come to their aid. Sterilizing cats by the thousands, Kotor Kitties is improving the lives of both the felines and the community members who revere them. "The minister of cultural and natural history says that by helping cats, we are protecting the cultural heritage," said their founder.

My greatest wish for our time in Montenegro was to hike to the San Giovanni Castle, a medieval fortress set high on a mountaintop, accessible by a trail that I'd heard might have cats along the way. To beat the heat, we started the route before the sun began to rise. As we trekked up the zigzagging footpath, the sun peeked over the hills to illuminate a delightful little calico meandering on the road ahead. We took a break, and the sweet tricolor cat joined us as we watched the sun rising over the bay, the sky dappled with clouds. We were only halfway up the hill, and already the view was sublime.

Farther up the path, we paused to catch our breath and spotted a crew of ear-tipped tabbies. We were in awe that these healthy, sterilized cats were living in such a remote location—and certain that we wouldn't find any others as we continued our climb to the top.

Our hearts raced as we arrived at the peak, swept up in the euphoria that so often welcomes hikers to a summit. We explored the ruins, which date back to the first century CE, and gazed in awe at the beauty of the mountains reflecting in the bay below. I thought that nothing could have made the view any more breathtaking . . . until we heard a high-pitched trill that could only mean one thing. A cat was living there!

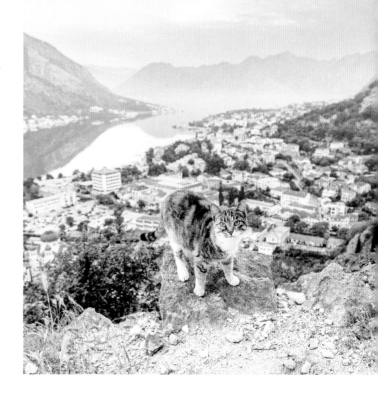

We have met cats all over the world, but I can truly say that none have captured my heart quite like the magnificent yellow-eyed tomcat who makes his home in the crumbling medieval castle atop that epic zenith. With a burly build, dense fur like a polar bear's, and a dignified grace, he stood tall on a stone and overlooked his empire with pride. The tip of his ear signified that he'd been seen by a veterinarian, which seemed incomprehensible at such an altitude. Rugged and regal, he was truly the king of felines. My eyes welled with tears, overcome with reverence for this majestic, sovereign being.

He graciously accepted cheek rubs as the price for admission to his scenic vista, but he had no desire to follow us down the mountain; this was clearly his territory. When we arrived back in town we learned that his name was Debeli, and that it was indeed compassionate volunteers who had climbed all the way to the top to ensure that he received care, then returned him to his rightful throne—high above the City of Cats.

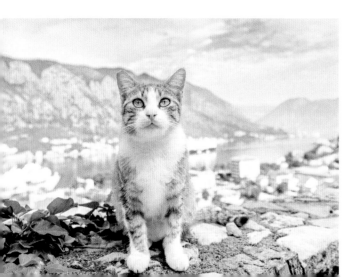

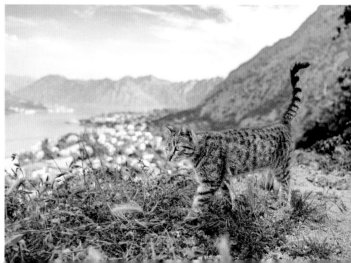

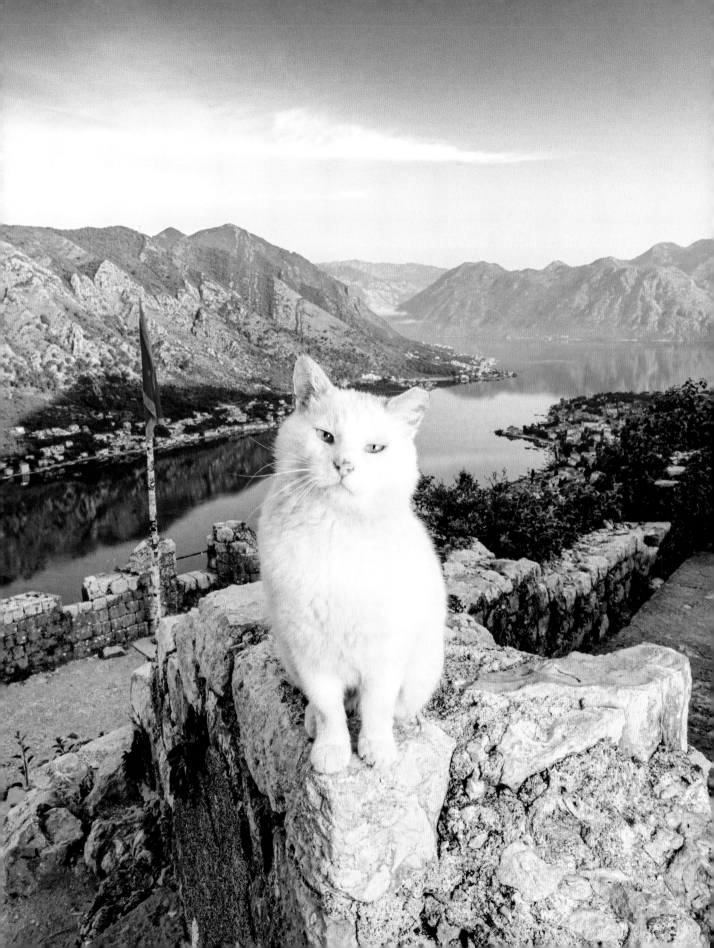

COMING HOME

Upon our return from the airport, our cats greeted us at the door and curiously sniffed our bags. We'd traveled light, but returned with so much to unpack. Our experiences left me in awe of the deep bond between humans and cats and affirmed that despite the complex hardships of our world, kindness dwells around every corner.

Over the course of our travels, we were struck by the revelation that the majority of domestic cats still live very much as their ancestors did: as members of our communities. Like the felines of yesteryear whose hunting prowess made them ideal allies in early civilization, so many of today's cats continue to live as our neighbors. We share our parks, our markets, our places of work and worship, and even our archaeological sites. How profound to observe these symbiotic partners both walking the ruins of our ancient societies and slinking through our modern world, seeking to find their footing in an ever-changing landscape.

The human-feline relationship is evolving. Cats now capture our hearts as companions, warming our laps and ruling over our homes from tall, carpeted towers. Simultaneously, they bear the weight of our presumed dominance and the resulting policies that govern their lives. Cats know nothing of human ideologies or borders, yet these anthropocentric constructs greatly inform how they live today. Their outcomes are a mirror of our outlooks; our perceptions are shaping their existence.

Of course, the lives of cats couldn't possibly be uniform in a world so vast; nor can our approach to their welfare. What's best for a cat in frigid Finland inevitably looks quite different from what's best for a cat in tropical Tanzania. As advocates, each of us contributes in our own way, guided by the goodness at our core and the unique lens of our lived experience. It's by listening with a soft openness that we can come to understand one another, grow together, collaborate, and discover that even when we stand on different paths, we tend to walk in the same direction—toward the hope of a better future.

To untangle in writing the complexity of the global relationship we share with cats seems an impossible quest, but we believe the heart of it can be gleaned from the simplest of stories: the Turkish pianist who soothes cats with music; the Dominican woman who welcomes felines in her factory; the Bosnian child who cuddles kittens at a playground. We're comforted to know that the human-feline story is composed of these small, tender moments between everyday people like me and you and the cats who cross our paths. As we marvel at the beauty of cats in all their myriad contexts, may we each be inspired to contribute in our own way, bound by the universal compassion that unites us all.

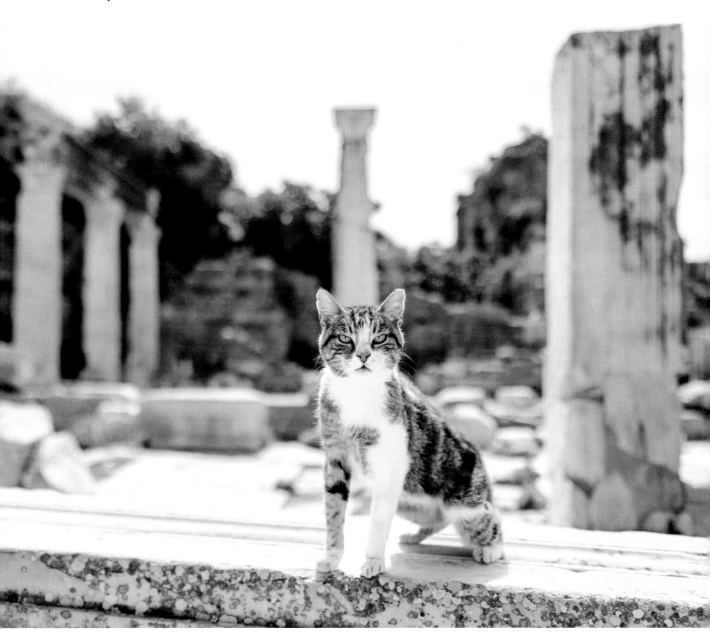

ACKNOWLEDGMENTS

Creating this book has truly been the adventure of a lifetime, and we are deeply grateful to everyone who helped bring the project to life.

To our wonderful literary agents, Myrsini and Lindsay, thank you for sharing our vision and being our partners and advocates in this journey. Your passionate expertise is unmatched, and we are so fortunate to work with you both.

Stephanie, our dear editor, it is always a delight to collaborate with you. Thank you for the perspective and wisdom you bring to each and every book you touch.

Jill, Charlotte, and everyone at Plume, we couldn't have asked for a better team. Thank you for believing in this project and trusting us with this enormous undertaking. Making books with you is a joy!

To our fantastic cat sitter Lauren, thank you for loving our cats (almost) as much as we do. Your devotion and dependability kept our minds at ease while we traveled, and we are so thankful for the bond you share with our feline family.

A special thank-you to our beloved cats—especially my darling Coco, who warmed my lap as I wrote these stories and listened intently as I read them aloud. To Chouchou, thank you for only deleting a small number of Andrew's photos as you rolled around his keyboard while he edited . . . that was very considerate of you.

Most important, we wish to extend our gratitude to everyone who opened their homes and shelters to us, shared their stories and ideas, cooked us a meal, showed us their city, laughed and cried with us, and let us pet their precious cats. Your warmth and hospitality were a gift; your compassion is contagious and inspires us beyond words. Thank you for giving hope to the cats of our world.

ABOUT THE AUTHORS

HANNAH SHAW, also known as Kitten Lady, is an award-winning kitten rescuer, humane educator, and unwavering animal advocate who has dedicated her life to innovating kitten care and protecting the most vulnerable felines. She is the *New York Times* bestselling author of *Tiny but Mighty*, *Kitten Lady's Big Book of Little Kittens*, *Kitten Lady's CATivity Book*, and the Adventures in Fosterland series. She is also the founder of Orphan Kitten Club, a 501(c)(3) nonprofit organization saving the lives of neonatal kittens throughout the nation. She lives in California with her husband, Andrew Marttila; their cats and dog; and an endless rotation of foster animals.

ANDREW MARTTILA is a professional animal photographer specializing in cats. Over the years he's taken millions of photos of our feline overlords, which have been used in worldwide media in both digital and print—from *Good Morning America* to the cover of *National Geographic*. He is the creator of several books, including *Shop Cats of New York*, *Cats on Catnip*, and *How to Take Awesome Photos of Cats*. He is also a board member of Orphan Kitten Club and has hand-raised hundreds of rescued kittens alongside his wife, Hannah Shaw.

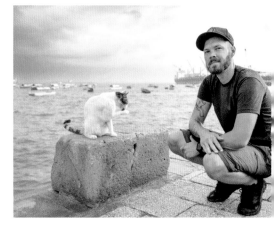